ART TREASURES OF THE PEKING MUSEUM

ART TREASURES OF THE PEKING MUSEUM

TEXT BY

FRANÇOIS FOURCADE

HARRY N. ABRAMS, INC., Publishers, NEW YORK

Translated from the French by NORBERT GUTERMAN

Library of Congress Catalog Card Number: 65-15981
Colorplates printed in Italy. Text printed in Holland. Bound in West-Germany

CONTENTS

LIST OF PLATES

Paintings

Ceramics

CHINESE PAINTING

WHETHER we are dealing with Chinese poetry, calligraphy, ceramics, or painting, we are at once made aware of the artist's deep love of nature and the feelings her pageantry arouses in him.

Once painting had become partially independent of ritual or narrowly religious concerns, the painter increasingly looked to nature as the major source of his inspiration, frequently encouraged by poetry to do so. Chinese painting speaks with astonishing directness to us across time and space. This is true of great mountain landscapes with waterfalls and rushing streams, broad rivers, scenes of fog and mist where a few peaks can just be made out in the distance, as well as of detailed, close-up representations of birds, insects, plants, and flowers. Down to his careful portrayal of the lowliest vegetable, the artist restores nature to us in her creative dignity and power of poetic evocation.

So keen a sensitivity to the spectacles of nature did not take on these forms all of itself. Nor is it due to some special Chinese temperament, some specific character of nature in China. It has developed from the fact that the ancient peasant populations of China were obliged to keep up a continuous dialogue with nature, in the course of which the language—and the forms of literary expression—took shape.

Among the ruling classes in the old Chinese society, theories of the universe were evolved which expressed a common conception of nature's materiality and dynamism.

In times of trouble, contradictions within the ruling class led some of its members to withdraw from the life of action entirely and to lead lives of seclusion, either in their own country houses or in Buddhist and Taoist monasteries. There they could give themselves over to poetry, calligraphy, and painting in the immediate presence of nature.

THE PRIMITIVE PERIODS

From the dawn of their civilization, the Chinese people's existence was based on agriculture, the rhythm of their labors dictated by phenomena of nature which they interpreted as signs. A whole mythology took shape to account for them. Thunder, for example, which is the precursor of life-giving rains, became associated with the dragon myth. However, the two realms—that of mankind and that of the forces of nature—were never in China thought to be separate and distinct. Men supposed that by their own acts they could precipitate the phenomena of nature, that they could, for example, induce rain by imitating thunder, whether by performing the Dragon Dance or by decorating a ritual vase with images or symbols (clouds, lightning) of thunder.

Graphic emblems, rightly used by those who know how, may produce the results desired. The ornamental motif which in the West is thought of as the Chinese version of the Greek key pattern, the *lei-wen*, was originally a stylized representation of lightning, itself evocative of thunder and rainstorms. In the ancient ritual bronzes the motif is heavy with symbolic meaning, whereas in Chinese porcelains it has changed into an elegant ornament. The same has happened with the ornamental pattern called "cloud streamers."

The order of society and the order of the universe are in correspondence: an insect's chirp or the song of a bird is a signal that it is time to begin a particular activity. The words, "The oriole is singing," mean it is time to strip the new leaves from the mulberry trees to feed the silkworms. In the same spirit, poetry supplies a great many images of springtime, young girls picking flowers or fruit, intense young men, and so forth. The various acts of social life follow a rhythm in conformity both with the activities of the group and with the cycle of nature.

To give expression to the changes going on throughout the universe, the Chinese sensibility very early found images corresponding to the feelings in men's breasts. Moreover, it was through reference to those changes that the Chinese measured the passing of time.

The most ancient Chinese poems, those of the *Shih Ching* (*Book of Songs*), are known to be much older than the fifth century B.C., when Confucius is supposed to have compiled them. They show how intimately linked was the expression of personal feelings with images of nature. They show, too, how great a part the passing of time has played in Chinese poetic expression from an early date, both in the sense of changing weather and in more chronological senses. Poetry conveys a feeling for the permanence or impermanence of things in highly concrete imagery, very much as Chinese painting does, but at an earlier date:

> The north wind... how icy!
> Rain, snow... such storms!
> Lovingly... if I am yours
> Hand in hand... let's leave together!
> What fear, what expectation?
> It is the moment, that is all!

Who'd be red if not the fox?
Who black if not the raven?
Lovingly... if I am yours
Hand in hand... let's mount the chariot!
What fear, what expectation?
It is the moment, that is all!

And this poem, too:

The May fly! Its wings...
Its raiment, so lovely.
In my heart, how much sadness!
Come back to me and stay.

The May fly! Its wings...
Its lovely shimmering garment.
In my heart, how much sadness!
Come back to me and rest.

The May fly, emerging from the ground...
Dressed in hemp, a snow flake...
In my heart, how much sadness!
Come back to me and rejoice.

CONCEPTIONS OF MAN, SOCIETY, AND THE UNIVERSE

The middle of the first millennium B.C. was a crucial period in the development of Chinese thought. The great states were constantly struggling among themselves between the seventh and the third centuries, although nominally they all fell under the suzerainty of a common ruler. Yet it was during this same Chou Dynasty that the various elements of Chinese thought began to come together in systems and disciplines. The foundations of Confucius' teaching, which was continued by his disciple Mo Tzu, were laid down between the middle of the sixth and the beginning of the fourth century of our era. Taoist thought was hammered out between the close of the fifth and the close of the fourth century. Confucianism and Buddhism were the leading systems of philosophical thought in ancient China.

Although they utilize the same vocabulary to a considerable extent, and also the same images, the teachings of Confucianism and Taoism are differently oriented. As the established system, Confucianism was to enjoy the prestige of orthodoxy for many centuries; primarily it stressed man's social relations. To achieve a mankind marked by wisdom and self-restraint, respect for the rules of social organization was essential. Taoism, on the other hand, emphasized the conduct of the individual.

The Confucianist sage was respectful of tradition, ritual, the established ways of doing things, and tried to conduct himself under all circumstances in conformity with an ideal of man as a social, civilized, cultivated being.

The Taoist sage behaved less punctiliously, was even capable of being impolite. Disdainful of the established order and of worldly honors, his ideal was one of retirement into comparative isolation—at least for as long as this might be feasible. He turned his back on the world in order to commune with nature through meditation, the practice of certain holy pastimes, and exercises in breathing and concentration not unrelated to those of the Indian yoga. In certain periods, Taoist sects pursued magical and alchemical researches in view of discovering the elixir of life.

Where the two systems especially differed was in the models of conduct they set their followers, the examples they offered as worthy of emulation. Their conceptions of the universe as a whole, or of nature, were not markedly opposed. The oldest Taoist texts put painting under the head of the "Five Perversions," along with music, scents, gastronomy, and the passions of the heart. Nonetheless, when the Taoist ethic, founded on a mystical naturalism, was incorporated with the Buddhist sect known as *Ch'an* (better known in the West by the Japanese name, Zen), it attracted many great Chinese painters.

From the beginning, Chinese thought seems to have excluded idealist theories of creation: the universe was neither created nor will it ever have an end. It is a succession of transformations of a principle that goes through well-defined but not radically different states—heat, light, and matter—and an indeterminate state to which, perhaps, the term "rest" might be applied.

The myths and legends by which Chinese thought in the archaic period sought to account for the universe and its transformations eventually came to be regarded as the history of the origins of Chinese civilization—or, what comes to the same thing in ancient thought, with those of humanity. The order of the universe was conceived of as an extrapolation from the social order.

Nature's various kingdoms—mineral, vegetable, and animal, and including man as individual—form a single whole.

Confucianists went so far as to include society as such within this whole, whereas Taoists and some other schools thought of the *natural* as opposed to the *social*.

We cannot here go more deeply into the ancient Chinese philosophical conceptions of matter and the universe, but there is one term of great importance in painting which deserves explanation. This is *ch'i*, which signifies breath, exhalation, steam, energy, ardor, the influence emanating from people and things, the outward sign of their inner dynamism.

In ancient thought, *ch'i* was conceived of as a sort of pulse animating all things and, especially to Taoists, as a force of life and vitality. We shall see how Hsieh Ho (c. A.D. 500) put *ch'i* first among his *Six Canons of Painting*, which were to influence all subsequent theory. The artist must first of all give expression to *ch'i*, in order that his work may by a sort of resonance or rhyme (*yün*) produce the movement of life.

Naïvely materialistic conceptions of the universe are met with in the theories of landscape painting elaborated under the T'ang and Sung dynasties.

Certain old Chinese texts, such as the *Lun-heng* by the remarkable philosopher Wang Ch'ung (first century A.D.), had already compared the earth's structure to that of the human body. Mountains and rocks constitute its skeleton and give it stability and solidity; streams are its blood and its humors; vegetation is its hair. Should this "hair" be shaved off, the *Lun-heng* tells us, the rains would cease to fall. The ravages caused by China's deforestation are well known.

A few centuries later, we find the same ideas expressed by Kuo Hsi (c. 1020–1090), a famous Sung painter and critic whose notes for *Essay on Landscape Painting* were arranged and edited by his son Kuo Ssu. To Kuo Hsi, rocks are the bones of the universe, and a painter should try to render their strength. Water, which is a living thing, is its blood, and brooks, streams, and rivers are the arteries through which it flows. Vegetation is the fur the mountains bear, while the clouds and mists enveloping them are their adornments. Kuo Hsi makes a point of singling out the various seasonal aspects of what he considered the essential elements of landscape.

"Mountains in spring have the seduction of a smile, those of summer are bathed in a bluish gentleness, while those of fall sparkle as with glistening make-up; those of winter, dozing, are calm and peaceful." Similarly, clouds and mists take on different meaning with the change of season: "In spring vaporous as a smile, cloudy blue in summer, in autumn... like a lovely woman in her finery. Through the fogs of winter, nature is glimpsed as in a dream."

Clouds and mists are an essential element in most landscape paintings, especially those by artists living in the humid climate of South China. The latter have been most successful at capturing the beauty and importance of such phenomena, in this respect recalling British landscapists who, by the nature of their climate, have also been made sensitive to blurred or hazy effects of light. As Whistler observed in a famous lecture, "The dignity of the snow-capped mountain is lost in distinctness... when the evening mist clothes the riverside as with a veil and the poor buildings lose themselves in the dim sky."

Painters from North China, to whom nature is presented in a drier climate and a clearer light, have more than those of South China stressed clear-cut lines and colors, and their compositions have made less use of unpainted areas of silk or paper. The rather arbitrary sixteenth-century distinction between a "southern school" and a "northern school" in part derives from this.

As for the watery element in nature, according to Kuo Hsi, "Mountains shape its features, pavilions and kiosks its eyes and eyebrows. Fishermen animate it with their nets and poles." A painter, according to Kuo Hsi, must render the life of a landscape, for "Streams that do not flow, that make no sound, are dead streams; without life, clouds become solidified; mountains without portions of light and dark are shadowless and lightless, and if not partly hidden lose their ornamentation of mist and fog." Also, the painter should know how his work is to inspire the viewer: "There are landscapes one would like to take a stroll within, some merely to wander through, others to stay and live in."

This last recalls Renoir's remark, the first part of which any cultivated man of Kuo Hsi's time could have agreed with, though the latter part would have struck him as incongruous: "I like pictures that make me want to walk around in them, if they're landscapes, or to caress their backs, if they're pictures of pretty women."

Landscape painting capable of inspiring a desire to "walk around" in it has obviously retained something of the magical significance which, in archaic epochs, was attached to the making of images. Very much to the point here is the legend that grew up around the demise of Wu Tao-tzu, great painter at the court of Hsüan Tsung in the eighth century. His last painting had been commissioned by the emperor and consisted of a broad landscape completely

covering one wall and depicting mountains, forests, streams, animals, and human beings. At the foot of one mountain was a closed door: the entrance to a cave inhabited by a genie or jinn. Wu Tao-tzu raised his hand and knocked, and the door opened! Inviting the emperor to follow, the artist stepped inside, but the door closed instantly after him. To the consternation of the emperor and his retinue, they now found themselves standing in front of a perfectly blank wall... the painting had disappeared! And no more was ever heard again of Wu Tao-tzu.

Actually, no painter has ever claimed to be endowed with the supernatural powers legend attributes to Wu Tao-tzu, although in the eighteenth century Lo P'ing sold portraits of ghosts to the gullible merchants of Hangchow, which he claimed to have painted from life.

Nor has any artist ever supposed that his creation, as a creation, is superior, or even equal to, the work of nature that inspired it. Shakespeare's compliment to a painter on his work (*Timon of Athens*, I, 1),

It tutors nature: artificial strife
Lives in these touches, livelier than life

like the paradoxes of Oscar Wilde, runs counter to the Chinese concept of painting. Nature's simplest creations, a bit of rock or a mere *p'u* (a piece of wood in the natural state, through whose veins can be sensed the life animating it), has something superior to the loveliest representations that can be made of it.

The aim of art is thus not to outdo nature but to plunge deeply into her and be incorporated in her, in such a way that the viewer is carried along. As Tao Chi said: "When you have attained the impassivity of rocks and fragrant flowers, your feelings will of themselves be transmitted to your brush."

Such sentiments are not mere rhetorical figures, for we have record of a great many artists practicing meditation and observation of nature while holding themselves still, seemingly insensitive, the better to study the blossoms, the bamboos, the insects, and the birds they will later paint. To such artists nature appears as a vast theater of movement to be entered "on tiptoe," without disturbing it, if its beauty is to be admired and borne witness to.

In the same spirit, Chin Nung (eighteenth century) speaks of an old master who liked to paint fruit trees in bloom on chilly moonlight nights, and took all sorts of elaborate precautions "not to frighten them, just as though they had been sea gulls resting on some icy shore." Centuries before, the same image had been employed by Lieh Tzu, the Taoist writer, portraying the sage living in the bosom of nature so completely that the gulls do not fly away at his approach but play with him, for he bears them no hostility.

THE PAINTER IN SOCIETY

Like the art of calligraphy, that of painting developed within educated circles during the early centuries of our era. Gradually, the anonymous craftsman came to be superseded by a new type of artist, the "scholar-official." Artisan-painters survived, however, as makers of funerary portraits, good-luck images, and talismans. For religious communities they supplied banners and holy pictures, and even some frescoes, though in the capital and the big cities, especially from the T'ang Dynasty onward, court artists were used more and more.

As early as the Sung Dynasty, craftsman painting took new forms as an increasing demand for works of art developed among less educated portions of the population, especially the merchant class. Truly professional painters, in the Western sense of artists who earn their living primarily by the sale of their works, began to appear.

Nonetheless, viewed as a whole, Chinese painting as it has come down to us seems to have been dominated by artists whose position in society, the way they thought of their art, and their refusal to set a price on their works make them more nearly amateur than professional artists. To understand the special nature of the painter's social situation in ancient China, we must point out the extremely important place given to the arts of the brush in the life of the educated man.

His training in calligraphy began early and he continued to practice it the rest of his life. This means he acquired perfect mastery of the brush. Rather early in life he adopted the style of calligraphy best suited to his own taste and temperament, blending study of the great calligraphers of the past with attempts to develop a style of his own. At the same time, if only for exercise in handling the brush, he was practicing painting.

Meanwhile, his friends were comparing and criticizing his accomplishments, and keeping examples of his best work. His reputation as an artist might slowly spread in this way, until he was sought out by artistic and literary circles patronized by the great of his day. A number of emperors

were themselves artists. This was the life of most "literati" in ancient China—that is, those who received the classical education—though not all, of course, were equally talented or became equally famous. But most of them practiced calligraphy, painting, and the composition of poems and essays throughout their lives. Of course, only members of a ruling class were in a position to devote such considerable time to artistic pursuits purely for their own pleasure, following their own bent.

The so-called scholar-officials, including the literati painters, made their appearance as a ruling class under the Han Dynasty (206 B.C.–A.D. 220). This epoch witnessed the gradual organization of Chinese officialdom along the lines it was to keep right down to the end of the Ch'ing Dynasty in the early twentieth century. For nearly two thousand years a few thousand educated families supplied China with the overwhelming majority of its civil and military officials. For the most part in comfortable circumstances, and sometimes extremely wealthy, these families lived on the income of lands which had become theirs as feudalism developed.

To enter the ranks of officialdom and progress upward to higher and higher posts, a system of examinations was devised at the local, provincial, and imperial levels. Held every three years, these examinations brought together China's most gifted young men. They were above all tests of literary culture, and a fine handwriting was as essential a factor to success as possession of a good style.

From his earliest years, a child destined to an official career had to pursue literary studies. Once he gained a foothold in the ranks, part of his time not occupied by official duties was consecrated to the noble pastime which most appealed to him: calligraphy, painting, poetry, prose essays, lute playing, checkers, gardening, or flower arrangement. Frequently he might be a collector as well, whether of art objects or of such products of nature as oddly shaped and colored stones. In short, he would have what the Anglo-Saxons call a hobby: he might botanize, study old bronzes or ancient inscriptions, etc.

Part of his leisure time was used in the performance of traditional obligations. Ritual demanded, for example, that on the death of his father he must return to the village where he was born and stay there for three years. Only when he retired from his official duties, between the ages of sixty and sixty-eight, could he give himself wholly to the artistic pursuit, the study, the research or the collecting activity of his choice. It is an interesting fact that the most beautiful

works by painters from this background were often products of their old age; only then, once they were free to spend their last years as they wished, did they fully succeed in expressing the feelings with which a landscape, a plant, or their own features inspired them.

Before reaching retirement age, the scholar-official would have traveled. Frequently transferred from post to post in the course of his career, he would have seen a good deal of many different parts of China. Moreover, in poems or sketches or both, he would have set down his impressions and feelings of different places: how a new landscape looked when he arrived at nightfall or left at dawn, the character of the inn or temple where he spent the night. In this way an image of his country was indelibly engraved on his heart.

A number of great painters held high official posts under the T'ang Dynasty. At the request of the emperor or other court dignitaries, they painted frescoes and silk scrolls. They belonged to the Han Lin or "Brush Forest," a court academy under the emperor's patronage which included scholars, philosophers, and other writers as well as artists.

Besides such high officials, other educated men painted purely for their own and their friends' pleasure, without necessarily being involved as painters in the performance of administrative duties. Wang Wei (651–716) may well be taken to represent the more independent literati painters under the T'ang Dynasty. He was a medical officer who lost his position for having attended the wounded in the camp of the rebel An Lu-shan, though he later regained it. Like other painters of this type, technique did not hold a primary place in his thinking, and his pictures are above all imbued with poetry and literary feeling.

Eventually, under the Yüan Dynasty, literati of this type—gifted alike in poetry, calligraphy, and painting; players of the *ch'in* (a zitherlike instrument); or fervent gardeners—came to constitute a school known as the *wen jen hua* (literati school of painting). They were characterized by disdain for technique, sense of poetry, nonconformist behavior, and total lack of interest in business or other "extraneous" aspects of art.

Under the Northern Sung, a conspicuously different type of painter-official appeared with the creation of a separate Academy of Painting. With this development, court painters came increasingly to exercise the functions of academicians, first and foremost. When the court moved south after the Mongol conquest of North China, the Academy was reconstituted, but growing formalism drove a number of

great painters to withdraw and take refuge in monasteries.

At the close of the Sung Dynasty, although the time-honored fine phrases were retained, a good part of the ruling class found its interests more and more closely linked with those of the rich merchants. Corruption rapidly set in, and in consequence a reaction developed within the ruling class on the part of those who remained faithful to the ancient literati ideals. Some great artists withdrew from the atmosphere of the court, where stuffy academicism ruled along with luxury and corruption. First Mu Ch'i, and then Liang K'ai, took refuge in Buddhist monasteries of the Ch'an (Zen) sect.

Under the Yüan (Mongol) Dynasty, apart from a few artists like Chao Meng-fu who held high office at the Mongol court, most of the great painters lived as far from official circles as they could. Among these were all four of the so-called Four Great Masters: Huang Kung-wang, Wu Chen, Ni Tsan, and Wang Meng, and also the artist Ts'ao Chih-po. They lived in retreat from the great world, painting as amateurs, their anticonformist behavior and their disinterested conception of art entitling them, along with the importance they gave to poetry and calligraphy in their work, to claim to be among the founders of that literati painting which goes back to Wang Wei.

Under the Ming Dynasty the mediocrity of official painting is in part accounted for by the fact that the most gifted of the literati, such as Shen Chou, sought no official career in government but led the quiet life of country gentlemen.

At the beginning of the Ch'ing Dynasty, in the seventeenth century, the greatest masters lived far from the Manchu court. A number became monks: Fang I-chih, known as Hung Chih; K'un Ts'an, known as Shih Ch'i, superior of a monastery at Nanking; Tao Chi, known as Shih T'ao; and Chu Ta, known as Pa-ta-shan-jen. The last two were from great families that had been allied with the Ming imperial family and were outspokenly anti-Manchu. "The brush can render rocks and mountains, but the soil itself has gone," wrote Pa-ta-shan-jen on one of his pictures. These artists all shared a contempt for wealth. Shih T'ao, who took the name of Venerable Blind Man, used to say, "I go blind in the presence of money." Pa-ta-shan-jen gave his pictures away to poor people or collectors of modest means; wealthy collectors could only obtain them, it seems, by hiring an intermediary.

The literati had a very poor opinion of "mercantile" attitudes to the arts of the brush. It would be as improper for a cultivated man to sell his paintings or calligraphy as to sell his poems. For a very long time, wealthy collectors who thought nothing of paying what seem to us fabulous sums for a ceramic or carved jade piece, or for an archaeological find, would not have it that money could play any part in the circulation of works done by the brush.

Mi Fei (1051–1107), who was a great collector as well as a great painter—when he was young his mother sold her hair ornaments so that he could buy an object he coveted—declared that "painting and calligraphy can never be the objects of commercial transaction." Literati were not supposed to buy works, but to exchange them among themselves. However, when a new breed of collector appeared—wealthy merchants, especially, toward the close of the Sung Dynasty—a new attitude began to assert itself, and little by little works of painting and calligraphy made their way to the market.

Yet the literati painters long refused to do work for money. They gave their works away. Many an artist, when he felt in the mood, would invite friends to bring paper or silk, and to carry off with them the picture he painted! The poorest might accept food or wine, occasionally, in barter. Kuo Pi, a painter who lived in Hangchow in the fourteenth century, accepted jars of wine, dried fish, and a cooked duck! To offer one of the literati money, or some really valuable gift, would have been considered an insult. The painter Wang Fu once wished to thank an unknown neighbor who had come at night and played the flute for him in a fashion he particularly enjoyed. Learning that the man was a cloth merchant, Wang Fu called on him to congratulate him on his flute playing, and brought a picture as token of his esteem. The merchant thanked him and then in his turn asked if the painter wouldn't like a carpet in exchange for a second picture, so he might have a pair? Furious, Wang Fu tore up his picture and stormed out.

FROM THE ORIGINS TO THE BEGINNING OF THE T'ANG DYNASTY (618)

We have no example of painting from earlier than the second half of the first millennium B.C. There is good reason for believing, however, that well before this the walls of palaces had been decorated with frescoes, and that there had been painted oriflammes or banners of silk and other cloth.

Under the Shang Dynasty the brush was already used, and

the decor of the magnificent bronzes from this period proves a mastery of line and an art of composition suggesting that an art of painting was already well advanced.

Somewhere between the seventh and the sixth centuries B.C. appeared bronzes in a new style, the decoration treated in fully pictorial fashion. Incrustations of precious metals, and, a little later, coats of lacquer, indicate concern for achieving color effects. These bronzes are ornamented with motifs combining the mythological with the realistic—hunting scenes and animals fighting, for example.

The oldest known paintings on cloth were discovered in tombs around Changsha in Hunan province. These are pieces of silk on which the decorative themes have a ritual or propitiatory character: charms and talismans against evil spirits. They seem to date from the fourth or the third century B.C.

There then existed, as no doubt for a long time before, an art of fresco. Written texts speak of palaces with fantastic scenes and portraits of great men painted on the walls. The great poet Ch'iu Yuan (third century B.C.), in an ode that puts questions to heaven which have never been answered, asks himself what is the meaning of the strange pictures he saw on the walls of a palace.

The Han Dynasty (206 B.C.–A.D. 220) has left us mural paintings of a funerary character, discovered in North Chinese and Korean tombs, dating roughly from the second century of our era. They are painted directly on the rock—which has been given preliminary coats—or on bricks. The range of color is quite extensive: green, red, blue, yellow, brown, black, and white. The brushwork is sharp and lively, representing the life of the deceased and other figures. Already, in the portrayal of these ancient worthies on foot, in chariots, or galloping on caparisoned steeds, we find the sense of life and movement that is to characterize subsequent Chinese painting.

There is an obvious relation between these works and the gravestones in shallow relief going back to the third or second century of our era, which have been found in great numbers in many parts of China, but especially in Shantung and Szechwan. These portray historical scenes and famous legends, episodes in the life of the departed, and battles, mingling realistic detail with fantasy and symbolism.

Figures are mainly presented in profile, but now and again we find people or animals shown in three-quarter and back view, suggesting depth. The total effect—and we doubt this is mere coincidence—reminds us of the way images are presented in shadow plays, the tradition of which goes back to ancient times in China.

We may note that bricks of the Han period, discovered in Szechwan, have molded decorations that often look like a real picture. In northeastern China and in Korea objects in painted lacquer have been found, some of which are ornamented with representations of human figures.

Down to the end of the Han Dynasty painting seems to have obeyed ritual, symbolic, funerary, or ethical promptings rather than decorative or aesthetic ones. Painting was essentially the work of craftsmen, that is, persons from the "lowly" classes, "the mass of men," in the language of the *Chuang Tzu*, a composite text the oldest portions of which go back to the third century B.C.

Let us single out a few of the characteristics of this earliest Chinese painting which will in varying degree remain constants ever after. First, even fantastic, mythological, and allegorical subjects are treated in a *realistic* spirit; there is *observation* and emphasis upon the characteristic features of the subject; and attention is given throughout to the expression of *movement*. A number of texts have come down from these archaic ages in which magical significance is ascribed to images.

Under the Han Dynasty the dry-brush technique was developed. It was first employed for writing, and is supposed to have been invented in the third century B.C. The use of paper also became widespread; legend attributes its invention to the eunuch Ts'ai Lun (c. A.D. 100).

By the third century of our era, the Han Dynasty fell apart into a congeries of warring states, and for the next several centuries China was a divided country. In the north, nomad peoples founded a number of barbarian kingdoms, the most important of which, that of the Wei, eventually (in the fifth century) brought about the unification of North China down to the Yangtze River under the suzerainty of a Turkish tribe, the T'o Pa.

Establishment of the kingdoms favored the development of Buddhism in North China. A Chinese Buddhist art began to take shape around the fifth century, its finest remains being cave frescoes and sculptures. Iconography and themes were borrowed from Indian sources, and the style reflects traces of the Central Asian regions by way of which Buddhism reached China. In Chinese Buddhist art, alongside Indian elements, we find Indo-European and Persian contributions, as well as traces of Syrian art of the Hellenistic period.

In South China, on the other side of the Yangtze, there were struggles throughout the period of the so-called Three Kingdoms, and these were later to supply the subject of many plays and an epic novel. A southern empire, with what is now Nanking as its capital, grew up around the Chin Dynasty (265–423). Internal rivalries and extreme corruption at the Chin court, as well as constant struggles to hold the barbarians at bay in the north, plus popular uprisings, brought about the fall of this dynasty. It was succeeded by four very short-lived dynasties within the space of 150 years.

Finally, in 589, a Chinese leader who had restored the unity of North China by driving out the barbarian invaders captured Nanking, re-established the empire, and founded the Sui Dynasty (589–617). Though also short-lived, the Sui Dynasty played an important part in Chinese history. Great construction projects were undertaken, including canals to link the Yangtze River and the Yellow River, that is, South China and North China. Relations with the rest of the world developed, especially with Japan, where Chinese culture began to permeate that civilization.

The feudal structure of society was strengthened. Up to now the land had been considered government property, rights to its enjoyment being merely "accorded" to individuals. Now it began to be distributed, with all legal observances, to nobles, high officials of the empire, and Buddhist monasteries. Buddhism had a profound effect on China; one of the Sui emperors withdrew to a monastery and lived there as an ordinary monk.

New developments in painting took place between the fourth and the sixth centuries in the colorful valley of the Yangtze, which has a southern, rather than a northern, atmosphere.

Ku K'ai-chih (344–406) is chronologically the first of the great artists from this early period. Two works of his have come down to us: if not the originals, at least very ancient copies. He had a great influence on subsequent painting. Living within the court circle at Nanking, he painted long silk scrolls depicting scenes of palace life and also illustrated ancient legends, both with a frequently scrupulous realism of detail. Short calligraphic passages separate the scenes on his long scrolls, specifying the subjects. The different scenes are harmoniously related, unfolding according to a well-paced plan. One of the two scrolls attributed to him employs landscape elements as a background to the figures. Color is delicately applied within outlines at once precise and yet not stiff.

After Ku K'ai-chih, still at the court of Nanking, we find Lu T'an-wei (419–500) and Chang Seng-yao (early sixth century), both of whom specialized in Buddhist and Taoist subjects. The latter is supposed to have painted snow scenes as well, dispensing with preliminary contour lines. This would make him the direct precursor of Wang Wei and other T'ang Dynasty painters.

Hsieh Ho (c. 500), was a theoretician of painting whose famous *Six Canons* were to serve as the basis for all subsequent works on the theory of the art. These may be defined as follows:

1. Give resonance (or better, rhyme) to the *ch'i* (the vital breath) to produce the movement of life.
2. Achieve mastery of the brush to apply the method of the bony structure.
3. Be faithful to the model in rendering the form of objects.
4. Differentiate types in applying color.
5. Organize composition by putting things in their proper places.
6. Copy the great masters to assure continuous transmission of their works and teaching.

Of course, no artist could be expected to achieve absolute mastery of the *Six Canons*. As all later critics will insist, the first of them is by far the most important: learning to render the *ch'i*, the very stirrings of nature. To succeed at this indicates real gifts. Conforming to the appearance of objects —what we call likeness—is of secondary importance, nor is it absolutely binding upon the artist if, by departing from the appearances, he may strengthen resonance of the *ch'i*. The point is a significant one. It explains why many great Chinese painters and critics have rejected likeness as a leading criterion in the appreciation of painting. This attitude is expressed in a few striking formulations which at first glimpse might appear paradoxical.

T'ANG DYNASTY (618–907)

Under the T'ang Dynasty, China experienced one of the most brilliant epochs in all her history. The empire spread, both directly and indirectly, from Korea to Kashmir and from the Himalayas to Mongolia. Tibet recognized Chinese suzerainty in the seventh century.

The Chinese empire was thus brought into contact with

the countries of western and southeast Asia, and permanent relations were established with Japan. China in those years was not just the greatest power in Asia, but in the world. Changan was the political, commercial, and cultural capital of a vast, firmly structured, hierarchical state, a cosmopolitan city where ambassadors, merchants, and missionaries from all over Asia met and mingled. The golden age of Chinese poetry coincides with the beginning of T'ang rule.

Though portraits and scenes of court life had their place, landscape more and more came first among the subjects of Chinese painting. New themes appear at the close of this period: flowers, birds, insects, etc.

Buddhism attained its peak in China in the seventh century. Buddhist art, in the sense of a specifically religious art, came to maturity. Beyond the borders of China, it had a notable influence on Japanese painting.

Not surprisingly, the spread of Buddhism produced Confucianist and Taoist reactions. The granting of lands and privileges to Buddhist temples and monasteries provoked widespread hostility. On the spiritual level, Confucianist thought assailed the Buddhist dogmas. Before long, the spread of the new religion as a temporal power, at least, was checked by a series of persecutions.

One sect of Buddhism in China, the Ch'an, was to attract a good many painters. Two major tendencies which, in the eyes of many specialists, characterize all Chinese painting—and can perhaps be discerned at earlier dates—become explicit under the T'ang. Though the line between them is not always perfectly clear, they can be singled out again and again over the course of the subsequent centuries.

One of these might be termed the *reconstitution of reality*. Color, in this connection, is relatively important, especially greens and blues. The artist seeks to fill his entire space. The brush is used with extreme precision, the construction is well balanced, colors are carefully laid down inside clearly defined outlines. Human figures are especially relevant: court scenes, portraits, etc. The execution is seldom rapid, more often carefully thought out, with detail work especially fine, even minutely elaborated. In landscapes, human figures are prominent—persons making a journey, very often—and so are the works of man: palaces and pavilions are set down with careful observance of the rules of aerial perspective. The element of poetry in such landscapes derives mainly from the well-nigh luminous transparency of the atmosphere. Animals, most often horses, are rendered with a realistic power which does not always rule

out a certain anthropomorphism on the part of the painter.

The other, contrasting tendency might be termed *synthetic transposition*. Color is secondary. The various tonalities obtainable with black ink may alone suffice to render the values. As in calligraphy, the brush stroke can by itself give the impression of dynamism. The ink wash, sometimes with color, is applied without any preliminary sketch, lavishly. Often different tones of the same color are superimposed to render gradations or contrasts. The execution is rapid, essentials are accentuated. Above all else, the artist is attempting to convey a poetic feeling rather than to reconstitute a scene descriptively. Landscape is the prevailing mode of such expression, with a certain emphasis on mist, rising smoke, horizons receding into an undefined distance. The subject is so placed as to give great importance to the blank, unpainted portions of the picture, to the neutral color and texture of the paper or silk. Portraits of this type or tendency, most often of imaginary figures, concentrate on the few essential traits which, to the painter, sum up the subject's basic character.

Among representatives of the first tendency we may cite Yen Li-pen, who was a painter at the court of Hsüan Tsung and an important official as well—what we would call a cabinet minister. He worked in the tradition of Ku K'ai-chih and made realist portraits of court figures. Chou Fang also painted court subjects, with a subtle sense of color harmony. Han Kan's vigorous paintings of horses from the imperial stables created a genre that artists of later periods have not let die out.

The work of Wu Tao-tzu, who painted Buddhist and Taoist themes, is not known to us directly, but he was famous for his frescoes and his landscapes. He seems to have been the originator of that rapid style of execution which we mentioned above as characteristic of the second, *synthetic* tendency in Chinese painting. Wu was a student of calligraphy and applied its principles to painting, in firm opposition to the linear approach. The following saying is ascribed to him: "The brush stroke should be free and spontaneous; when it looks carefully drawn, the painting ceases to be art, is mere craftsmanship."

Li Ssu-hsün, who was related to the emperor and was a general of the imperial guard, painted in color, with azurite blues and malachite greens predominating. He painted large landscapes in which human figures and architectural constructions stand out. His style stayed within the linear tradition, the poetic feeling in his works arising from the

transparent limpidity with which he was able to endow the atmosphere. His son Li Chao-tao succeeded him both as painter and as a high official at the court.

Wang Wei was a very great Chinese painter who lived in the time of the emperor Hsüan Tsung. He was an official, and as a doctor cared for the wounded rebels in the camp of An Lu-shan. When the emperor had successfully put down the uprising, Wang was stripped of his privileges. When the next emperor succeeded, he was restored to favor and made a provincial governor. His biographers depict Wang Wei as a man whose modest way of life (he had only one wife, for example) set him apart from the life of the imperial court. His wife was a Buddhist, and on her death he was converted to that faith.

Besides practicing calligraphy, painting, and art criticsm, Wang Wei was also one of the T'ang Dynasty's great poets. The literati painters who were to play so considerable a part in later centuries—mainly from the Yüan (Mongol) Dynasty on—always looked back to Wang Wei as their chief ancestor.

With Wang Wei, no doubt for the first time, the arts of painting and poetry come together. His poems are full of the love of nature, and to a rare degree possess the power of evoking images. Similarly, his paintings are infused with poetic images. Su Tung-p'o said of Wang Wei: "Reading his poems, I find myself looking at pictures; in front of his pictures, I find myself admiring poems." His principal technical innovation was to borrow the ink-wash technique from calligraphy, and especially in his snow scenes to incorporate untouched areas of the surface into the picture.

Between them, Li Ssu-hsün and Wang Wei best illustrate the two tendencies of Chinese painting in the T'ang period. It was around these two names that later critics, in the Ming Dynasty, formulated their rather arbitrary scheme of two "schools" of Chinese painting: a northern one founded on the memory of Li Ssu-hsün, and a southern one founded on that of Wang Wei.

THE FIVE DYNASTIES AND THE SUNG DYNASTY (907–1279)

The T'ang empire broke up at the close of the ninth century. Popular uprisings were set off by a number of factors: abuses in the system of landed property, including establishment of ever vaster private estates and crushing taxes and customs

duties. A peasant rebellion in 873 was put down with the help of Turkish tribes. The great feudal landlords built up private armies as the central power was increasingly undermined by corruption. In 907, the emperor was deposed.

In North China, one dynasty after another succeeded to the imperial throne, by their very names evoking past grandeur: the second or later Liang, the later T'ang, the later Chin, the later Han, the later Chou. During this period the capital shifted back and forth between Kaifeng and Loyang. Meanwhile, in South China, the country was divided up into great feudal states independent of the central power.

In 960, in North China, a general who had been in the service of the last of the Five Dynasties took power, founding the Sung Dynasty and beginning the long task of bringing China's vast territory back under a central authority—military, political, and financial. This task was completed by the end of the tenth century, and Kaifeng was made the capital of the reunified empire.

The Mongol incursions began early in the thirteenth century. First settling down in territories controlled by the Chin (a Tartar) Dynasty, by the close of the century the Mongols had spread into every part of China. Though the Sung Dynasty was a time of many troubles, the country also made great strides in certain respects. A number of important inventions date from this period, among others the navigational compass. The crafts expanded and production was, on the whole, marked by steadily improving quality—especially in ceramics, silk textiles, and metalwork.

Commerce bulked larger and larger in the nation's economic life. The three great southern ports—Canton, Hangchow, and Foochow—enjoyed an ever busier international traffic. And, infallible sign of prosperity, paper money made its appearance.

With the growth of business and the crafts, the cities became cultural centers and new social groupings made their presence felt. Among the merchant class, for example, an interest in the arts developed. With the invention and spread of printing, literature reached wider audiences and new genres were invented. Painting, between the tenth and the thirteenth centuries, was extraordinarily active and accomplished.

Unfortunately, the works of many painters from the period of the Five Dynasties have been lost almost in their entirety. What we know of them derives from written records, from copies, and from the influence they exerted on

later painters, especially in the Yüan and Ming periods.

At the court of the Southern T'ang (957–975), one of the independent kingdoms of South China, aesthetic questions took on considerable importance. An atmosphere of luxury and refinement, which prefigures that of the Sung court, was created. An independent academy of painting was established in this period at Nanking.

Landscape, in the tenth century, continues the tradition of the T'ang masters and tends to become the leading subject of painting. A number of masters follow in the footsteps of Li Ssu-hsün, producing large landscapes utilizing color and the linear method, and depicting travelers, sages communing with nature, or wild animals. Other artists confine themselves to the ink-wash method, working without a preliminary outline, modeling broad lighter areas according to the *p'o-mo* technique ascribed to Wang Wei. This consists in going back over details with progressively deeper intensities of ink so as to bring out color contrasts and differences of color or intensity. Still other artists, who also limited themselves to ink, utilized a nervous brush stroke borrowed from calligraphy to paint such subjects as twisted trees, oddly shaped rocks, and mountains emerging from a neutral background, enveloped in a romantic atmosphere. Lastly, there were artists whose large landscapes were done in light colors delicately applied without recourse to any preliminary sketch. In their works a foreground of trees and other verdure is sometimes in contrast with a broad expanse of river, dotted with small boats on occasion, and in the distance, pale bluish mountains veiled in mist, evoked with very light brush strokes. This last type of landscape, especially associated with the name of Tung Yüan in the tenth century, was to inspire artists of the Ming Dynasty such as Shen Chou.

Around this same period another new technique made its appearance in landscape painting. This was the method of ink wash with color highlights, a style of painting that was to develop under the Sung. On the whole, landscape in this period was more concerned with arousing the feelings of the viewer than it was under the T'ang, somewhat less concerned with impressing through bravura effects.

The political and other disturbances in this period encouraged artists to think of life in the bosom of nature as a refuge, a view also encouraged by Buddhist and Taoist teachings. Nature—stones, flowers, animals—came to seem more real than the world of men although under the Five Dynasties paintings of court life still found favor, especially in the kingdoms of South China. In such works realism is carried to new lengths, certain of them seeming to have been extremely literal reports on the life and habits of one or another court figure, executed at the emperor's request by artists such as Ku Hung-chun.

The Ch'an sect of Buddhism, already referred to, grew up in China in the ninth century and attracted many an artist, especially in times of trouble—for example, when a foreign dynasty such as the Yüan or the Ch'ing was assuming power, or when the atmosphere at court grew heavy with formality, or academicians were overbearing. The Ch'an sect assigned importance to painting, though contrary to what might be supposed, religious subjects as such were little favored. The Ch'an artist more often sought to set down in a few brush strokes a fleeting visual impression, a fleeting sentiment. The bulk of the work done under this inspiration consists of landscapes, in which details of plants, birds, insects, and rocks are captured with great economy of means. The charm of these pictures has not faded with the passing of time.

Toward the close of the tenth century, a new genre known as Flowers and Birds made its appearance, associated especially with a school of Chengtu, capital of one of the independent kingdoms of South China. Under the Northern Sung, Pien-ching (present-day Kaifeng) attracted artists and literati, both northerners in flight from the Chin Tartars and southerners as well.

The first Sung emperor, T'ai Tsu (960–976), reorganized a painting academy which was to take on great importance under the emperor Hui Tsung (reigned 1100–1125). Whereas earlier academies—under the T'ang Dynasty, for example—had grouped representatives of the fine arts with scholars and men of letters, Hui Tsung created separate academies of the fine arts, that of painting being known as the *Hua Yüan*. There was also an academy of music and one of calligraphy, the *Shuo Yüan*.

The emperor himself subsidized the academies and acted as patron. Members were selected on the basis of examinations and progressed step by step from probationer to graduate to academician to master (*tai-chao*), the highest rank. The most appreciated masters were rewarded with the decoration of the Golden Belt. Examination subjects were set by the emperor in the form of a terse poetic phrase.

Besides his passion for painting and calligraphy, Hui Tsung was also interested in archaeology, and collected rare flowers, unusual stones, and valuable ceramic pieces. He was a musician too. His private collection of paintings alone,

21

which was seized by the Chin Tartars in 1126, came to a total of 6396 works, signed by 231 names, extending in date from the period of the Three Kingdoms to his own day. Works of his own brush were included, for he was an excellent copyist of ancient masters, his own favorite subject being birds—quail especially.

After North China was wholly occupied by the Chin Tartars, the academy moved with the court to Hangchow in 1138. There, the emperor Kao Tsung did what he could to help it regain the splendor it had known under Hui Tsung.

Landscape painting gained steadily under the Sung, though portraits and genre scenes were still made, especially under the Southern Sung. These last took on new meaning in connection with the development of urban life and the appearance of a merchant class. At Kao Tsung's court of the Southern Sung, influence of the T'ang and Five Dynasties masters was kept very much alive, but before long a new, more emotive style appeared. Landscape, especially, tends more and more to reflect—along with the characteristic atmospheric conditions of South China—the artists' personal feelings. In the twelfth and thirteenth centuries some great artists give free rein to their poetic urges.

Ma Yüan, a painter of the Hangchow academy in the late twelfth and early thirteenth centuries, used the ink-wash method to create landscapes of extreme simplicity, in which a great deal of the picture is composed with the neutral, undefined tone of the silk to indicate stretches of water, fog, or distant horizons. Hsia Kuei, his contemporary, had much in common with Ma Yüan, but his foregrounds, especially, and his treatment of detail elsewhere, employ a dynamic, rapid, terse brush stroke adapted from the *ts'ao* or "grass" style of calligraphy then much in vogue. In his landscapes there is marked contrast between sharp details and dim or hazy distant backgrounds. Like Ma Yüan, he places man in the bosom of nature, and his pictures express deep peace and stillness. The frequently large-sized landscapes are invariably presented as viewed from a certain height above ground level. This style, called *Ma-Hsia* for its inventors, has frequently been imitated since.

Artists in the academy of the Southern Sung were also fond of painting birds, animals, and flowers in a style inspired by their immediate predecessors, when the academy was located at Kaifeng. At least a few artists, however, were not content with the academy's form of organization and the demands upon its members. There were a number of Ch'an monasteries in the Hangchow area which served as refuges

for painters like Mu Ch'i, who never was associated with the academy and his friend Liang K'ai, who left the academy although he had attained the rank of master and been awarded the Golden Belt. Such artists practiced a freer style of painting with greater scope for individuality. They were faithful to the monochrome ink method, but their work is characterized by extreme scantiness of detail and the importance assigned unpainted areas of the picture surface. Nothing but the strictest essentials enters into these works, in which fog-drenched landscapes predominate, the shapes of mountains, river banks, and villages barely suggested with a few adroit brush strokes. Among them are paintings of birds, insects, flowers, and even persons, similarly characterized by great economy of means. Every line that is set down simultaneously expresses the most essential features and the artist's feeling with respect to his subject.

YÜAN (MONGOL) DYNASTY (1279–1368)

Moving eastward from the Altai region at the close of the twelfth century, the Mongols had begun to penetrate North China early in the thirteenth. In 1211 they defeated the Chin Tartars and a few years later the Hsi Hsia (Tanguts), and then for a time turned their attention to eastern Europe. However, as masters of North China they kept pushing southward and in 1279 eliminated the last pockets of resistance to their rule over all China.

For the first time in history, barbarian hordes only a generation or two removed from tribal society, whose own economy was based on cattle raising and the spoils from wars of conquest, found themselves at the head of a vast, long-settled empire, the most advanced country in the world at the time, both technologically and culturally. Thousands and thousands of acres of cultivated land were turned back to pasture for the Mongols' sheep and horses. Also by the thousand, Chinese peasants and craftsmen were reduced to the status of slave laborers.

The Mongols did not, however, destroy or greatly interfere with the administrative system of the state they now ruled. Only the key posts were occupied by Mongol officials. The scale of the problems they had fallen heir to made it necessary for the conquerors to preserve the Chinese system of scholar-officials. A tacit alliance was formed between the Mongols and a part of the Chinese ruling class. The peasant masses of China, whose standard of living was low

at best, suffered greatly. Population dropped rapidly from something like one hundred million under the Sung Dynasty to something like sixty million.

Within the ranks of the feudally privileged, educated Chinese, internal conflicts appeared. Some were ready enough to collaborate with the occupying power, but others tended to make common cause with the people. Nor did things always run smoothly between the Chinese who accepted official posts under the Yüan Dynasty and their Mongol overlords. The latter were suspicious of Chinese motives and shook the administration by frequent transfers of officials. We find, for example, Chinese being named to posts in the Persian portions of the Mongol empire, and Persians named to posts in the Chinese government. This is the period when Chinese ceramics reflect Iranian influences and Persian miniatures reflect Chinese influences.

Despite the generally somber situation in China under the Mongol yoke, some progress was realized. The Mongols were not slow to pick up the arts of the trader, and were quick to realize the advantages to be gained by furthering commerce both at home and abroad. With the help of Chinese slave labor, they helped a number of industries to expand. Cities, and especially port cities, continued to grow, and the merchant class played an ever larger role in Chinese life.

One literary development was the appearance of works written in the vulgar tongue, hence accessible to the comparatively uneducated. A number of long novels exalted national feeling, perhaps the most famous being *Romance of the Three Kingdoms (San-kuo Chih)* and *All Men Are Brothers (Shui-hu Chuan)*. In this period the Chinese drama came into its own, in language and subject matter alike exerting wide appeal. The repertory of the Chinese classical opera thus began to be built up in these years.

Painting during the Yüan epoch is not simply a transitional stage between Sung and Ming painting, though this has often been alleged. The special conditions under which it developed gave it a markedly original character. A number of Yüan artists looked back to pre-Sung models for their inspiration, to the great painters of the Five Dynasties especially. The misty landscapes of the late Sung, with their extensive use of unpainted space, give way to a more clearcut, precise style, at once more compact and more energetic.

By and large, the relations between painting and both literature and calligraphy grow more close. From the Yüan Dynasty onward, calligraphic texts play an important part.

There were painters who worked at the Mongol court in official positions. They painted subjects likely to appeal to their masters—hunting scenes, for example. Occasionally they managed to make satirical allusion to the gulf separating the cultivated Chinese from the barbarian. Chao Meng-fu, a descendant of the Sung imperial family, was the greatest painter at the courts of Kublai Khan and Tamerlane. He specialized in painting horses, but was also a great landscapist and one of China's finest calligraphers. His painting has profound affinities with calligraphy. His most admired works are limpid, light-drenched landscapes.

The so-called literati school of painting, whose distant precursor was Wang Wei, gained ground in this period. Under this name are grouped artists for whom painting represented no source of gain, whether from rich collectors or officialdom; it was linked with the expression of their literary tastes. Very often their pictures incorporate a text specifying or elaborating their intentions.

The great literati painters of the Yüan period strike us as complex individuals. A number of them came from lowly social origins, or from the merchant class, and yet they identified with the ancient cultural ideals at their most lofty, refusing to compromise and exhibiting great personal and artistic integrity. They uniformly refused official posts in Mongol China, those not privately wealthy earning their living at modest jobs or becoming Buddhist monks and Taoist hermits. Disdain for the newly wealthy led them to associate with people of lowly or modest social condition. Much as, later, many Chinese painters were to be anti-Manchu, these were anti-Mongol.

Though there was some flower painting, the literati painters of this period were primarily landscapists, the monochrome ink method predominating. Concern for resemblance was secondary to the expression of literary feeling. Detesting professional painters for flattering, as they supposed, the taste of the wealthy merchants, they claimed to practice art solely as a pastime.

Few examples have come down to us, but there was another type of painting in this period as well, which developed in the cities. It depicted the daily life of ordinary people, going about their ordinary affairs, practicing their crafts, buying and selling. The work of professional or semi-professional artists, this kind of painting was kept from becoming well known or much appreciated in subsequent centuries by prejudices in favor of the literati ideals.

MING DYNASTY (1368–1644)

A widespread movement of popular uprising against the Mongols began in 1340. Financial mismanagement and a paper-money inflation caused great distress, to which terrible floods along the Yellow River in 1350 added increased hardships. Peking was recaptured from the Mongols in 1367 and, the following year, one of the rebel leaders, a Buddhist monk named Chu Yüan-chang, founded a new dynasty which took the name Ming and established its capital briefly at Nanking.

The first Ming emperor addressed himself to the task of restoring the country's disabled economy, and especially its agriculture. Liberation of an artisan class long subjected to conditions of slave labor by the Mongols gave a much-needed spurt to the manufacturing crafts. Nonetheless, by the time the dynasty reached its mid-term, corruption had once again set in. The emperor's eunuchs had become tax collectors, and their exactions touched off revolts in the towns where the most heavily taxed industries were located.

Both trade and the manufacturing crafts were very active under the Ming Dynasty. Besides the government-run industries, employing serfs, merchants set up workshops employing paid labor. The class of independent artisans increased in numbers. Foreign trade had an enormous expansion. The vigor of the merchant class, however, which had become a producing class in certain areas, was held in check by the central power. A number of products, including some ceramic products, came under the state monopoly system.

It was in 1514 that the first European ships appeared in South China ports. First the Portuguese, then the Spanish, the British, and the French traders became regular clients, and by the close of the century their missionaries established a foothold. The numbers of landless peasants increased in consequence of the dynasty's attempts to re-establish and strengthen feudal institutions. Mounting poverty and frequent famines gradually drove the peasant masses to rebellion, sometimes aided or even guided by members of the middle classes.

In 1644 rebellion reached Peking, now the capital, and the great feudal landowners appealed for help to the Manchu tribes, which until then had been confined, not without difficulty, to the northeastern frontier. This was the opportunity the Manchus had been waiting for. Once they had put down the popular rebellion, they deposed the Ming emperor —who committed suicide—and founded the Ch'ing (Manchu) Dynasty.

Intellectually, the Ming period was marked by conservatism and attempts to reinforce the Confucianist tradition. At the same time, however, a number of works gave expression to a new sense of need for the increase and spread of knowledge, brought about by developments in trade and industry. More than 5000 persons were involved over a five-year period in producing an encyclopedia which was published by order of the emperor Yung Lo. Covering every field, this great collaborative effort constitutes a veritable *summa* of Chinese knowledge in that period.

In literature, both the drama and the novel written in colloquial language continued the great vogue they had enjoyed since the preceding dynasty.

There were notable advances in architecture, attested in particular by the extensive constructions of the Ming emperors at Nanking (their capital until 1409) and at Peking.

Especially during the Hsüan Te reign, ceramics and works in cloisonné, objects in carved stone and ivory, and bronzes —as well as furniture, silks, carpets, etc.—all attained a very high quality. As taste for decorative and ornamental work developed, symbolism took on great importance. Paintings and ceramic works composed for special occasions— anniversaries, promotions, holidays—employ a variety of decorative schemes to convey the special circumstances of their composition. Both literati and merchants became passionate collectors in all these fields.

The Ming emperors tried to revive the aesthetic climate which had prevailed at the T'ang and Sung courts, and re-established the painting academy. A number of the emperors themselves practiced an art. Hung Wu, the first of them, was both a painter and a calligrapher, though this did not prevent him from putting to death a number of artists, especially painters, whose works displeased him—perhaps for their satirical intentions. It is still unclear why he allowed the aged master of the Yüan Dynasty, Wang Meng, to die in prison.

The emperor Hsüan Tsung (name of reign: Hsüan Te), 1426–1435, has left us some fine paintings of animals, birds, and flowers, done in a style reminiscent of the Southern Sung academy.

Around the restored Ming academy an official court painting grew up, with artists appointed to minor government posts. The emperors and their entourages set themes, often specifying that they were to be treated in a specific

T'ang or Sung style: scenes of court life, old legends, animals, flowers, and insects. The result was most often painstaking in detail and linear in method, with azurite blues and malachite greens delicately applied. An impression of limpid clarity is often given by these works, especially the landscapes.

The greatest official painter of the period was Ch'iu Ying (1510–1551). A man of humble origins, he first worked as a painter's apprentice. Neither a poet nor a calligrapher, he was solely a painter. His delicate, precisely observed, and meticulously executed works have been as much appreciated for their technical qualities as for their originality.

A number of professional painters lived and worked apart from the court, especially in the cities that lived by trade. They were highly skilled, often gifted, and we owe to them, besides ancestor portraits, purely decorative compositions and "occasional" paintings of birds and flowers, a number of copies of masters then in fashion, and even some of great painters of the past. Not only could they imitate the style of their models down to the last brush stroke, they could also copy their calligraphy and signatures. In other words, we are indebted to these artists for numbers of extremely convincing forgeries.

Nonetheless, for all the talent of the court painters and the professional artists, it is the amateur painters who best exemplify Ming painting. Never before, perhaps, had China possessed so many amateur painters, though comparatively few are represented by works that have survived to the present. Two schools may be singled out, the Che (name of the region covered by the provinces of Chekiang and Fukien, where these artists lived), and the Wu (from Wuhsien, the former name of Soochow).

The Che school produced landscapes and paintings of birds and flowers inspired by artists of the Southern Sung, especially by Hsia Kuei. In the seventeenth century, Lan Ying (1585–1660) is a good representative of this vivacious, often colorful and decorative style.

The greatest name in the Wu school is that of Shen Chou (1427–1509), a painter in the literati tradition, also a poet and writer, who led the comfortable but quiet life of a country gentleman. Shen Chou seems to be an extension of the literati tradition as developed under the Yüan Dynasty, but in his use of color he owes a good deal to masters of the late T'ang and the Five Dynasties periods.

Critics have always praised him for the variety of his subjects, which extend from birds and flowers to the portrait and the landscape, for his delicate sense of color, for his vigorous handling of the ink wash, and for the sensitivity of his brushwork in tiny details—*luan ma ts'un*, "Brush strokes like entangled hemp fibers." Also, without ever seeming labored, his drawing has great firmness.

CH'ING (MANCHU) DYNASTY (1644–1912)

The Manchus were originally fierce warrior tribes who broke through China's northeast frontier. For as long as their domination lasted, they kept a wall between themselves and the Chinese people. It was they who obliged the Chinese to wear pigtails, as a sign of subjection. They encountered lively resistance, especially in South China, and to the end of their reign never wholly overcame anti-Manchu sentiment.

Anti-Manchu movements, sparked by powerful secret societies, first appeared in the eighteenth century and grew more numerous with every generation. In the late nineteenth century, they became identified with resistance to the foreign powers. The latter had, indeed, made the mistake of supporting Manchu rule and helped it put down the Tai-p'ing, a powerful nationalist movement which between 1846 and 1864 controlled large areas of China.

Down to the end of the eighteenth century, Manchu power followed a relatively conciliatory policy aimed at restoring the Chinese economy at home and the greatness of the empire abroad. There were two great emperors, K'ang Hsi (1662–1722), and Kao Tsung (1736–1796), perhaps better known by the name of his reign as the "Ch'ien Lung emperor."

Various measures were taken to restore agricultural production and the health of small industry. In the eighteenth century, trade with Europe became very sizable, centering on the port of Canton. This was the more remarkable since the balance of exchange was generally unfavorable to the European countries, and in particular to Great Britain. The latter had little in the way of merchandise to interest the Chinese, though its own home market was avid for quantities of such Chinese products as tea, ceramics, silks, etc.

It was in an effort to improve the balance of exchange that England attempted to open up hitherto "closed" Chinese ports, employing force to do so. She engaged in opium smuggling—export of which was forbidden by the Chinese government—for much the same reason. With the Opium War in 1841, a new era began for China, one of increasing

interference in Chinese internal affairs, first by the European great powers, then by the United States and Japan as well. By military force or by the threat of it they all sought concessions for themselves and special spheres of influence, and in brief, gained increasing control over essential areas of the Chinese economy.

Despite its constantly declining power, the Manchu Dynasty managed to survive down to 1911, in large part thanks to the support of foreign nations.

During the second half of the seventeenth century and throughout the eighteenth, a very high level of technical competence was attained in the crafts and in small industry, notably in ceramics. The Ch'ing emperors, who were nothing if not fond of magnificence on an enormous scale, gave new stimulus to architecture. They had many old structures restored and underwrote the cost of splendid new ones, especially in North China. Peking and the region around it owe a great many palaces and residences to them—the city had burned down in 1644. The new constructions were in traditional styles and reflect a lively appreciation of color and ornamentation.

Despite the Manchu court's encouragement of painting and calligraphy, its official art is on the whole of rather poor quality. Numbers of Chinese and Manchu artists worked at the court, as well as some European missionaries. The latter, notably during the Ch'ien Lung reign, worked in a style peculiarly their own, half-Chinese, half-Western. They brought with them to China the principles of linear perspective and the technique of shading.

Ch'ien Lung commissioned European artists including two Jesuits, Castiglione and Attiret, to celebrate his victories in Central Asia. Though their art may have pleased the Manchu sovereigns, it ran sharply counter to traditional Chinese taste. The influence of such Western painters on Chinese painting was, in fact, all but nonexistent.

There were, however, a few great artists who stood out amid the prevailing mediocrity of official painting. Wang Hui (1632–1717), an excellent painter from South China, worked for a time at the court of K'ang Hsi. Very great sensitivity is in his work allied with impeccable technique.

In the seventeenth and eighteenth centuries there were professionals as well as many amateur painters, and even a few semi-professionals—literati who sold some part of their work without the repugnance felt in earlier epochs.

During the Ch'ien Lung reign in the eighteenth century an interesting group of painters grew up in the merchant city of Yangchow. Both highly original and highly nonconformist, they have been dubbed "The Eight Eccentric Masters of Yangchow." In this book we reproduce typical works by four of them: Hua Yen, known as Hsin-lo-shan-jen, Chin Nung, Li Shan, and Lo P'ing. They had in common a spirit of independence, contempt for convention, anti-Manchu convictions, and an ideal of painting simply and decoratively. We need not take too seriously their claims to derive from no school and to owe nothing whatever to the old masters.

Besides Wang Hui, mentioned above, who was a semi-professional literati, the most remarkable artist of the early Ch'ing were Yün Shou-p'ing (1633–1690) and the so-called "Four Monks." These last were all well-educated members of distinguished families who chose to live as Buddhist monks or Taoist recluses. These were Chu Ta, known as Pa-ta-shan-jen (1625–1705); Tao Chi, known as Shih T'ao (1630–1707); K'un Ts'an, known as Shih Ch'i (1610–1695); and Kung Hsien (active c. 1660–1700).

Throughout the nineteenth century and into the twentieth we find amateur and semi-professional painters working in a highly decorative style in which color plays a leading part. The most interesting of them employ what is called the "boneless" technique, using broad splashes of wash or color to render with spontaneity and freshness the poetic quality of flowers, fruit, vegetables, birds, insects, crustaceans, and fish. Chao Shih-ch'ien (1829–1884) followed the *wen jen hua* tradition and influenced Chi Pai-shih (1863–1957), who in the course of his long career produced an enormous number of elegantly decorative works, touching for their love of life and of mankind.

Wu Chün-ch'ing (1844–1927) was a great calligrapher in whose works we find that perfect alliance of painting with poetry and handwriting which was always the literati ideal.

Chinese Painting

PLATES

LANDSCAPES

1. In Front of the Waterfall

Unsigned. Attributed to Ma Lin (active c. 1246)
Ink on silk. 69¹/₄ × 41 inches

Ma Lin, son of Ma Yüan (c. 1190–1225), was merely following a family tradition when he became a member of the Sung Academy.

His style comes close to his father's. Like the latter, and like Hsia Kuei, he is fond of setting foreground detail against misty backgrounds, but Ma Lin stresses his foregrounds more vigorously and treats them more lyrically than Ma Yüan.

It will be noted that, in conformity with the spirit of the Ma-Hsia school, the unpainted parts of the silk serve to suggest depth and to create a steamy atmosphere around the waterfall.

The twisted old tree (a frequent theme in Chinese art) is shown clinging to the rock wall. It evokes tenacity, the scholar triumphant over obstacles.

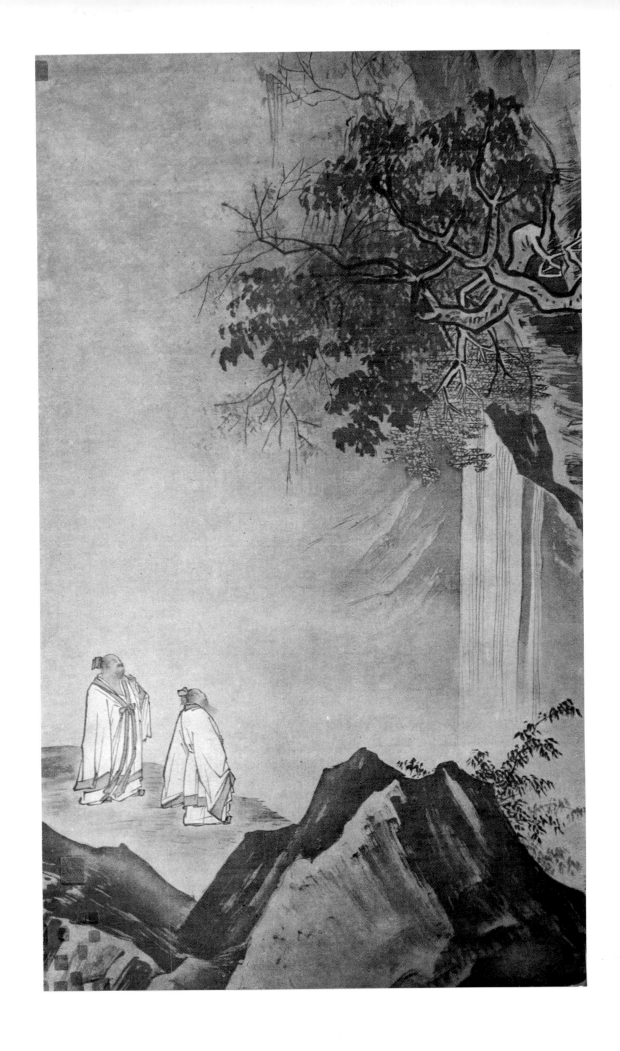

2. Mountains and Clouds

Unsigned. Attributed to Hsia Kuei (Southern Sung, c.1190–1225)
Album leaf, ink and color on silk. $9^7/_8 \times 10^5/_8$ inches

Hsia Kuei, the artist who probably created this work, is one of the great painters of the Southern Sung. He was a member of the Hangchow Academy, and with Ma Yüan helped to develop a style of painting subsequently known as Ma-Hsia, for the two artists.

Hsia Kuei, a greater master of the brush, was also endowed with a highly developed sense of the poetic. Like Ma Yüan, he was fond of landscapes in which the misty backgrounds melt into the silk on which they are painted.

It will be noted how important a part the unpainted portions of the picture play in it. The actual brushwork covers only the lower right corner and a diagonal strip near the center. Often, in Ma Yüan's pictures, only one of the lower corners is painted, hence his nickname "One-corner Ma."

The foreground is strongly emphasized. The symbolic pines and the jagged rocks contrast with the vaporous airiness of the middle ground and background. The figures—two scholars and their servant—define the scale of the landscape they are contemplating.

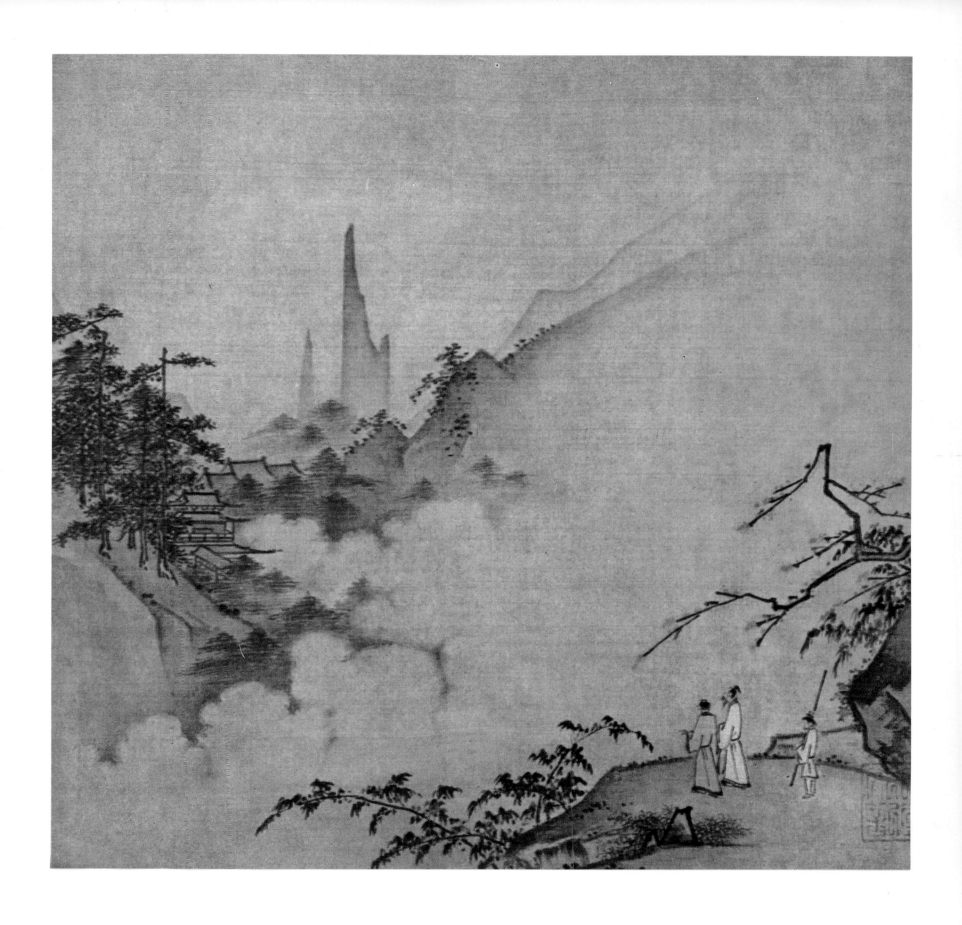

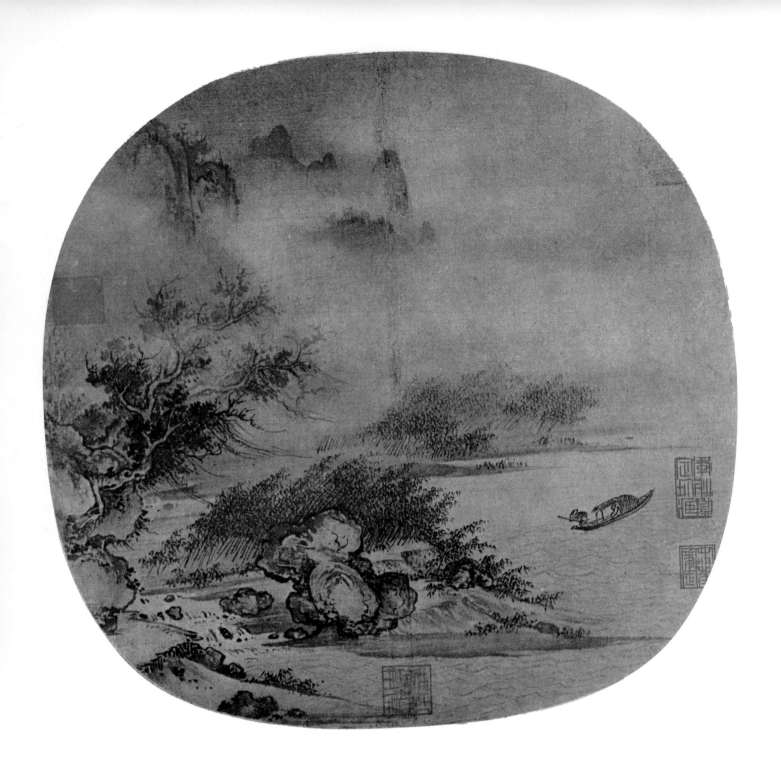

3. Landscape with Snow

Signed Li T'ang. Southern Sung (c. 1050–1130)
Screen painting, ink and color on silk. Diameter: 9 3/4 inches

This is a winter landscape. A fisherman is selling his catch on a cold foggy day with snow on the ground. Whereas Chinese literature, particularly poetry, is often sensitive to the wretched life of the poor (especially fishermen), painters as a rule see in them only "the presence that animates the water," as Kuo Hsi, the great eleventh-century theoretician of landscape painting put it.

At the left is a small signature: Li T'ang.

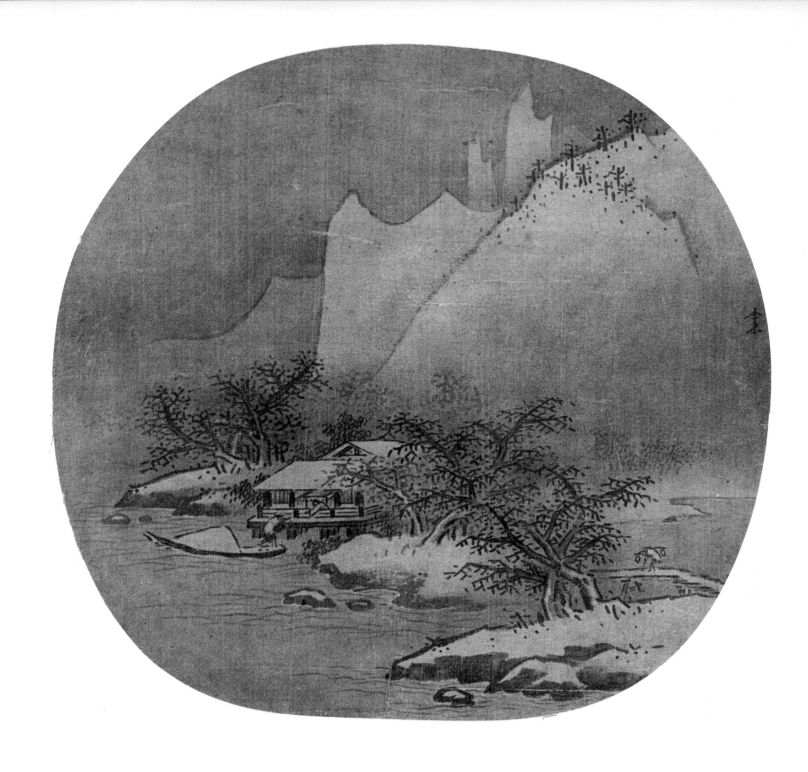

4. The Storm Breaks

Unsigned. Southern Sung (c. twelfth century)
Screen painting, ink on silk. Diameter: 10 1/4 inches

This little landscape in the style of the Southern Sung Academy shows a storm which has just dispelled the mist. The wind is stirring up the surface of the lake, shaking the trees and the grasses, whipping at the boatman.

5. Landscape

Wu Chen (1280–1354)
Ink. 33^1/$_8$ × 11^5/$_8$ inches

Wu Chen—one of his nicknames was "The Old Man of the Fruit Blossoms"—is one of the four great masters under the Yüan Dynasty. He lived as a recluse, devoting himself to poetry, calligraphy, and painting. He also studied divination and was a practicing Taoist.

Like his contemporary Ni Tsan and like a number of seventeenth-century painters, such as Pa-ta-shan-jen and Tao Chi, Wu Chen shunned the company of high dignitaries and the wealthy, and associated only with common people.

Much room on his pictures is taken up with poems written in the so-called grass style of calligraphy, which is particularly hard to decipher.

For him, as for other of the literati artists, painting was a kind of game—*mo-hsi* ("ink play").

Critics praise the pure quality of his ink, the subtle effects he achieved by varying the color tone with ink, his luminosity, and the vigor of his very personal style. A recluse, his goal was rendering nature and expressing the calm and peace he experienced contemplating it.

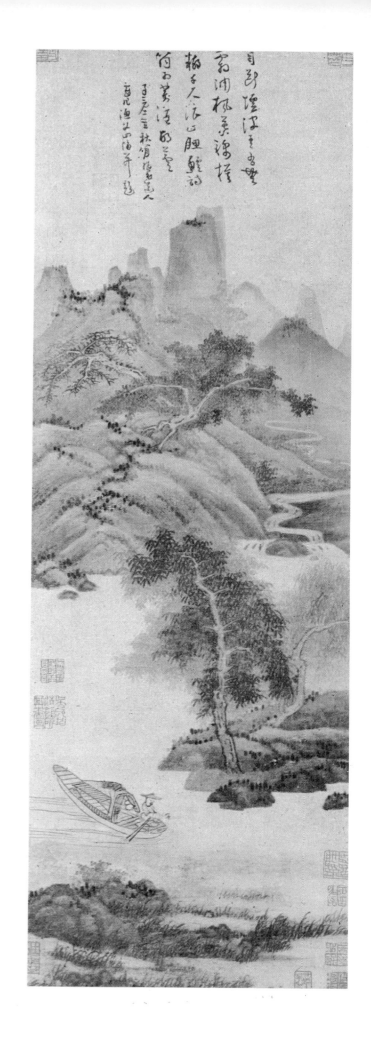

6. Scattered Firs, a Peaceful Valley, Hidden Bamboos

Ts'ao Chih-po (1272–1355)
Ink on paper. 29 ¹/₈ × 11 inches

This literati artist who lived under the Yüan Dynasty was for a time an official at the Mongol court (he taught at the academy in the reign of Kublai Khan), but left it to devote himself to painting, the study of Taoist texts, and meditation. His biographers depict him as an old man who recited poems under his breath and played with his long beard while he painted.

Critics have praised the clarity of his landscapes, their gentle luminosity and peaceful mood, the exquisite quality of his ink, and the subtlety and precision of his brush strokes.

The work shown here contains three inscriptions which have been damaged over the centuries. Some of the characters have been scratched out, as forming part of an emperor's personal name under the Ming and the Ch'ing dynasties. Use of such characters was prohibited for the rest of the dynasty's reign; they were removed from earlier inscriptions.

The first inscription (upper left) tells us that the work was executed by Ts'ao Chih-po in his eightieth year, in the second decade of the spring of the year Hsin-Mao in the reign of Che Cheng (March 1351). The second inscription (top center) seems to be in the painter's own hand; some characters are illegible. The third inscription is of later date, by an owner of the work (probably a friend of the artist's). It seems to have been composed shortly after the artist's death:

> The Old Genie of the Upper Course of the Torrent, in his eightieth year, covered his paper with many rivers and countless mountains.
>
> The West Wind was blowing clouds eastward. A silvery foam was following the icy rocks along the sky-blue precipices. To his old eyes, it was a marvel beyond compare...
>
> I hang this picture in front of the window: the sky is reflected in it. I roll it up and then unroll it again. Only three years ago! Alas, alas! We shall not see again the likes of such a man, such a picture! We shall not see again the likes of such a man, such a picture!
>
> Twentieth day of the seventh month of the autumn, in the year I-Wei of the reign of Che Cheng [August 28, 1355].
>
> Written by P'an, in the Studio of the Green *Wu* Tree.

The *wu t'ang* tree—*sterculia plantafolia*—was one of the Chinese trees most appreciated by poets and painters, and most evocative of images because of its slender trunk and its lovely green tones.

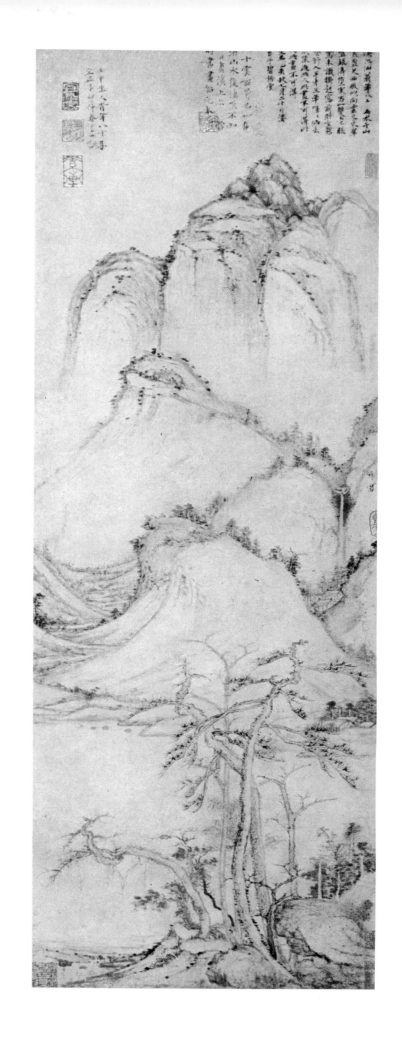

7. Summer Retreat in the Mountains

Wang Meng (1308–1385)
Ink on paper. 46³/₄ × 14³/₈ inches

Wang Meng, one of the four great painters of the Yüan Dynasty, came from a family of high officials. He was a nephew of the famous painter and calligrapher Chao Meng-fu who worked at the court of Kublai Khan. He held a high post in the magistracy, and seems to have been the victim of a plot. He died in prison by order of Hung Wu, the first emperor of the Ming Dynasty.

His landscapes, always done in this elongated format, produce an impression of balance, compactness, and grandeur. Rocks and mountains are harmoniously distributed, with little of the picture surface left vacant.

The rich vegetation and the massive rocks express nature's power. Critics praise his *tsun*, his art of bringing out details with brush strokes: the vegetation on a mountain, the crevices or cracks in rocks. According to some of these critics, they evoke the texture of fur—an analogy in line with the old conception of geomancy.

The inscription by the artist (upper right) says: "Summer retreat in the mountains. In the second month of the Che-Cheng year [February–March 1368]. The Man of the Yellow Crane Hill, Wang Shu-ming [one of the artist's surnames] made this picture for the Chao-shih T'ung Huan, in the Magnificent Tree Studio owned by Mr. Tao."

The inscription at the left was composed by the Ch'ien Lung emperor (1736–1796) who liked to decorate pictures with verses. He was a mediocre poet, but an excellent calligrapher.

The meaning of the first part is hard to grasp, for one important character has been scratched out.

The second part, still in the emperor's hand, may be translated as follows: "In my residence at Luan Yan [province of Chu-li], I also possess a 'Magnificent Tree Studio,' which bears the same name as that where Shan-ch'iao [The Wood Chopper of the Mountains, another of Wang Meng's names] made this picture.

"In the year Wu-Yin of the Ch'ien Lung era [1738], written by the emperor."

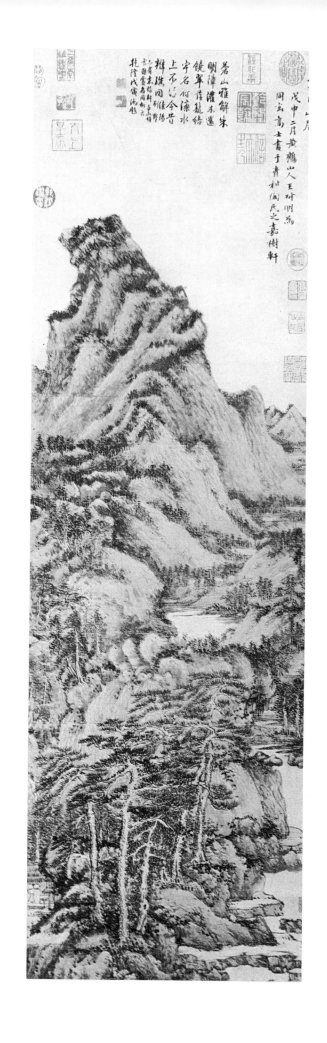

8. The Sage's Hut in Autumn

Ni Tsan (1301–1374)
Scroll, ink on paper. 53 1/8 × 13 3/8 inches

Ni Tsan, one of the four great masters of the Yüan Dynasty, is looked upon as the most accomplished representative of *wen jen hua*, the literati school of painting which goes back to Wang Wei, but which became organized in its principles and technique—or rather in its rejection of technique—under the Yüan Dynasty.

Ni Tsan did not come of a family of scholars, but of a wealthy merchant family from near Wuhsien (the former name of Soochow). He received a literary education, and the earlier part of his life was spent in luxurious surroundings, collecting precious objects, practicing painting and calligraphy, and composing poems.

At the age of fifty-five he gave away much of his fortune to relatives and friends, and left home, accompanied by his wife.

For nearly twenty years he lived very simply on a houseboat, wandering up and down the rivers, canals, and lakes of Kiangsu. He kept aloof from officials and court circles (this was the Mongol Dynasty) though they would have welcomed him for his talent. He very much preferred the company of the poor and unknown.

After his wife died he went back to his birthplace and spent his last years there.

He has always been highly esteemed by art lovers. Even in his lifetime he was imitated, and attempts were made to copy him.

Under the Ming Dynasty, the dream of every collector was to possess a painting by Ni Tsan. Many counterfeits circulated, though all critics recognize that his brush stroke is inimitable.

In their calssification of painters, the Ming critics placed him in their highest and rarest—"exceptional" —category.

Ni Tsan, "Child of Clouds and Forest," never aspired to be anything but an amateur: painting was to him *mo-hsi* ("ink play"). He scorned technical procedures and had only contempt for those who judged a picture by its "likeness." One of his sayings has become famous. When someone criticized him for not achieving a likeness, he said proudly: "It is not given to everyone to achieve the absence of likeness."

Ni Tsan was not the first Chinese painter to oppose those who held that resemblance is the supreme quality in painting. Before him, Ching Hao (tenth century) had written: "Likeness renders the formal aspect of objects, but neglects the spirit." And Su Tung-p'o said: "Criticisms concerning likeness disclose a puerile comprehension of painting."

One might quote here a passage from one of Van Gogh's letters to his brother: "Tell Sernet thas I would give up if my figures were good. Tell him I don't want them to be academically correct... that my greatest wish is to produce such anomalies, such alterations in reality, that the result—oh, yes!—would be lies, but lies truer than literal reality."

Ni Tsan seeks to communicate his own feelings as economically as possible. He rejects "effects," leaving them to "professionals." His primary aim is to be subtle, sensitive, almost discreet. He takes everything out of the picture that might take on excessive importance plastically, that might obstruct the expression of the feeling—often that of solitude—which he is trying to convey.

According to his contemporaries, he "used ink as sparingly as if it were gold." They praise his "dry" brush and the extreme delicacy of his wash drawing, carefully related to the tonality of the paper—which itself plays a very important part.

Human figures never appear in Ni Tsan's paintings, and yet his purpose is to express humanity in the presence of nature. To give more power to the poetic images which the painting seeks to convey, he merely suggests that men have passed this way by showing relics of their passing through: an abandoned hut (a favorite theme of his), the hint of a bridge, a board across a stream.

The following poem by the artist accompanies the work shown here:

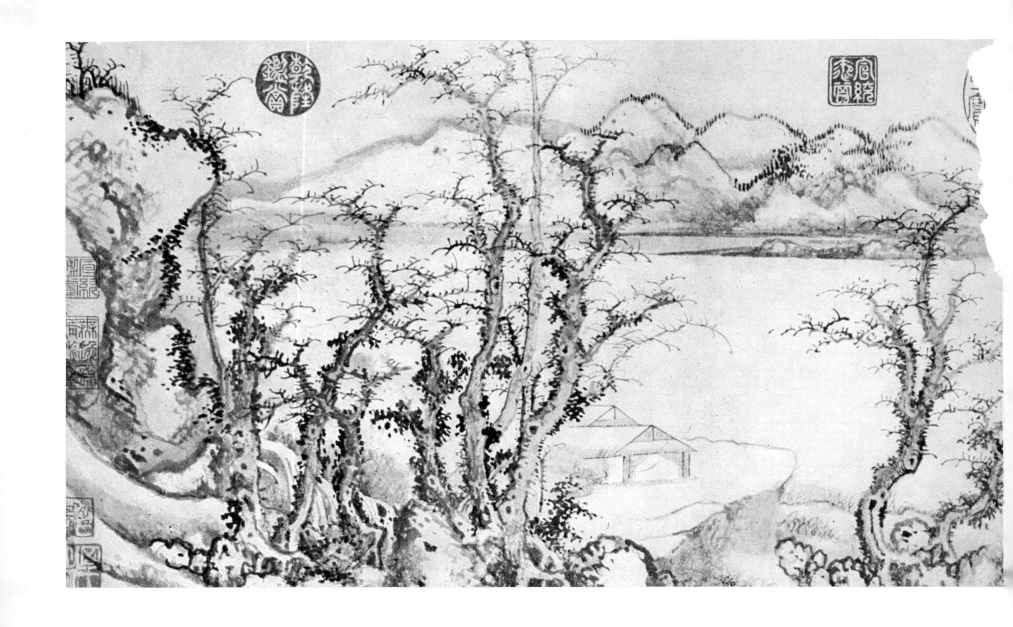

9. The River under Snow

Yao T'ing-mei (active c. 1360)
Ink on paper. $9^5/_8 \times 32$ inches

Yao T'ing-mei was a literati painter of the Yüan Dynasty. A delicate artist, he painted beautiful landscapes skillfully contrasting different tonalities of wash drawing. Similar play of contrast marks his use of line now dry and firm, now soft and velvety.

This painting has a commentary by the Ch'ien Lung emperor with several of his seals:

> It is cold... the fish have stopped biting... on the snow-covered river fishermen are putting in their nets...
> At one side, an old man won't let go of his pole. They call him an old fool.
> "I'm just passing the time," he says, "it's not worth spending pot-and-pan money."

Early spring of the Kuei-Wei year [mid-February 1763]. In the emperor's hand.

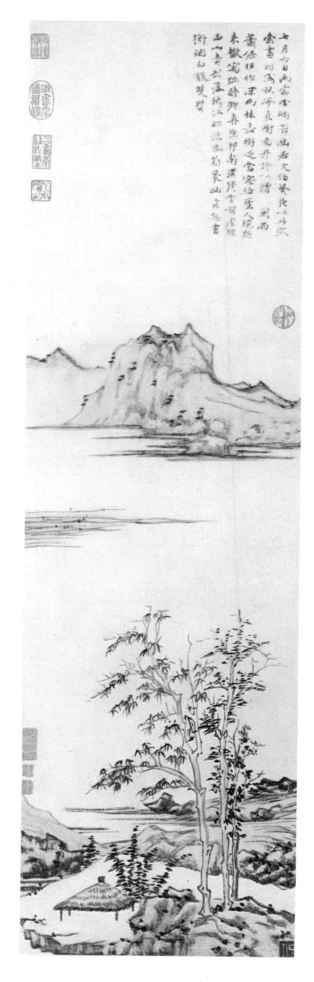

On the sixth day of the seventh month... a rainy night... the mountain tops in mist...

In the Old Man's retreat, Wen Hsien-liang gave me this sheet of paper and asked for a picture. So, I made this Pavilion and Chia Trees in Autumn, with a poem, and I hope he likes it.

Wind, rain, melancholy solitude. It is cold tonight. Two magnificent trees are just outside my window.

The dwelling of those who built this pavilion—the tracks leading here have disappeared—is situated in a region conducive to drinking... truly, a dream land.

Beyond the islets to the South, thick clouds are piling up in the emptiness of the window frames, the bluish shadow of the mountains to the West falls across the autumnal stream.

Near the ripples in which I dip my brush to write my innermost thoughts, a pair of white cranes suddenly rises, cutting through the mists.

—Tsan

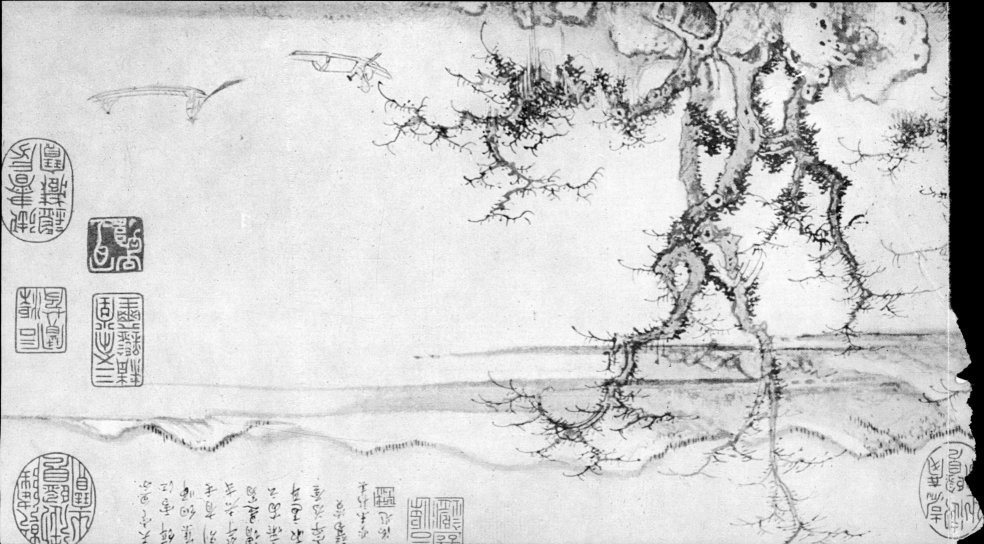

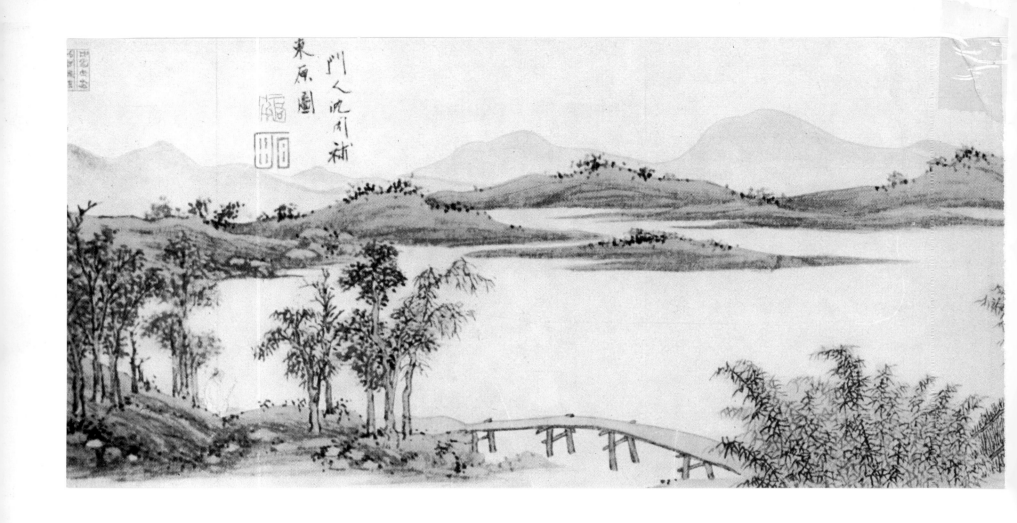

10. Landscape in the Style of Tung Yüan

Shen Chou (1427–1509)
Ink and color on paper. 11¹/₂ × 47 inches

Shen Chou, a great master of the Ming Dynasty, was born at Soochow. He is regarded as the founder of the so-called *Wu* school. Born into a family of high officials, he was carefully educated from an early age. In addition to a broad literary education, he was given thorough training in calligraphy and painting. His grandfather and his uncle both possessed very fine collections. His biographers tell us that he was strongly urged to enter the administration but declined on the pretext that according to the *I Ching* (*The Book of Changes*, the most important text on divination) such a career was not indicated for him.

He lived all his life as a country gentleman, keeping aloof from court circles and surrounding himself with friends chosen for their cultivation rather than for their birth or wealth.

His biographers adduce many examples of his Confucian humanism: his filial piety toward his mother, who was widowed when he was still very young, his kindness and generosity toward the poor. He was hospitable to common people and gave them his paintings. It is said that he even went so far as to sign works falsely attributed to him, so that their owners could raise money on them when they needed to sell them. At the same time he would never for a moment have considered selling his own paintings.

At first he tried to paint in the style of the great Yüan masters, particularly Wang Meng, Wu Chen, Ni

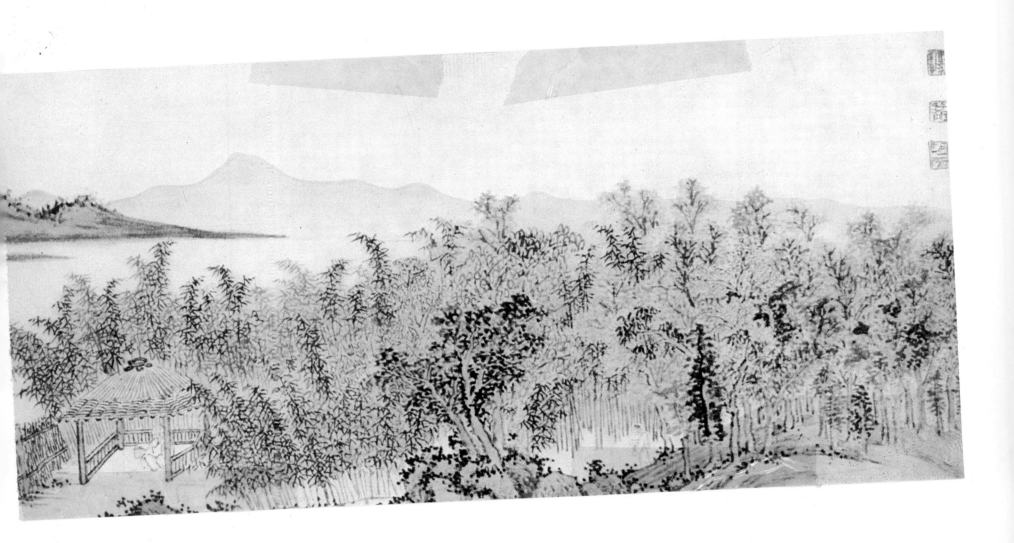

Tsan, Chao Meng-fu, as well as that of some Five Dynasties and early Sung painters—Tung Yüan, Chen Ju-yen, and Chao Ta-nien (twelfth century).

Later he evolved a more and more personal style. He aimed at the closest possible union of painting with calligraphy and poetry.

The vast landscape of South China shown here is a personal interpretation of a work by Tung Yüan (tenth century).

The viewer will admire the perfect brushwork, the way the masses of greenery, water, and mountains balance each other, and the bluish mountains in the background.

It should be noted that this landscape was meant to be seen while being unrolled slowly from right to left. We are being invited to go for a stroll, and pass successively through the dense foliage of the foreground, past a hut where a sage is sitting, and over a footbridge at the end of the lake.

The short inscription (upper left) reads: "Inspired by Tung Yüan, his disciple Shen Chou."

There are two seals of the artist: Shen Chou and Shih-t'ien.

11. Reading in the Autumn

Shen Chou (1427–1509)
Album leaf, ink with color on paper. 11 × 15 inches

In this study, which seems to date from 1470, Shen Chou portrayed himself seated, holding a book, in an autumnal landscape.

The little poem composed and written by the artist reads:

> The big trees exposed to the west wind are losing their leaves.
> To be comfortable I have unfastened the collar of my robe; sitting here, I'm letting the time go by.
> Doing nothing, I've turned my back on encroaching autumn... I've not finished my book.
> My spirit has gone wandering in the sky... Who can fathom it?
>
> —Shen Chou

There is the artist's seal: Shen Chou.

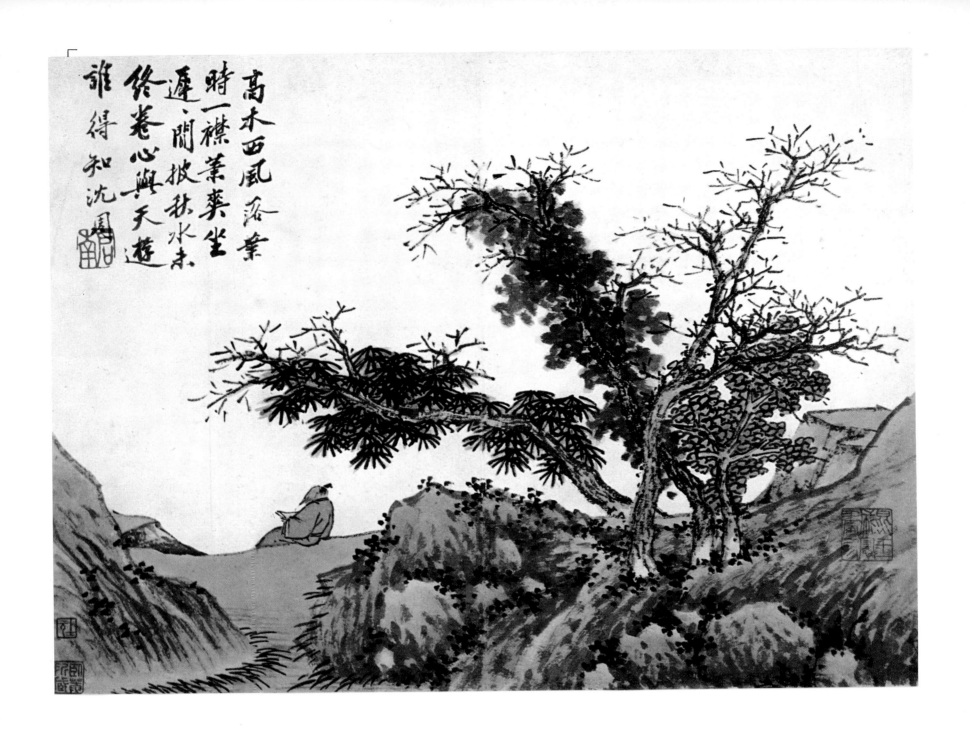

高木西風落葉
時一襟葉葉坐
遲遲間披秋水末
終卷心與天遊
誰得知沈周

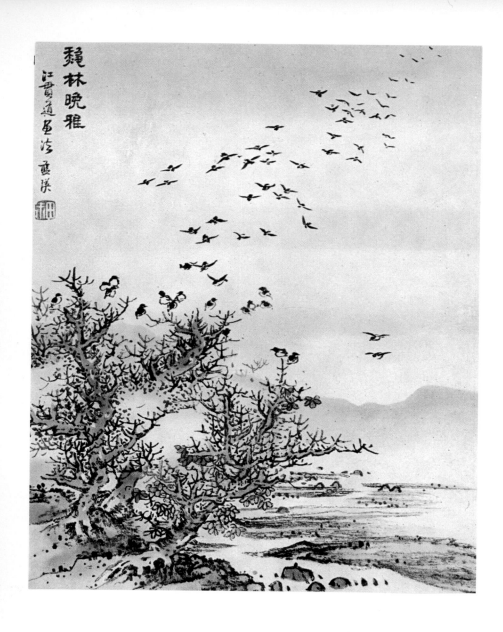

12. Autumn Trees and Crows at Evening

Lan Ying (1585–1660)
Album leaf, ink with color on paper. 12¹/₄ × 9⁷/₈ inches

Lan Ying, a semi-professional painter in Hangchow, was one of the last representatives of the *Che* school.

His works are inspired by Sung and Yüan masters, but he developed a simple and expressive style of his own.

We shall repeatedly encounter the classical theme of *Autumn Trees and Crows at Evening*, a title written in characters (upper right) followed by a few more which read: "In the manner of Chiang Che-t'ao, Lan Ying."

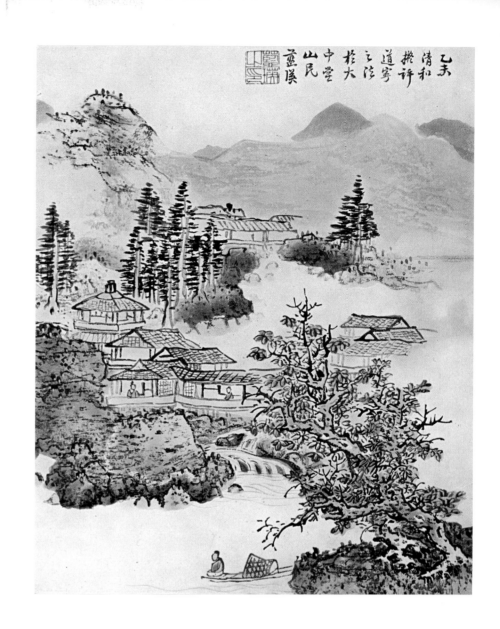

13. Village by a Stream

Lan Ying (1585–1660)
Album leaf, colors on paper. 12¹/₄ × 7⁷/₈ inches

Here the artist was inspired by Hsü Tao-ning, Sung painter (first half of eleventh century), as mentioned in the inscription:

> In the fourth month of the I-Wei year [May 1655], in the style of Hsü Tao-ning.
> At Ta Chung-t'ang, the Shan-min [Man of the Mountain], Lan Ying.

14. Mountain after Rain

K'un Ts'an, called Shih Ch'i (1610–1695)
Ink on paper. 40¹/₂ × 23¹/₂ inches

K'un Ts'an is one of the four painter-monks of the seventeenth century. Born into a prominent family of scholars in Honan province, he took orders and became prior of a Ch'an monastery near Nanking. His biographers portray him as reserved and contemplative. He relaxed form his meditations by practicing calligraphy and painting.

Shih Ch'i was primarily inspired by the Yüan masters, and in his balanced and well-constructed compositions sought to render the power and complexity of nature, which, in line with Buddhism, he looked upon as an expression of universal life. In the landscape shown here he attempts to reproduce the atmosphere of the Chekiang mountains in the autumn rains. The accompanying poem is in the artist's own hand.

> Washed by the rain, the foothills are clear and clean as a stream on an icy night.
> Showing their calm purity through the mist, the peaks rise up before me in throngs.
> The stones glisten with their fresh bluish color... the heights are lost in steam.
> Alone, by the green bank, a fisherman is standing.
> Indistinct rustles... the song of unseen birds... momentary crackles... gurgling springs...
> Subtlety and coarseness do not stand out, a single tint conceals these mountain ranges.
> I should like to stay here a long time, leaning against green, green pines... looking upon the clouds... falling asleep.
>
> In the fall of the Kuei-Mao year, eighth month [September 1663], Palace of Yu-t'ien-lung; residence of Yao-hsi-tien: K'un Ts'an Tao-jen.
>
> There is also the artist's seal.

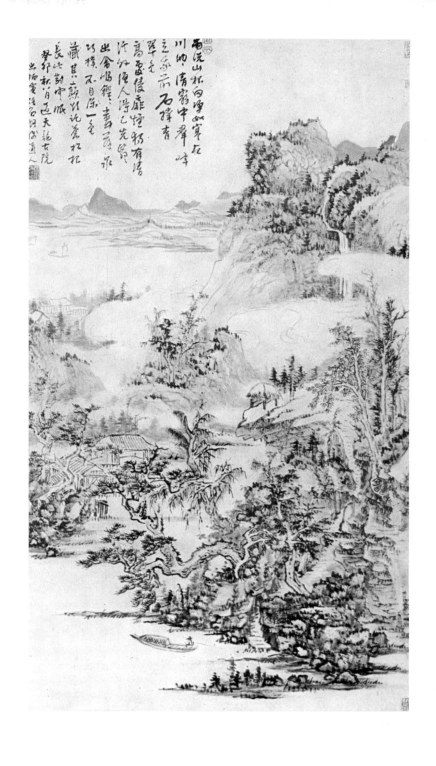

15. Flight of Birds on an Autumn Evening. Two Friends Drinking Tea in a Pavilion

Wang Hui (1632–1717)
Colors on paper. 46¹/₂ × 29¹/₈ inches

Wang Hui was one of the greatest Ch'ing Dynasty painters. He was born in the south, into a family of painters. In his early youth he studied the old masters, particularly Ni Tsan and Wu Chen. But he never confined himself to a uniform style: he was also inspired by the Sung and T'ang landscapists.

A very prolific painter, master of a flawless technique, he was very successful, and worked at the K'ang Hsi court. He was abundantly copied and imitated in his lifetime. He succeeded in perfectly harmonizing the possibilities offered by the two types of brush—the hard and the flexible.

The inscription in his hand is a poetic phrase by T'ang Yin, the great Yüan master:

> The little pavilion at the edge of the stream is even more beautiful toward nightfall when the crows gather on the trees whose branches brush against the curved edges of the roof.
> When shall I be able again to receive the hospitality of the Divan of the Western Bay, and enjoy the sweets and the delicate tea under the lanterns?
> I am adding this poem by the Laureate of the Provincial Examinations, T'ang Yin.

> In the Jen-Chan year, eve of the full moon of the second month [February 20, 1712]. Keng-yen Hsüeh-jen [one of the artist's names].
> —Wang Hui

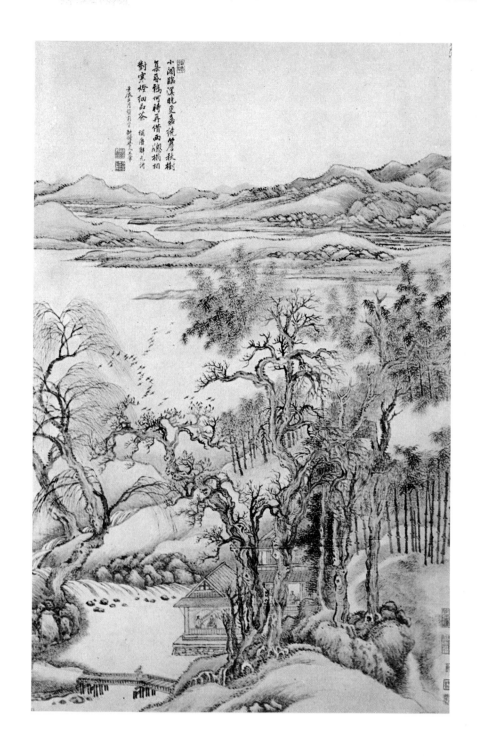

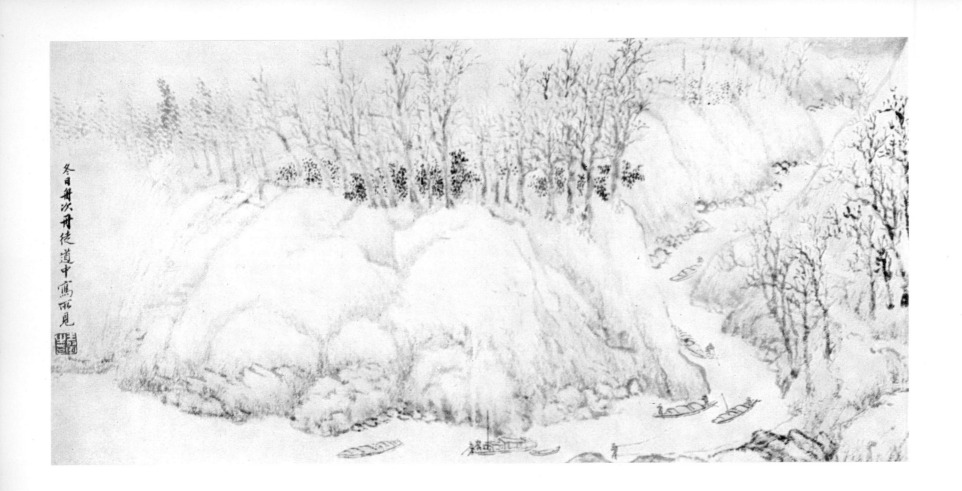

16 and 17. Winter Landscapes in Kiangsu:
 Snow-Covered Village by the Water
 Boats on the River

Wang Hui (1632–1717)
Two studies, black ink on paper. 13 × 18¹/₈ inches

These fine studies illustrate Wang Hui's ability to render the delicate poetry of a winter scene in Kiangsu through the interplay of ink tones with the color of the paper.
 Two short texts accompany these studies:

 The village by the water. It is dusk, and snowing.

 On a winter day the boats follow one another on their way downstream. I am noting things I see during my journey to Tan T'u.

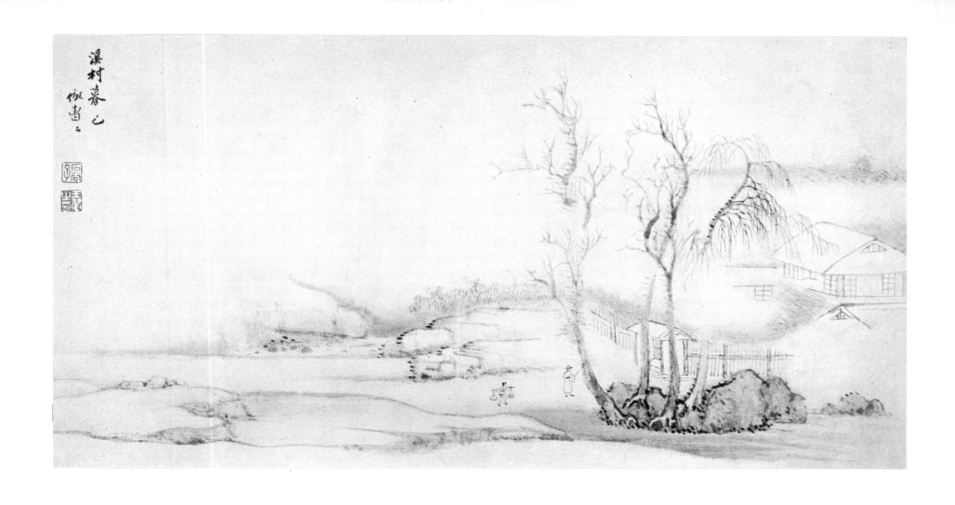

18. Toward the Pond

Tao Chi, called Shih T'ao (1630–1707)
Ink on paper. 51³/₄ × 17³/₈ inches

Tao Chi, whose real name was Chu Jo-chi, was born in Kwangsi province. Like his kinsman and friend Chu Ta (called Pa-ta-shan-jen) he belonged to a prominent family allied to the Ming imperial family, and, again like him, joined a Buddhist order in 1644, the year the Manchus seized power. It was then that he took Tao Chi as his name in religion; Shih T'ao is his name in art.

Later he was to leave the monastic order and turn to Taoism.

He is one of the greatest Ch'ing Dynasty painters. A perfect representative of the literati painters, he was poet, calligrapher, philosopher, specialist in the floral art (he wrote a treatise on this subject), and critic. He also composed a work on the art of painting.

When not traveling—he visited all of North China—he liked to stay at Yangchow (now Kiantu). In 1673 he settled there for good and helped found the school associated with that city. Judging by his contemporaries' remarks, he held himself very much aloof, scorning the company of the rich and accepting only people of modest means as his friends. He took the surname of "Venerable Blind Man," for, he said, "My eyes differ from those of most people: I go blind in the presence of money."

In his view, painting is an integral part of an artistic whole that includes poetry and calligraphy.

In his poems he was influenced by the great T'ang poets, particularly by Li Bo, as well as by certain Sung poets, such as Su Tung-p'o (1034–1101).

As a painter, he refused to follow any of the masters of the past: "I paint in my own style," he said.

Painting for him involved two kinds of freedom—a free mind and a free brush. His view of the world combined Buddhist and Taoist conceptions of nature, and led him to strive for a flexible and easy rhythm closely attuned to the rhythm of universal life.

Whatever his ideas may have been, his works are those of a realist who suceeded in admirably rendering the exuberance of South China's warm damp scenery and the feelings it arouses.

His calligraphy is that of a very great master, now ardent and seemingly spontaneous, now powerfully controlled.

His poems are often difficult to understand, with multiple images suggesting different interpretations according to the reader's culture and tastes. The text included in this picture evokes the artist walking down to the lake on a peaceful evening, enjoying the view:

> Four sleeves... lotus-leaf gown.[1] Wearing a short robe, stick in hand, my sandals shuffle toward the edge of the water.
> On the lake, a boat is coming back to the sky-blue cliffs.
> Twilight is falling upon the people who live at the foot of the mountain...
> One lovely goose is flying over from the south. Care and trouble seem far away.
> The evenly spaced ringing of a bell comes to me... its echo lingers.
> At moments like this I forget my own names, even my first name.
> Here there are yellow flowers.[2] I am getting drunk with the fragrance of the evening.
>
> The Ch'ing-hsiang[3] Ta-ti Lao-jan-chi, under the Kuang Ling tree.

There are two of the artist's seals: Ch'ing-hsiang and Lao-jan

[1] Habit of the recluse. [2] Dandelion. [3] Tao Chi's ancestors were Ch'ing princes; *ta-ti*, the Great Purification, whence the name of Tao Chi.

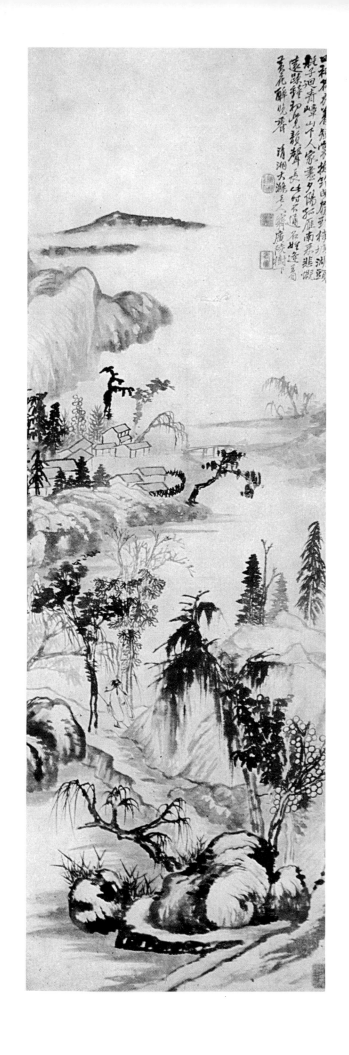

19. Hamlet Between Cliffs

Tao Chi, called Shih T'ao (1630–1707)
Album leaf, ink on paper. $9^1/_2 \times 17^3/_8$ inches

This vigorous study shows us a new aspect of the talent of Tao Chi.

The brief inscription in his hand is a two-line poem. In each line the same character is repeated three times (the first meaning "stone," the second "peak"):

> Stones break open the stone in stones,
> Peaks link up with peaks that dominate peaks.

> Shih T'ao Chi Shan-sung, the Monk of the Mountains.

There is also one of the artist's seals.

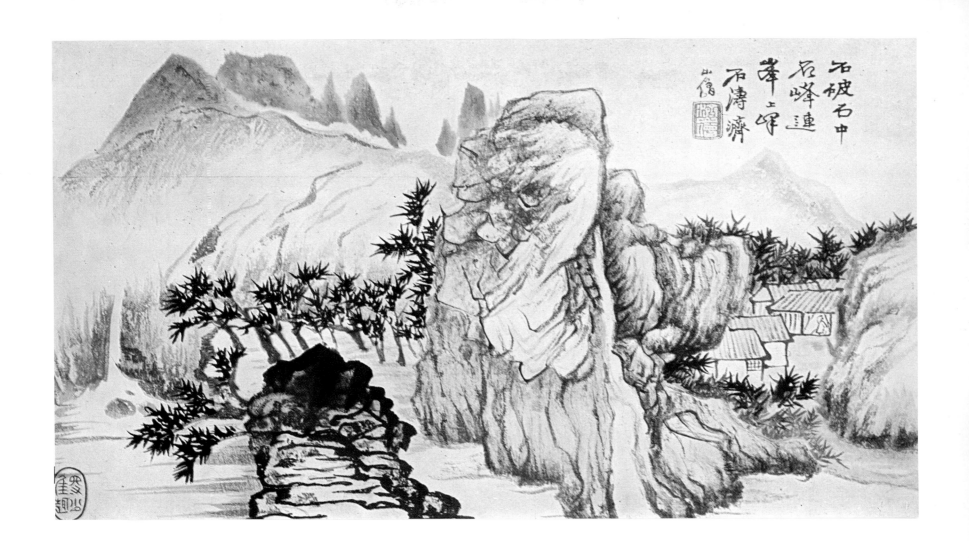

20. Autumn Trees, Crows at Evening

Ch'i Pai-shih (1863–1957)
Ink on paper. 40^1/$_8$ × 13^3/$_8$ inches

Ch'i Pai-shih is the most outstanding of recent Chinese painters.

Deep love for nature is expressed in his paintings of plants, flowers, fruits, birds, insects, crustaceans, fish, and vegetables. His so-called boneless style (he dispenses with outlines) derives from eighteenth-century masters, primarily Pa-ta-shan-jen. He was directly influenced by Chao Shih-ch'ien (1829–1884).

In the work shown here he treats the traditional theme of "Autumn Trees, Crows at Evening" which was treated by Lan Ying (plate 12) and Wang Hui (plate 15).

The picture bears two inscriptions in the painter's hand, followed by his seal.

The first records the date of the work:

> Made in my fifty-second year [probably 1914, according to the Chinese reckoning].

> By the Old Man of the Water Lentils [one of the artist's brush names].

The second inscription, made forty-four years later, says:

> In my ninety-sixth year [by our own reckoning, his ninety-fourth year, when he died], I am looking at this picture again.

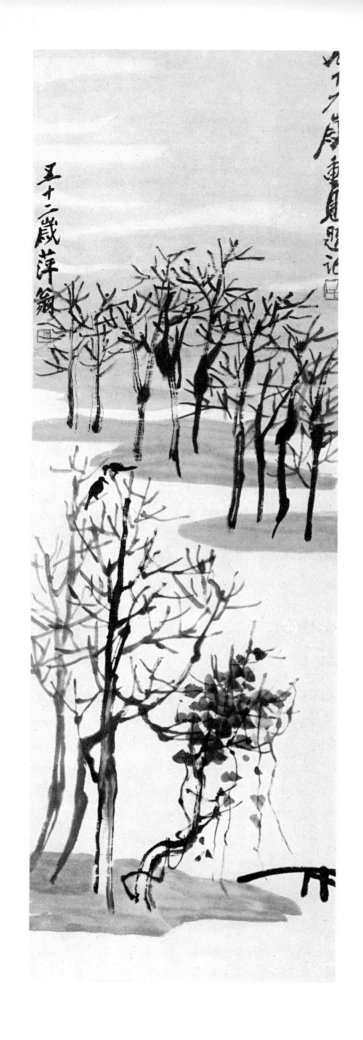

FIGURES AND PORTRAITS

21. Listening to the Ch'in

Attributed to the emperor Hui Tsung (1082–1135)
Colors on silk. 57⁷/₈ × 20¹/₈ inches

We have mentioned elsewhere the interesting figure of the emperor Hui Tsung, a passionate collector and a lover of painting, calligraphy, music, indeed, of all forms of art. He attached greater importance to running the Academy of Painting he founded than to defeating the nomad hordes which eventually sacked his palace at Pien-ching (Kaifeng) and took him prisoner. He was no doubt the most talented of the Chinese emperors who painted. He favored birds as subjects, though a very few genre scenes and figure paintings are attributed to him.

The work shown here bears his strange signature (lower left), to which no definite meaning has been given, and his seal. However, this may be an old copy. Caution is indicated in determining the authorship of very old paintings, which have often been meticulously reproduced. The emperor himself was an excellent copyist.

Hui Tsung here portrayed himself playing the ch'in (a zither-like instrument), an admirably subtle instrument. Tunes performed on it are always grave and melancholy.

Under the symbolic pine tree, near a few bamboos which evoke the literati, the emperor is seen playing for two high officials who are listening with absorption.

The viewer will notice, in the foreground, one of those strange rocks with jagged forms which Chinese poets find so stirring. This may be a piece of meteorite.

By its style and its careful, even laborious, treatment, this work is related to the linear tradition.

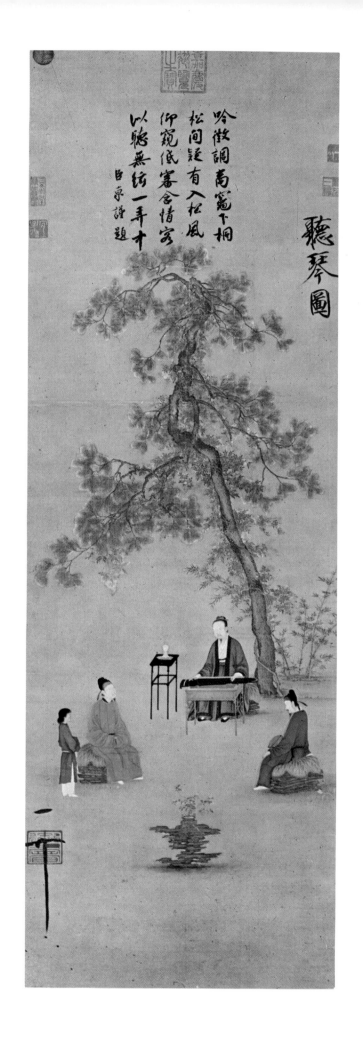

22. Illustration for the Poem "The Purple Cliffs" by Su Shih

Ma Ho-chih (1130–1170)
Detail of a handscroll, ink on paper. 10 1/4 × 12 3/8 inches

Ma Ho-chih, a great Sung painter, was never a member of the Academy. A high official (he was Vice-President of Public Works), he was a friend of the emperor, who called upon his talent to illustrate his poetic works. He is said to have executed about three hundred paintings, each illustrating a poem by the emperor.

The work shown here is a fragment of a long scroll illustrating a very famous poem by Su Shih, better known as Sua Tung-p'o (1034–1101), great statesman under the Northern Sung, who was himself a painter and calligrapher, as well as a poet, critic, and philosopher.

The Purple Cliffs represented here are situated near Hangchow, to which Su Shih was exiled for a time. The poem alludes to a passage in the *Romance of the Three Kingdoms*, which recounts a decisive battle fought in 208 in the vicinity of Wuchang, between two of the Three Kingdoms then struggling among each other for hegemony.

We are translating lengthy extracts from the poem to show how the poet succeeded in rendering the atmosphere of a boat trip on a summer night with a group of friends who recite poems and sing songs full of literary and historical allegories.

In the fall of the Jan-Hsiu year, on the day following the full moon of the seventh month [August 11, 1082], I, Su Shih, and some friends, took a boat ride.

We rowed to the foot of the Purple Cliffs. The wind had risen, so gently that it caused no ripples. Raising my cup I asked my guests to drink. Then we murmured a poem, "The Glistening Moon," and we sang "In My Modest Retreat."

A bit later the moon came out over the eastern hills and began its hesitant course between Sagittarius and Capricorn.

A white dew seemed to be covering the river, the water sparkled and merged with the sky.

Utterly happy, we drank our wine and sang, beating time on the side of the boat:

> Cinnamon-tree oar! Orchid scull!
> Beat at the reflection of the moon!
> Lift us up to the bright track—
> Vast, unlimited, the domain of our thoughts!
> They go toward a Beauty, a region of the firmament!

One of the guests could play the bamboo flute,

He took up the song and the notes poured out: Plaints, anger, tears, reproaches, the tune unrolled like a silken skein, till the water dragons trembled in their lairs, and the widow alone in her boat began to weep.

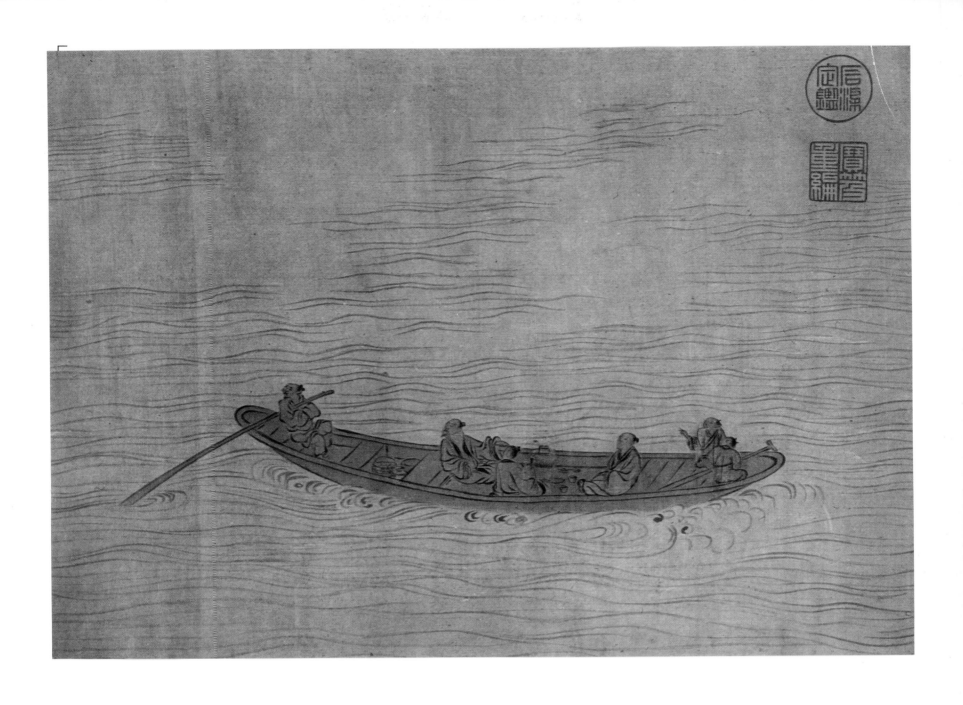

23. A Goddess Carried Away on a Phoenix

Artist unknown. Sung Dynasty (eleventh–twelfth century)
Screen painting, colors on silk. Diameter: $9\,^7/_8$ inches

This illustrates a mythological scene of Taoist inspiration: a goddess is being carried off on a phoenix, on a night when the moon is full.

This fine painting, which bears seals indicating how many important collectors have owned it, is remarkable for the refinement of its execution and the poetic way the subject has been treated.

The work recalls a famous sequence attributed to Chang Seng-yu (first half of the sixth century), depicting the planets. In it, Venus was portrayed as a beautiful goddess borne through the air by a phoenix.

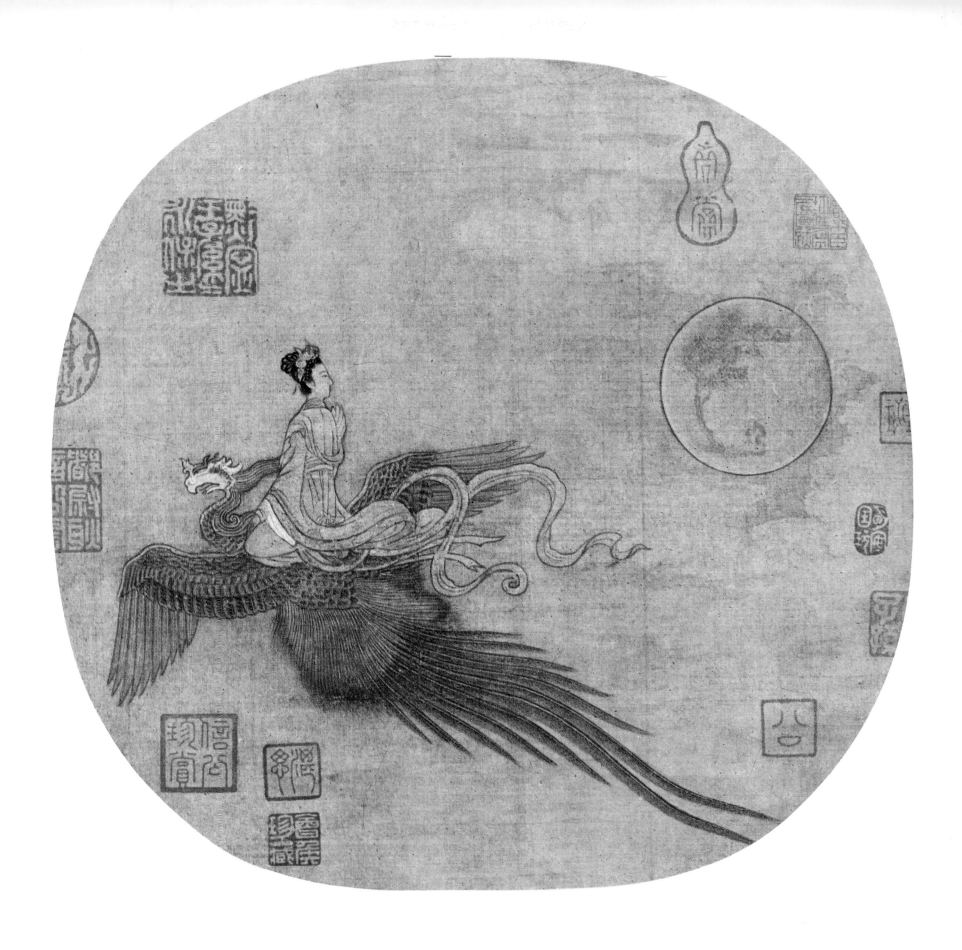

24. The Poet T'ao Yüan-ming (365–427)

Wang Chung-yu (fourteenth century)
Study, ink on paper. 12⁷/₈ inches square

Most of the works of Wang Chung-yu, a fourteenth-century literati painter, were inspired by the poems of T'ao Yüan-ming, the great writer who lived in the fourth and fifth centuries. The same artist illustrated, for example, the famous "Where the Peach Blossoms Come From," which has figured in Chinese anthologies for fifteen centuries.

This poem, whose subject was treated, among others, by Wang Wei, relates the story of a fisherman who finds his way to a kind of Eden, a projection of the dreams of a Golden Age which haunted the Chinese literati, particularly in times of trouble. A very similar legend is found in the West: it is the subject of the "Paradise of Queen Sybil" by Antoine de la Sale (early fifteenth century).

In the work shown here the painter portrays the poet as he imagines him on the basis of his writings and the most important events of his life.

He gives us the image of a dignified, calm, somewhat haughty man, qualities he displayed in the incident that put an end to his official career. T'ao Yüan-ming then held the post of sub-prefect. An inspecting governor was about to visit him and he was told that he must prostrate himself before him, as was customary. Whether because he judged this formality humiliating, or, more likely, because of contempt for the man, the poet declared that he would not "crook the hinges of his knees" for a mere five measures of rice a day, and resigned on the spot.

On this occasion he composed a poem which became as famous as the one on the peach blossoms— "Home Again"—in which he justifies what he did.

After describing the idyllic pleasures lying in store for him on his return to the country, the poet concludes: "Honors and riches are not what I desire."

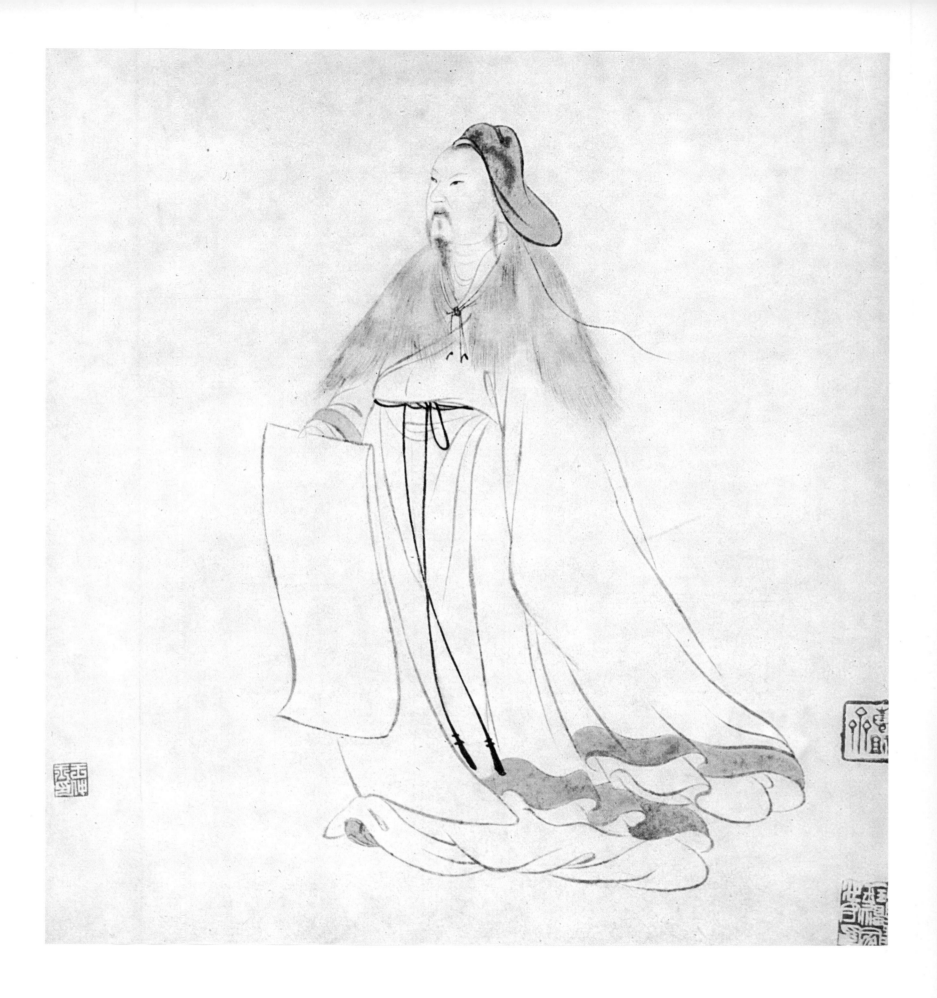

25. Portrait of the Artist at the Age of Eighty

Shen Chou (1427–1509)
Ink and colors on silk. 28 × 20⁷/₈ inches

This fine self-portrait is both simple and moving. There is no doubt—the text of the inscriptions confirms it—that it was in view of his approaching death that the artist recorded his own features in an austere, almost hieratic style, related to that of ancestor portraits.

Like the artists who specialized in such portraits, Shen Chou seems to have observed the rules of physiognomics—the art of reading facial features in relation to moral character.

The two fine inscriptions are in the artist's own hand and were composed by him.

The first (left) was made at the same time as the portrait; the other, a year later.

The first inscription is hard to read: an important character was scratched out, because at one time it formed part of an emperor's name. It is, however, possible to reconstruct the approximate meaning:

> It will be opined that the eyes are too little... or it will be said that the forehead is too narrow. I cannot even know my "Self"... how could I know its imperfections?
>
> Is appearance worth the trouble of calculation? The only thing I fear is that not enough truth comes through.
>
> In this eightieth year which I do not deserve, I am close to death.
>
> First Cheng-Te year [1506], written by Shih-t'ien Lao-jen in person [the Old Man of the Stone Field—one of the artist's other names].

The second inscription, still in his hand, was written a very short time before his death:

> A likeness or not? True or not? From the bottom to the top of the shadow, the outside of my body. Death, life, a dream. The sky... the earth... motes of dust rushing past.
>
> Looking back it occurs to me, since the spring [when this portrait was made] more than a year has passed.
>
> Written again by Shih-t'ien.

This portrait seems to have served as model for a sixteenth-century painting now in Taiwan, copied by Ch'u-'ki and accompanied by a poem whose content is similar to that of the first inscription, recopied by Wen Chia in 1622.

70

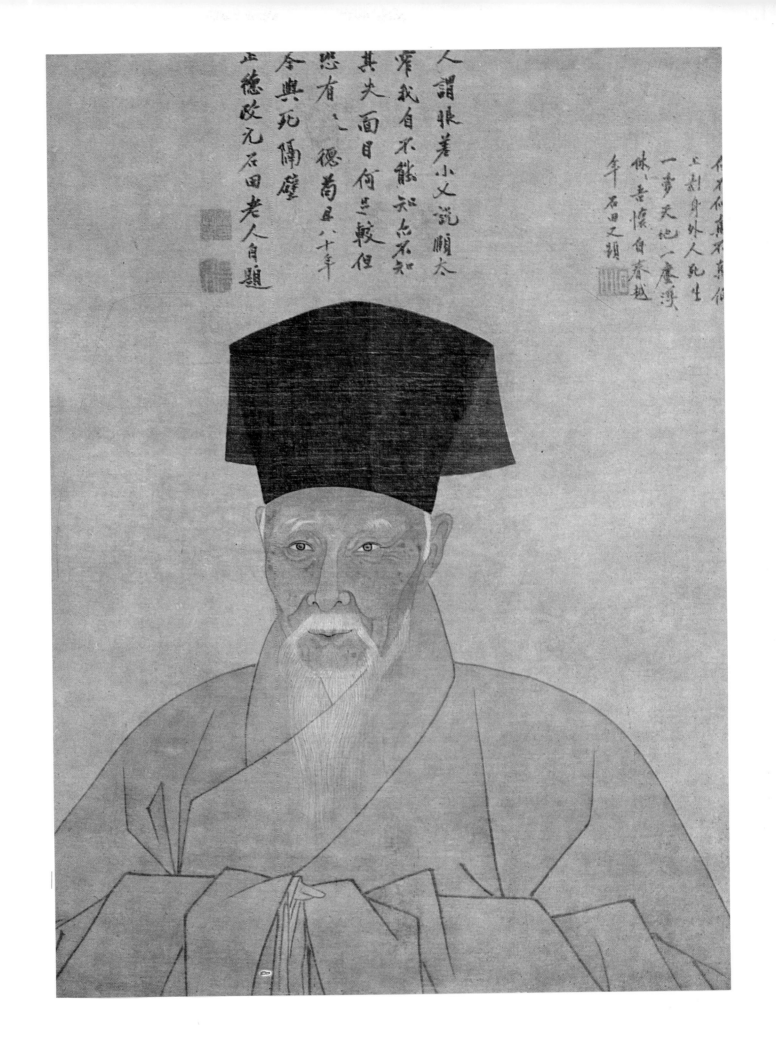

人謂眼著小又說眼太
窄我自不能知此不知
其矢面目何些較但
愁有之　德蒍臣八十年
今與死隔壁
正德改元石田老人自題

何不何兼不東備
上刻身外人死生
一夢天地一塵漫
休休吾憬自春越
午石田之頎

26. Thinking of My Parents

T'ang Yin (1470–1523)
Ink on paper. 11 1/8 × 42 1/4 inches

As a result of unusual circumstances, T'ang Yin was both a literati painter and a professional painter. He was born into a family of rich merchants in Soochow at a time when rapid increase in population, the growth of trade and industry, and the creation of a great many new administrative posts had partly broken down old barriers that had kept the merchant class from entering government service.

T'ang Yin, brought up by private tutors, was given the finest literary education. At fifteen he obtained highest marks in examinations at the local level. A few years later he obtained the highest marks at the provincial examination.

He was beginning to be noticed. He displayed great talent as a calligrapher and painter; the literati artists of Soochow, particularly Chou Ch'en, took interest in him and gave him advice.

He presented himself at the Imperial Examinations in Peking, which were held every third year. He was accompanied by a friend, also the son of a rich merchant, and similarly a candidate.

The behavior of the two young men from Soochow seems to have shocked the literati of the capital. T'ang Yin and his friend, while waiting for the eximinations, set out to have a good time. They had plenty of money to spend, and among other things took young actors riding on their fine horses. In short, they acquired a very bad reputation.

T'ang Yin's friend succeeded in bribing an official to get advance knowledge of the examination subjects. Did T'ang Yin profit from this? He always denied that he had.

When the results of the examination were posted, T'ang Yin was at the top of the list, a circumstance that drew the attention of the high imperial dignitaries.

An acquaintance of the two friends, no doubt an unsuccessful candidate, went to the authorities charging that there had been cheating. T'ang Yin denied having had anything to do with his friend's dishonesty, but he was nonetheless stripped of all the honors he had won. He was offered a minor post, but declined and went back to Soochow, brokenhearted. His old friends and family greeted him with contempt, and even his wife left him. In a letter to a friend who had remained faithful, he describes how he

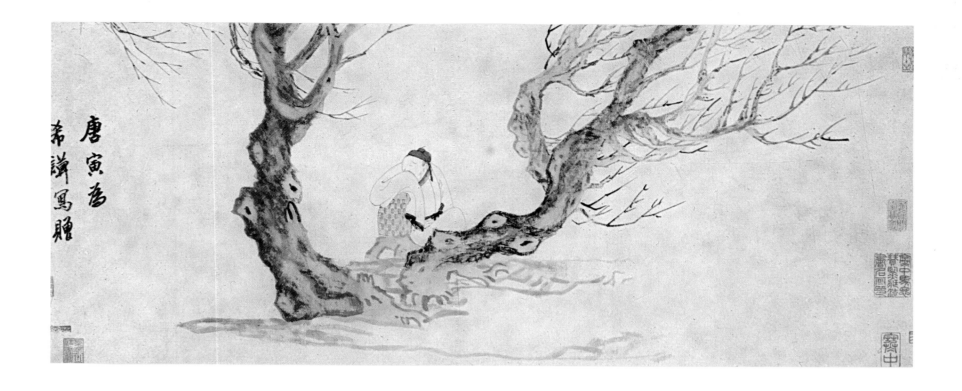

felt: "A precious stone reduced to ashes. A jewel that has been destroyed, now I am the vilest thing, the object of universal contempt. Those who know me, and even those who don't, point their fingers and spit. My mother's love for me—three words were enough to blacken it."

He recovered eventually. His talent as a painter enabled him to earn a living. He found comfort in alcohol and in the arms of Soochow's pretty courtesans.

He set out deliberately to shock the literati who had turned on him. He painted, for money, the kind of pictures that people buy: portraits of famous courtesans and dancers then in vogue. He did not shrink from painting erotic works, and he employed "ghosts" whose works he signed and sold as his own. He cynically set out to make money and led a riotous life.

However, his talent did not suffer. His works have a special quality all his own, and occasionally he painted as a literati, not for money. He executed admirable washes in a sober, simple style, characterized by a nervous brush. Even his commercial works, usually in color, are sometimes of high quality, very decorative, and executed with great care. His handwriting is that of a great calligrapher.

Toward the end of his life T'ang Yin changed his ways, withdrew from the world and, like many other painters, adopted Ch'an Buddhism.

He exerted considerable influence. Critics recognized him as a great master. Later the painters designated as the Eight Eccentrics of Yangchow took him for their model, not only in art, but also in the anti-conformism and whimsicality of his way of life.

The first painting of his reproduced here shows the lyrical, personal aspect of his art.

The figure depicted is the literati artist whose hopes have been shattered, shaking with sobs, close to a leafless tree. The autumn wind is blowing; he is recalling his disappointed parents, and reliving his youth.

The incisive, nervous, delicate drawing is that of a great literati painter and calligrapher.

The inscription in the artist's hand tells us that the work was a gift to a friend.

27. Four Beauties

T'ang Yin (1470–1523)
Colors on silk. 34$\frac{1}{2}$ × 67$\frac{1}{2}$ inches

This other painting by T'ang Yin shows another side of the artist: the delicate colorist, painter of pretty women. The technique is no less perfect though the style is very different; the tasteful colors have been applied most carefully to produce an elegant balance.

A poem in the artist's hand and of his own composition accompanies the picture. Though the subject is scarcely a solemn one, T'ang Yin introduces historical and literary allusions that give it a serious, not to say moralistic, ring:

> In their Taoist garb, lotus blossoms on their heads, they used to wait on princes at glittering banquets.
>
> Flowers cannot tell when people are no more... year after year they go right on holding their own beauty contests.
>
> The last king of Shu,[1] when he gave a feast, had the palace dancing girls put on Taoist garb with lotus blossoms in their hair, and ordered pretty girls to be present.
>
> The songs of Shu speak of nothing else, but the king did not care... and a time finally came when the cups overflowed.
>
> Looking back, remembering, one shakes one's head and suddenly is overcome with endless regrets.
>
> —T'ang Yin

[1] In the Three Kingdoms epoch (third century A. D.) the kings of Shu in western China (present-day Szechwan) were actually the legitimate successors to the Han Dynasty, but court intrigues and debauchery—here in question —led to Shu being annexed by the kingdom of Wei.

The ruler of Wei was himself shortly to be deposed by the family of his major-domos, who held the real power and went on to found the Chin Dynasty. This last, when it had annexed the third kingdom, completed the unification of China, but was in turn destroyed by barbarian invasions in the early fourth century.

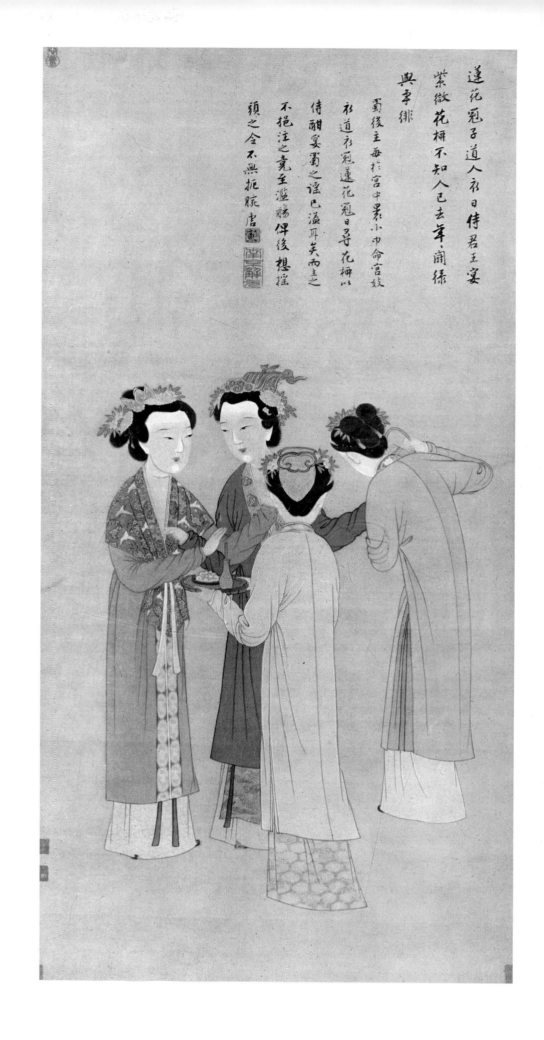

蓮花冠子道人祇日侍君王宴

紫微花褪不知人已去年開綵

與季緋

蜀後主每於宮中暴小巾命宮妓

衣道衣冠蓮花冠日尋花栘以

侍醺宴蜀之謡巳溢耳矣而之

不挹注之竟至滛賜伴後想摇

頭之全不無抚賑唐寅畫

28. Sage's Retreat

Ch'iu Ying (1510–1551)
Fragment of a hanging scroll, colors on silk. $8^5/_8 \times 10^5/_8$ *inches*

Ch'iu Ying was beyond question the best professional painter of the Ming Dynasty. Born into a family of craftsmen, neither a scholar nor a calligrapher, he worked as a painter's apprentice before being called to the court.

He was extraordinarily successful in his day. He satisfied the backward-looking tastes of the imperial entourage with balanced mastery. In his genre scenes he was inspired by the masters of the Sung Academy. In this respect his painting may be related to that attributed to the emperor Hui Tsung.

Ch'iu Ying followed in the footsteps of the masters of the so-called Northern School, themselves successors to Yen Li-pen (seventh century). His linear, so-called *kung-pi*, style is smooth and elegant. The lines are extremely clear, the finish is flawless. Details are rendered meticulously with all the color areas contained within outlines. Generally, his landscapes and figures seem bathed in transparent luminous airiness.

Though his compositions evoke associations of ideas, they are the exact opposite of the literary painting, *hsieh i* ("write idea"), practiced by the literati. The scholarly critics, incidentally, were not overawed by his contemporary fame. They reproached him for being over-meticulous, "for putting legs on the snake," i.e., giving too much importance to details. The Ming and Ch'ing critics put him in the *cheng* ("accomplished" category), the third order of excellence. However, he is an artist easy to grasp, without literary complexity.

The work shown here portrays a sage in his retreat, playing the *ch'in*, while his family and servants are busy preparing a meal. The scene evokes a legendary Golden Age, "the good old days." This work is known under the title *Garden of the Immortal of the Jade Grotto.*

At the right, preceding the artist's seal, there is an inscription in tiny characters: "Made by Ch'iu Ying."

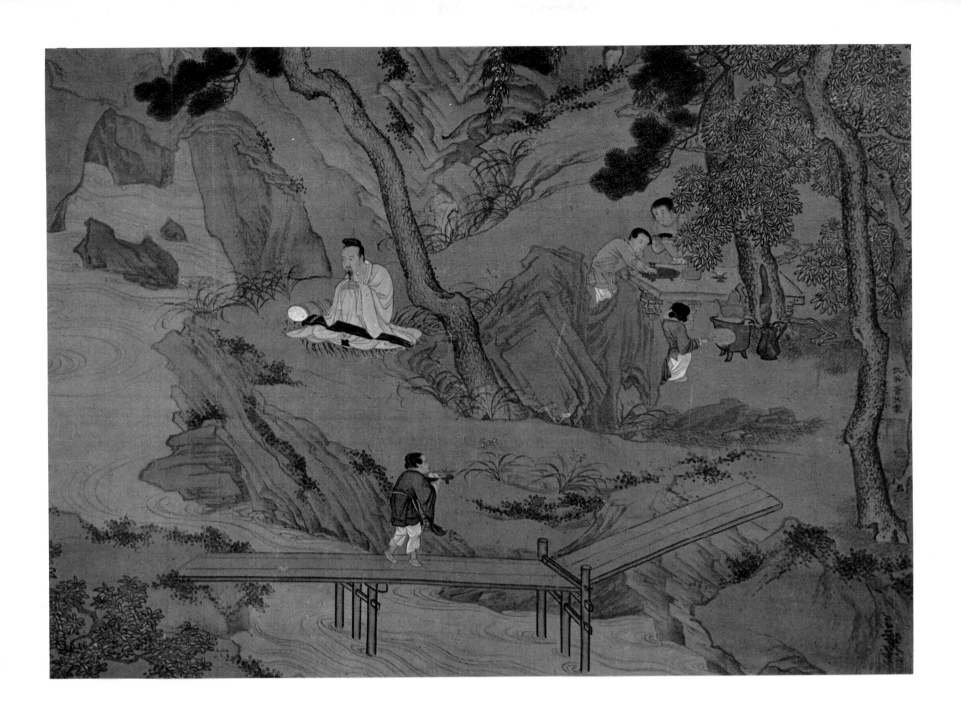

29. The Painter-Monk Seng Ni

Lan Ying (1585–1660) and Hsü T'ai (seventeenth century)
Ink and color on paper. 32 1/2 × 11 3/4 inches

This painting was executed by two artists. Lan Ying is responsible for the arrangement and the tree on which the figure is seated.

The inscription (upper left) in the hand of Lan Ying tells us that the figure is the Shan-seng ("Monk of the Mountain"), Master Seng Ni, and that the painting was composed by Lan T'ai (Lan Ying) in his seventy third year (about 1657).

At the bottom left Hsü T'ai states that he painted the figure.

ANIMALS, BIRDS, AND FISH

30. Two Crows and a Weeping Willow

Liang K'ai (active after c. 1200)
Screen painting, ink on silk. Diameter: 10¹/₈ inches

This small painting clearly shows the exceptional talent of the great painter Liang K'ai. A few brush strokes were sufficient to render the sight of a weeping willow shaken by the evening wind, at the time when the crows take wing. There is not a line that is superfluous, that does not contribute to expressing the poetic feeling experienced by the artist, which he set down in a few moments.

What skill, what training are evidenced by twigs so rapidly sketched, whose thickness and tonality decrease with the gradual lightening of the pressure on the brush! What great art of composition to compel the viewer to set the scene in a broader frame of his own devising!

At the bottom, slightly to the right, a short signature: Liang K'ai.

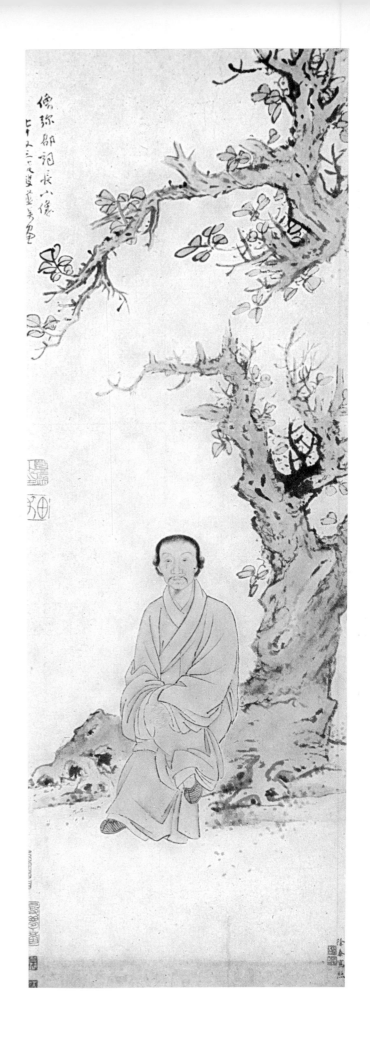

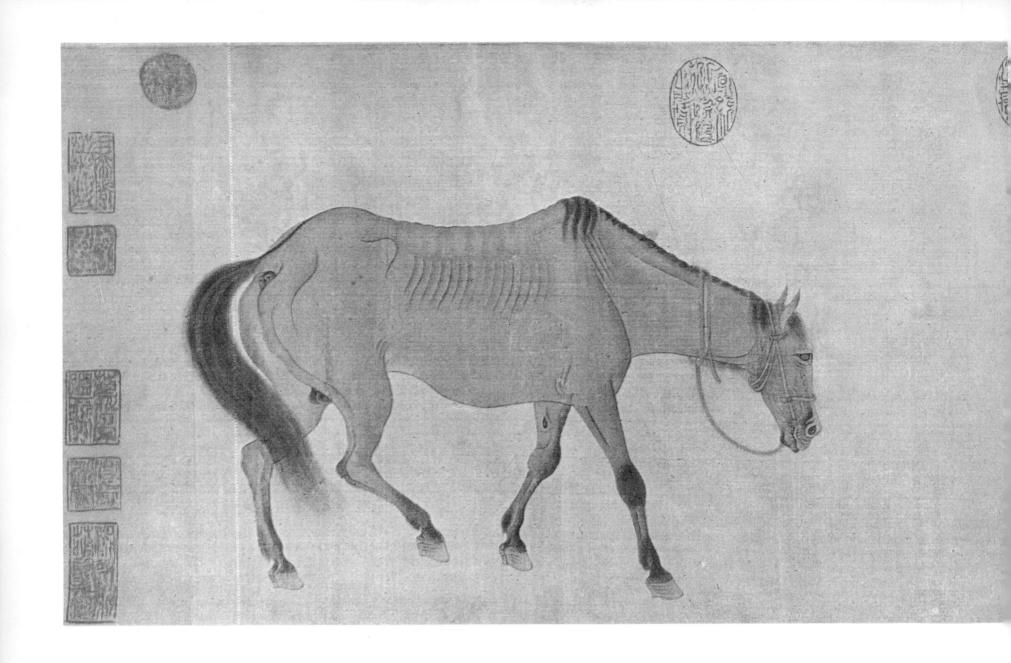

31. The Lean Horse and the Fat Horse

Jen Jen-fa (1254–1327)
Colors on silk. 11 3/8 × 37 inches

Jen Jen-fa, a native of Kansu, was a scholar official under the Yüan Dynasty. Like Chao Meng-fu, the great painter and calligrapher, he entered the Mongol administration, where he held the post of Vice-President of the Office of Water Control. Although he agreed to work for the foreign dynasty in a period of universal careerism, he preserved his dignity and sense of justice. He put his painting at the service of his ideas, to satirize contemporary society.

Like Chao Meng-fu and other artists who worked at the Yüan court, he made numerous paintings of horses—a subject particularly appreciated by the Mongols.

The wretched horse at the left symbolizes the scholar-official who has remained honest, but is ill-fed and maltreated, whereas the horse at the right, fat and arrogant, symbolizes the corrupt high official, who seemingly has an easy life.

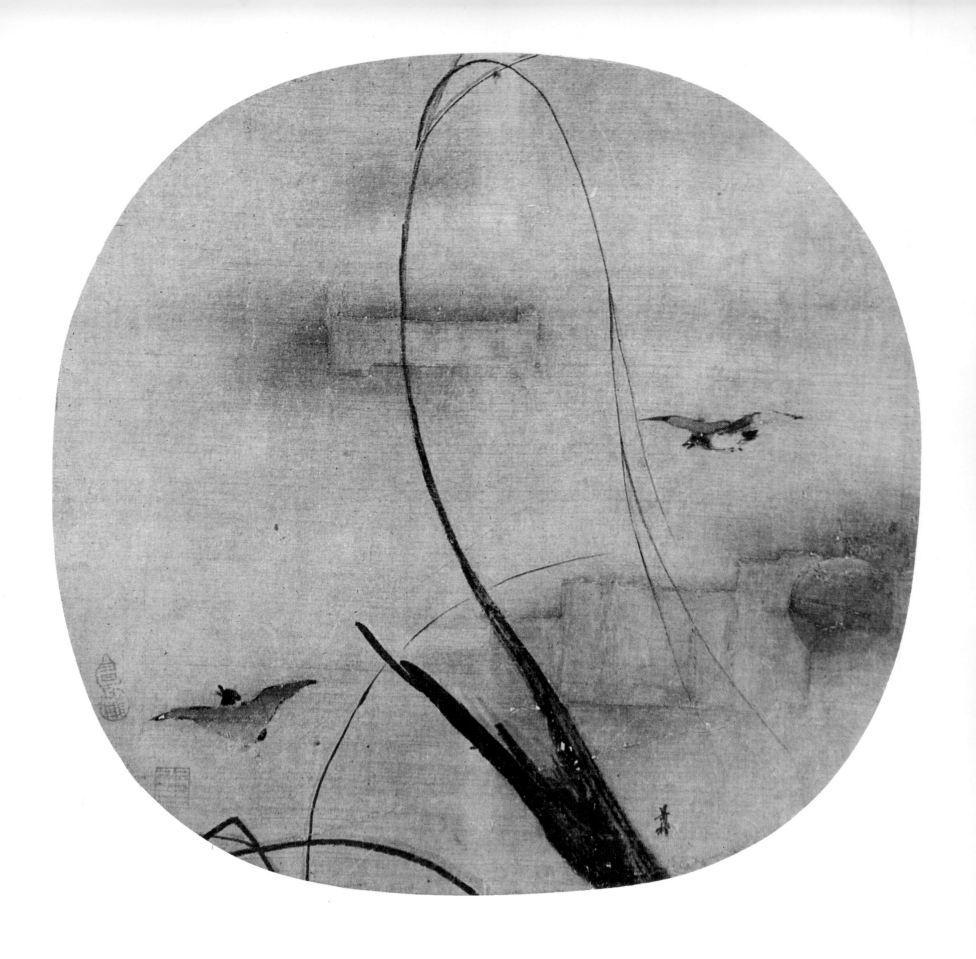

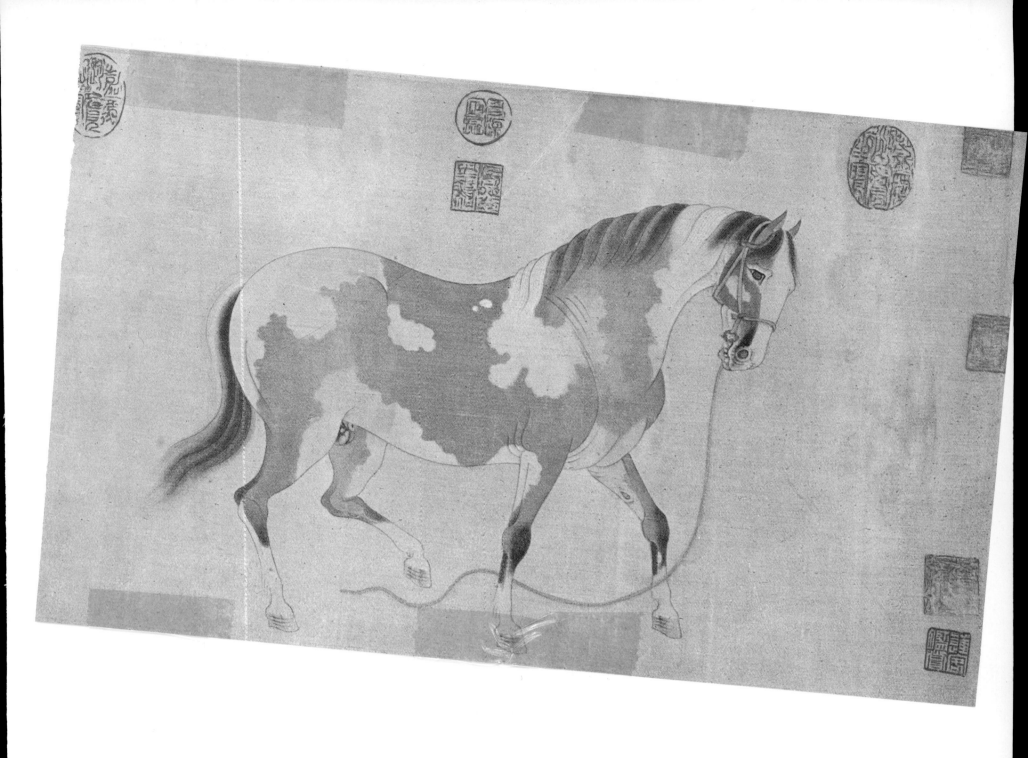

32. Waterfowl and Lotus

Chu Ta, called Pa-ta-shan-jen (1625–1705)
Ink on paper. 49 ⁵/₈ × 18 ¹/₈ inches

Pa-ta-shan-jen, whose real name was Chu Ta, came from a prominent family allied to the Ming emperors.

After the Manchu conquest he became a Buddhist monk (of the Ch'an sect) and all his life he remained hostile to the Manchus.

His name in art, Pa-ta-shan-jen, may be translated "Hermit of the Eight Great" or, perhaps more accurately, "The Hermit Great among the Eight." According to some writers the name can also be read, in accordance with the two-character graphism he used as signature, "Weeping... laughing"

After his father's death in 1644 he vowed never to speak again, and from that time on communicated only in sign language.

His biographers portray him as now living alone, caught up in long meditations, now enjoying himself in the company of friends, a cheerful guest and great lover of wine. It may be noted that in the case of many Chinese painters drunkenness stimulated creativity, and some authorities relate this fact to ancient ritual drinking bouts.

Chu Ta liked lowly people and often gave them paintings. He kept aloof from high officials and the wealthy who tried to befriend him with an eye to his paintings. According to his biographers, such persons could obtain them only by hiring a poor man to act as intermediary.

Many of his peculiarities recall those of the "sages" described in ancient Taoist texts. For instance, his vow of silence may be related to Lao Tzu's aphorism: "He who talks does not know, he who knows does not talk," and to Chuang Tze's precept: "Do not speak, express yourself without words: some men speak a whole lifetime and say nothing, others never speak, yet always have something to say."

Chu Ta was in the direct line of descent from great Southern Sung painters such as Mu Ch'i and Liang K'ai who, in order to escape the prevailing academism, withdrew to Ch'an monasteries. Like their painting, his own is related to the *hsieh i* ("write idea") style. That is, it is characterized by freedom and spontaneity and opposed to the more deliberate and meticulous *kung-pi* style. This style sacrifices every detail not absolutely indispensable to the viewer, who is supposed to reconstuct the scene by his own mental effort, to go beyond the field of vision defined by the painting, and above all to produce a flow of images, emotions, ideas, and recollections to enrich the subject as actually given.

The extreme simplicity, the deliberate bareness of Chu Ta's works bring to mind two of Matisse's sayings: "Whatever is of no use in the picture is for this very reason harmful," and "A work requires an over-all harmony; any superfluous detail merely detracts from another, essential detail in the viewer's mind."

Chu Ta never painted human figures. Rocks, plants, insects, birds—especially waterfowl—these supplied his favorite subjects, through which he expressed his love of nature and vision of the universe. According to critics, his dynamic brush "succeeded in giving resonance to the *ch'i*—the breath of life."

In the work shown here the viewer will note the sureness and depth of observation required to render the bird perched on one leg on a rock sticking out of the water. The line is now vigorous, now delicate, and the subtle interplay of different tones in the wash drawing succeeds in suggesting color variations.

Those acquainted with the lakes and ponds of South China will at once be able to identify this peculiar end-of-summer atmosphere, the odor of vegetation rising from the sluggish water, the lotus blossoms at their maturity, the warmth and calm pervading this scene. A tide of images and poetic recollections is evoked here, giving substance to the viewer's feelings and emotions.

The painter's signature appears, "Pa-ta-shan-jen," and two of his seals (upper left).

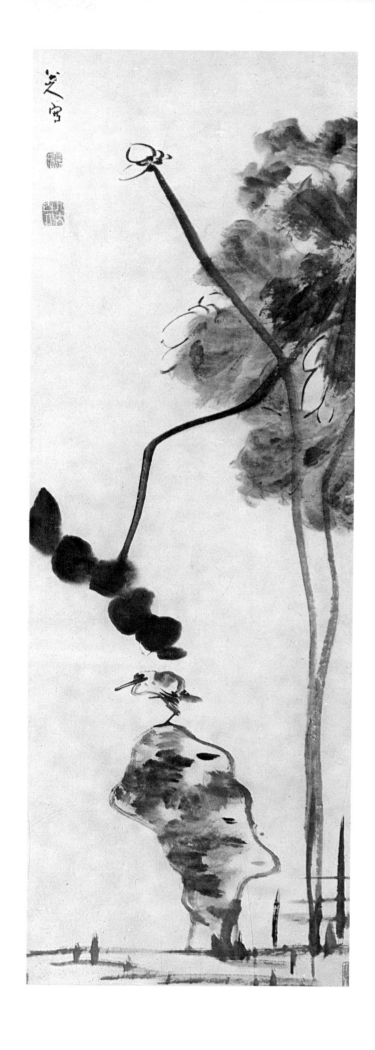

33. Shrike on a Willow Tree

Chu Ta, called Pa-ta-shan-jen (1625–1705)
Ink on paper. 46⁷/₈ × 23 inches

The viewer will admire the rightness of the bird's position and the contrast between the twisted old tree and its fragile drooping branches.

Here too we are reminded of the art of Liang K'ai, the great independent master of the Southern Sung, who painted a shrike in a similar style.

The brief inscription in the artist's hand, followed by his signature, informs us that this work was executed on a winter day of the Keng-Wei year.

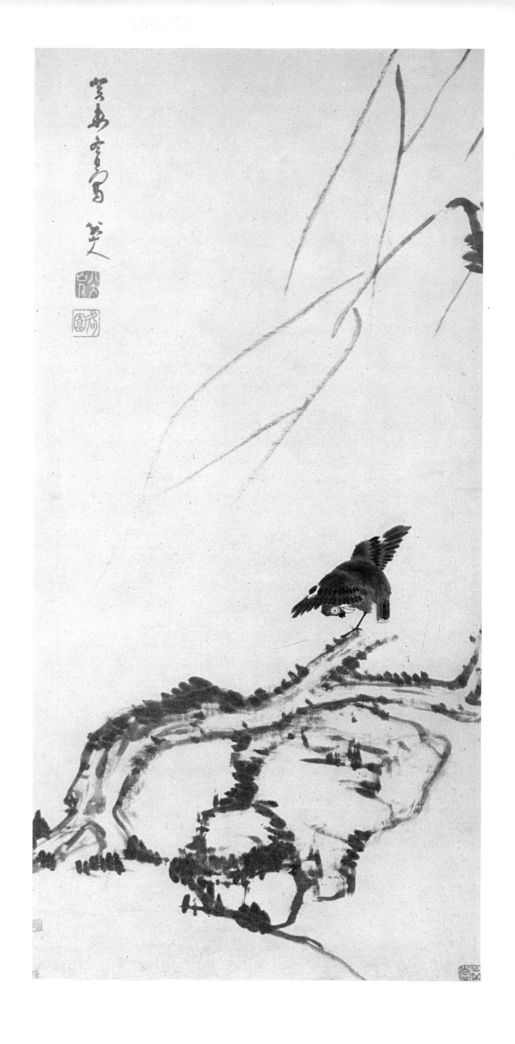

34. Eagle on a Maple Tree

Hua Yen, called Hsin-lo-shan-jen (1683–1755)
Ink and color on paper. 52 × 17¹/₂ inches

Hsin-lo-shan-jen (real name: Hua Yen) was one of the so-called Eight Eccentric Masters of Yangchow, others of whom were Chin Nung (1683–1764), Li Shan (1711–1754), and Lo P'ing (1733–1799). Although these artists declared that they intended to follow no school, they were often influenced by old masters. Hua Yen, more particularly, studied the Yüan and Sung artists. He painted flowers and landscapes, but his favorite subjects were animals and birds. These, though never anthropomorphic in feeling, often evoke certain aspects of the human character. In this respect he was following an old tradition. Under the Five Dynasties, especially in the Szechwan School, many painters were fond of evoking human qualities in their portrayals of birds: the heron, solitary and aloof; the parrot, brilliant and expressive; the eagle, proud and farsighted.

The signature (lower right), Hsin-lo-shan-jen, is followed by the artist's seal.

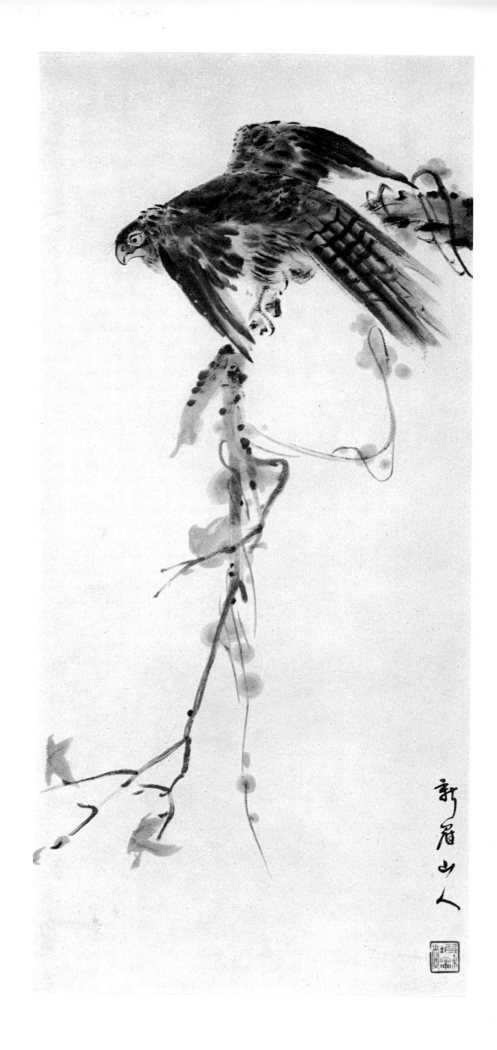

35. Red Fishes and Wisteria Reflections

Hsü Ku (1824–1896)
54³/₈ × 26¹/₂ inches

The monk Hsü Ku belonged to a family of scholars in Kiangsu and was an officer of the Chinese army.

Many of his paintings treat this subject of red fishes and wisterias which, as we learn from the short inscription (upper left), are symbols of decorations conferred upon men of the highest class—the violet ribbon and the gold seal.

The inscription dedicates the picture to a high official with these words: "Violet ribbons... gold seals. Painted respectfully in homage to the *ta jen* (great man) Ch'üan Fang-po." Next to it is the artist's seal.

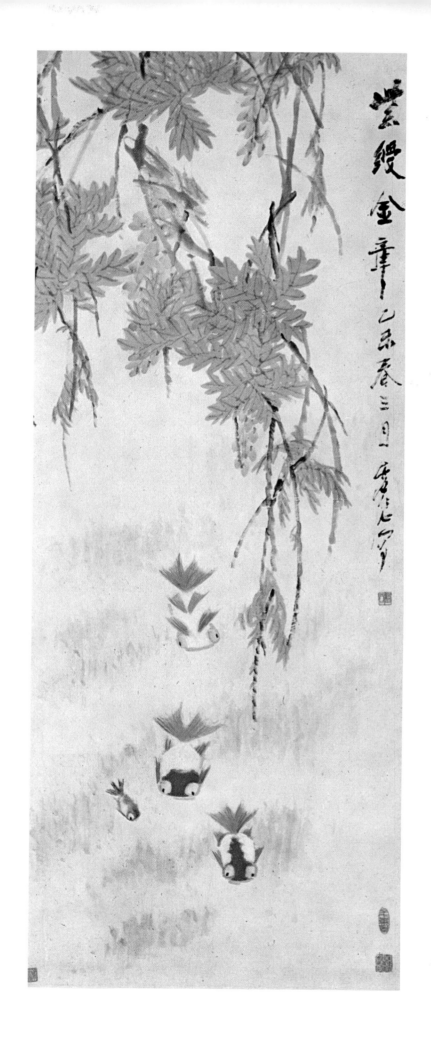

PLANTS, FLOWERS, AND INSECTS

36. Lotus

Artist unknown. Sung Dynasty
Screen painting, colors on silk. Diameter: $10^1/_4$ inches

This painting of a lotus at the height of its bloom is a perfect example of decorative, realistic art, and of the perfect technique of the Sung flower painters.

The work is not signed. It may date from the eleventh century. Technically speaking, the artist follows the linear tradition: the contours have been lightly sketched in, the colors carefully set down inside them.

Comparison of this picture with the wash drawings of lotuses by Tao Chi shows the differences between the two great tendencies of Chinese painting.

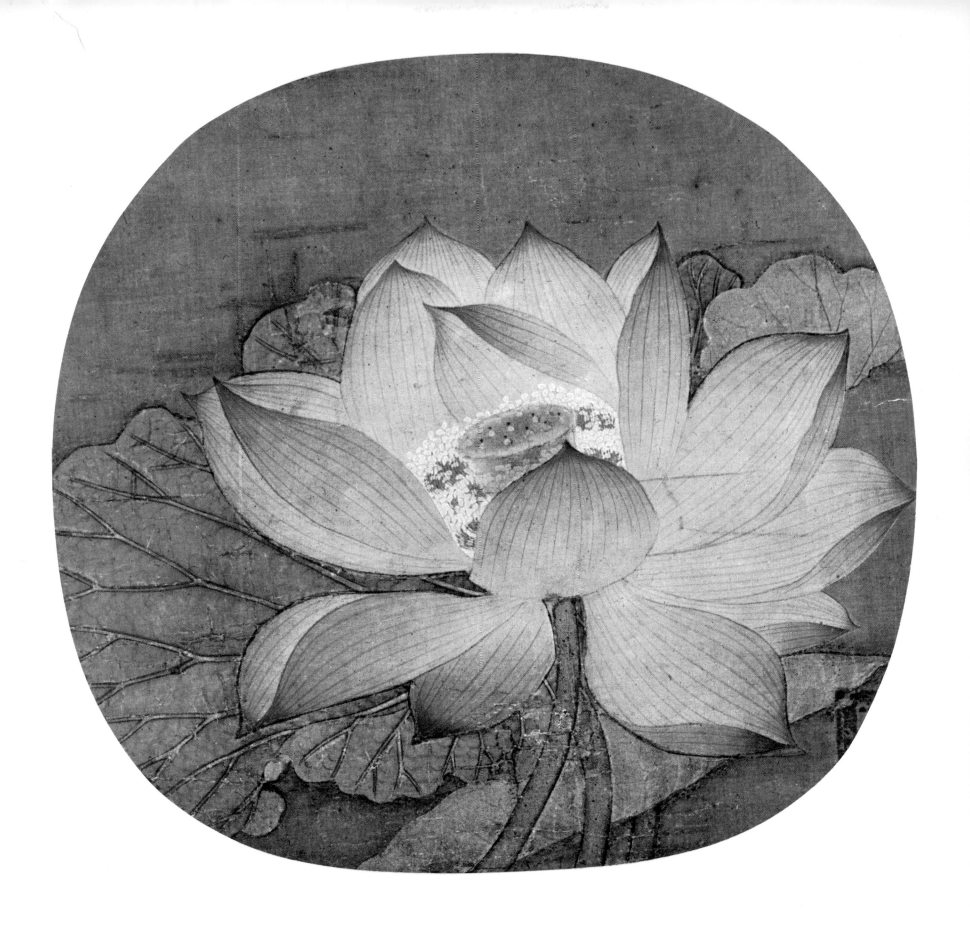

37. Branch of Plum Blossoms

Wang Mien (1335–1415)
Ink on paper. 12⁵/₈ × 20¹/₂ inches

Wang Mien, one of the greatest of the Yüan artists, did not come from a family of scholars, like Wang Meng, or one of rich merchants, like Ni Tsan, but from a poor peasant family in Chekiang.

As a boy he tended cattle. His biographers tell us that he used to bring them close to the village school and post himself near the classroom window so as to follow the lessons. This would be how he learned to read and write. Later he entered a Buddhist monastery as a novice, where he was no doubt able to continue his education and to study calligraphy and painting.

His whimsical and independent temperament made it difficult for him to adjust to monastic discipline, and so he tried to enter the civil service, but the best he could wangle was a minor post in the army. He performed his duties in a rather unusual way: according to his biographers, he used a water buffalo as transportation—a placid beast on whose back he could read and study while traveling from place to place. His superiors must have treated him with special leniency in view of his talent as a painter of rocks, bamboos, and fruit trees. Influential figures offered to recommend him for more important and more remunerative posts in the Mongol administration, but he always declined, contenting himself with a modest post as a teacher.

However, he became a well-known painter, and collectors came to visit him, bringing silk to exchange for a painting.

Faithful to the literati tradition, he never took money, but would occasionally accept gifts of food.

Fruit trees in blossom were his favorite subjects. Throughout his long life he studied the flowering trees every spring, trying to capture them in every stage of their growth, from every vantage point.

To Wang Mien, every fruit tree was endowed with its own individuality and had its own rhythm of growth. It was up to the artist to discover what this was and to attempt to render it.

He also looked upon the blossoming fruit tree as an emblem of China. Wang Mien, who refused to have anything to do with the Mongols, saw in the blossoms a symbol of resistance to the barbarians. On a painting of just opened, thickly clustered blossoms he wrote: "The blossoms are as firmly knit together as jade or ice, and not even the Mongol flute can break them apart."

There are two inscriptions on the painting. The one at the right was added at a later date by the Ch'ien Lung emperor (1736–1796), whose seals are recognizable. The text is full of obscure allusions that cast no light on the painting. The second is by Wang Mien:

> Where I live, around the pond where I wash my inkstone, all the trees are in bloom, and the blossoms have faint traces of ink. It matters little that people praise their lovely colors. It is enough that what they breathe out fills Heaven and Earth.—Wang Mien Yüan-chang made this painting for Liang Tao.

There are two of the artist's seals.

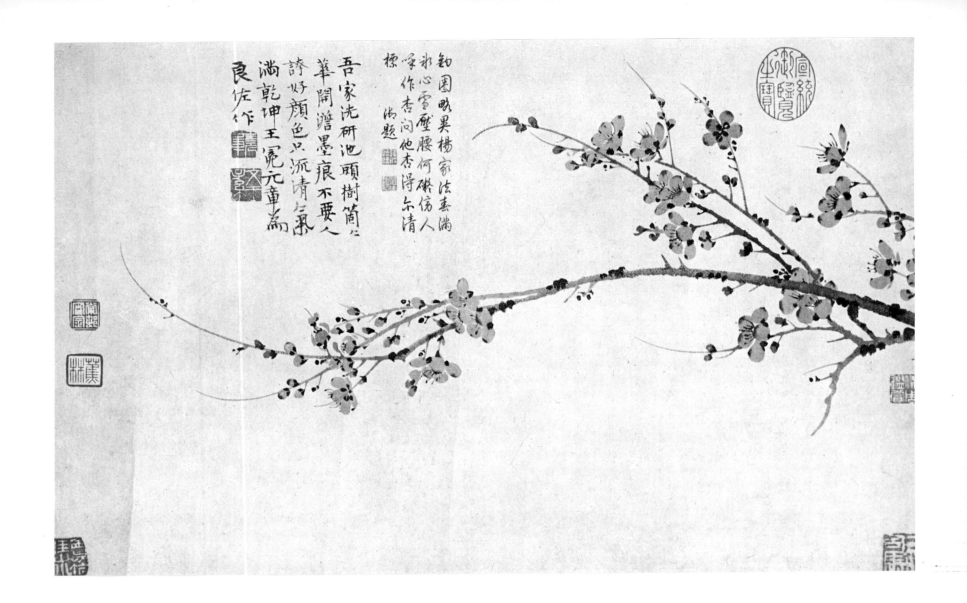

38. Flowering Plum Tree by Moonlight

Ch'en Hsien-chang (1428–1500)
Ink on silk. 62¹/₄ × 29¹/₈ inches

Ch'en Hsien-chang, a literati painter from the Canton region, felicitously continued the style of Wang Mien. Note the contrast between the delicacy of the scarcely opened blossoms and the almost glacial atmosphere created by the full moon.

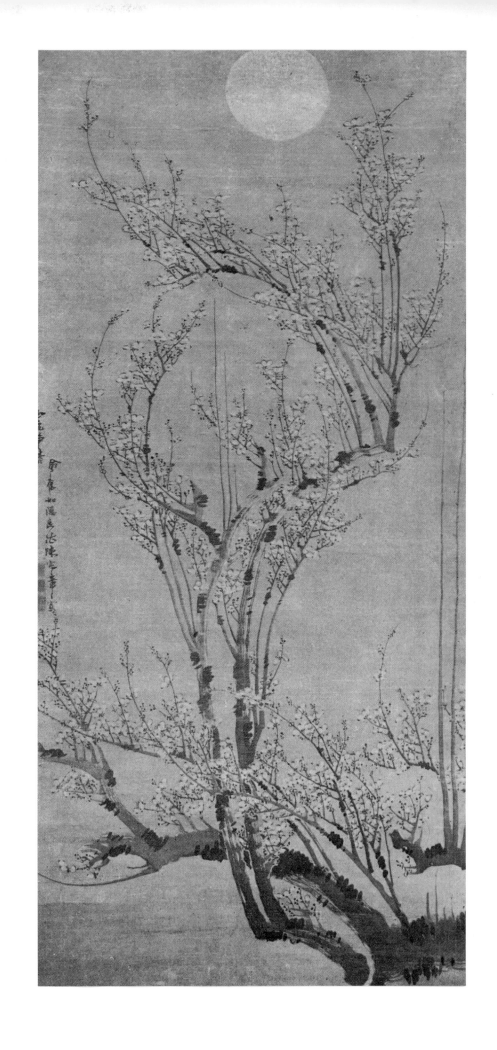

39. Butterfly and Reed

Hsiang Sheng-mo (1597–1655)
Ink on paper. 44$\frac{1}{2}$ × 22$\frac{7}{8}$ inches

Hsiang Sheng-mo, born in Chekiang, was a literati artist affiliated with the Yangchow school. Sensitive and refined, he succeeded in giving vivid poetic expression to the beauty of flowers, reeds, bamboo, fruit, and insect.

The brief inscription, with a Buddhist undertone, says:

> The matting for meditation is in shreds… I painted just as I liked… A butterfly came flitting. It quivered peacefully as if about to fall asleep.
>
> —Hsiang Sheng-mo

There are two of the artist's seals.

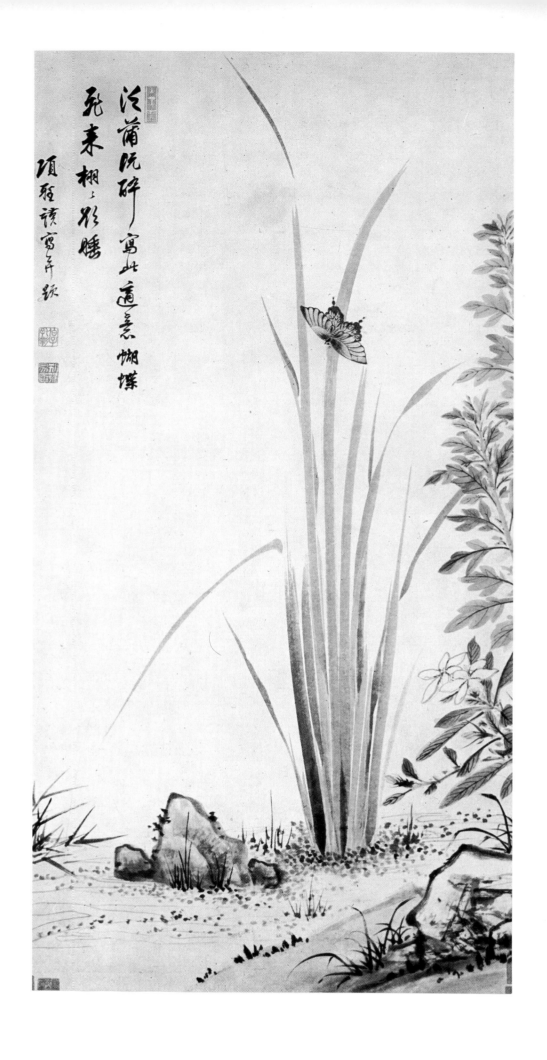

99

40. Banana Tree and Bamboos

Chu Ta, called Pa-ta-shan-jen (1625–1705)
Ink on paper. 86¹/₂ × 32⁵/₈ inches

This painting by Chu Ta discloses the same concern for immediate concise expression and the same vigor that characterize his birds.

Banana trees and the bamboo were among his favorite subjects. By varying the pressure of his brush he succeeded in contrasting the somewhat soft fullness of the former with the nervous slenderness of the latter. By exploiting the diverse tones of his wash drawing he renders the various greens, suggesting the contrast between the pale yellowish green of the banana tree and the more singing green of the bamboo.

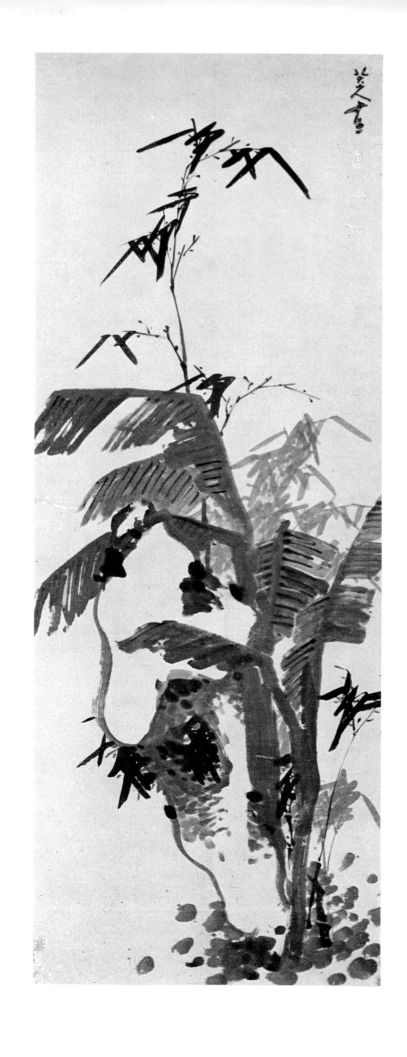

41. Flowering Pear Tree

Yün Shou-p'ing (1633–1690)
Album leaf, ink on paper. 10 5/8 × 13 3/8 inches

Yün Shou-p'ing or Nan-t'ien (the name by which he is best known) was a literati artist, poet, and calligrapher, whose prominent family was loyal to the Ming Dynasty. At first he painted mostly landscapes. Disappointed because, it is said, he did not succeed in surpassing his friend Wang Hui, he began to paint flowers. His delicate, sober style brings to mind certain Sung and Yüan artists.

A short poetic phrase accompanies the picture:

On the jade terrace there is dazzling snow. In imitation of the laureate T'an Yin, Pai Yün K'iyu [The White Cloud Fisherman], Shou-p'ing.

Three of the artist's seals under three different names appear: Nan-t'ien, Shou-p'ing, and Yün Shang-ku.

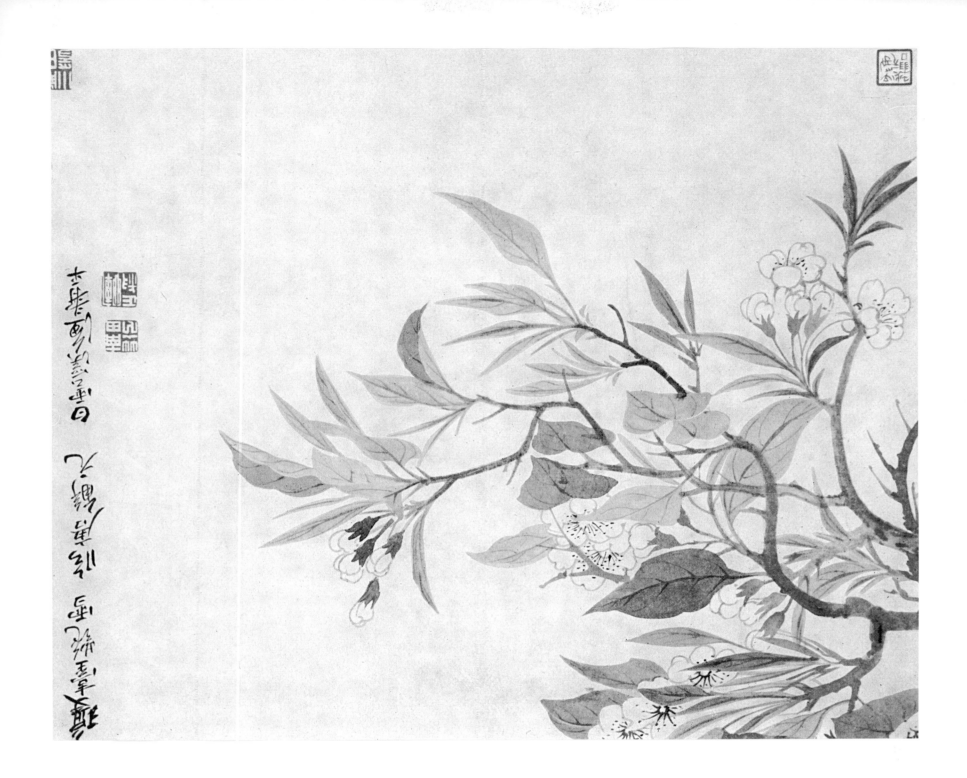

42. Lotus Blossoms

Tao Chi, called Shih T'ao (1630–1707)
Ink on paper. 36⁵/₈ × 19³/₄ inches

These vigorous and poetic lotuses evoke the ponds of South China, the moist, tepid air of late summer. By means of sweeping brush strokes and nervous lines resembling those in the inscription, the artist has succeeded in conveying with feeling what he saw. We are reminded of Monet's variations on a theme— *Water Lilies*.

 A poem containing historical and literary reminiscences and suggesting many subtle images is intended by the artist to harmonize with the somewhat melancholy charm of this picture. A literal translation of this poem reads:

> Han gardens, still lovely. Palace of Chu, deserted. The singer returns from her wanderings, she misses Yao Meng.
> On the other side of the pond lotuses, by the thousands, by the tens of thousands. We do not know from whom wafts this fragrance of yesteryear.
>
> —Ta-ti-tzu

One of the artist's seals appears: Ch'ing-hsiang Lao-jen.

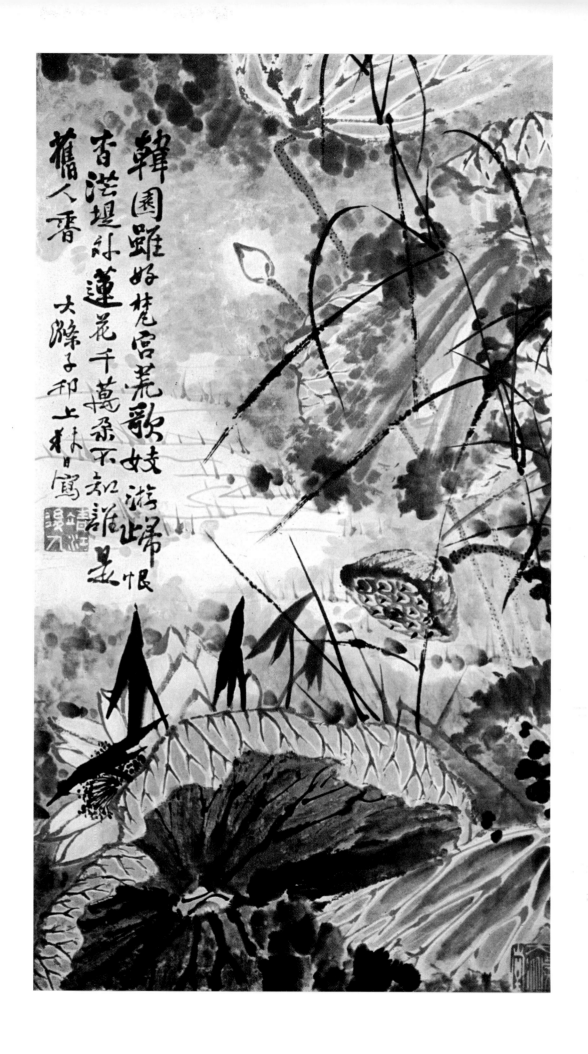

43. Flowering Plum Branches

Chin Nung (1683–1764)
Ink on paper. $46^1/_8 \times 17$ inches

Chin Nung was one of the Eight Eccentric Masters of Yangchow, the group of independent, anti-conformist, anti-Manchu artists which was active in that great commercial city under the emperor Ch'ien Lung.

Most of these artists received the education of literati but, taking T'ang Yin as their model, they ostentatiously scorned all conventions. They sought to confound the bourgeoisie. Ching Nung, probably the most talented of the group, was a poet, essayist, philospher, and calligrapher. He was over fifty when he began to paint seriously. He practiced several genres—plants, bamboos, flowers, horses.

It is in his paintings of fruit trees, inspired by Wang Mien, that he most fully expressed his sensibility and his poetic temperament.

Like T'ang Yin, several of these Eccentric Masters spent their last years meditating in Buddhist monasteries.

The inscription in Chin Nung's hand tells us how, according to the teaching of Wang Mien, fruit trees should be painted—in the chilly hours of the evening when they give up their secrets at the same time that they are most fragrant:

> A good friend of my third brother, Hsiang-yu, gave me a sheet of paper taken from the imperial storehouse of the ancient Ming Dynasty, asking me to make a painting of fruit blossoms for him.
>
> Therefore I took as my model the style of the Yüan Master Wang Yüan-chang [Wang Mien].
>
> In homage to his teaching, at a moment fragrant with the vapors of tea, when the hidden qualities of things are surely most completely appreciated, I composed this poem:
>
> The water on the inkstone is turning to ice... the ink is half dry. Fruit trees should be painted in the chill of the evening.
>
> Then they lose their wildness and communicate their fragrance to our sleeves.
>
> Those who do not care for flowers need not look.
>
> Chi-liu-shan-min [one of the artist's names] Chin Nung, in his seventieth year [c. 1754].

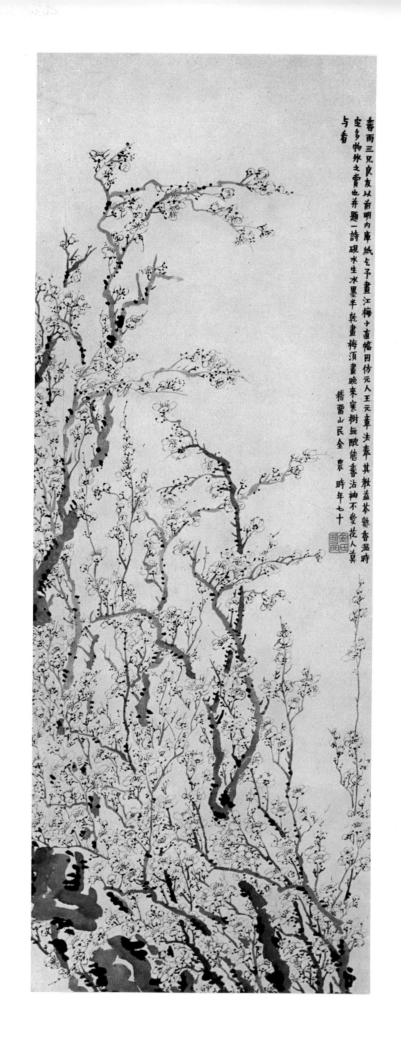

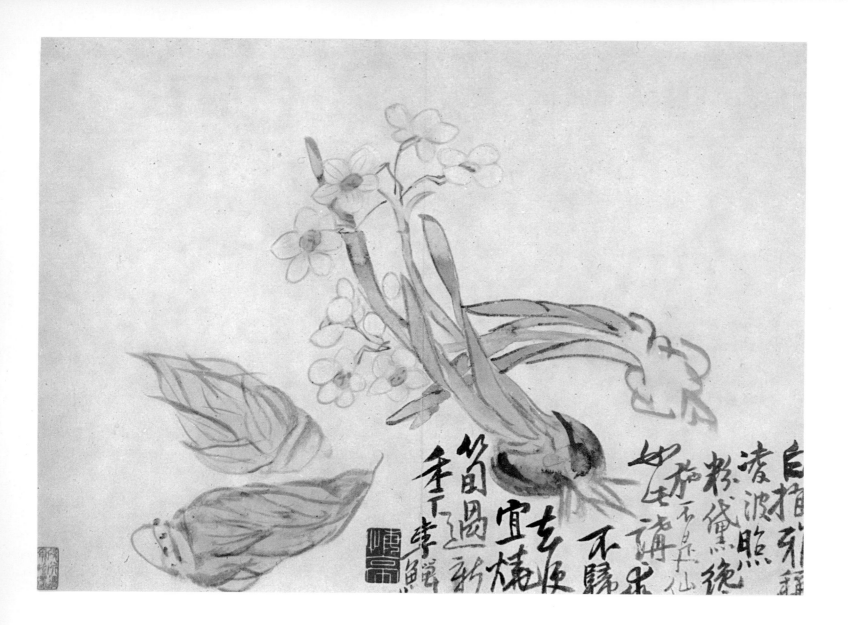

44. Silkworms and Mulberry Leaves

45. Narcissus and Bamboo Shoots

Li Shan (1711–1754)
Album leaves, ink and colors on paper. 10⁵/₈ × 14⁵/₈ inches

Li Shan, born in Kiangsu, was one of the Eight Eccentric Masters of Yangchow. He specialized in paintings of flowers, birds, and insects. His works, executed in the so-called boneless technique, strike us as elegant and decorative. The artist often adds a poem, occasionally very hermetic, full of evocations, literary allusions, and barely suggested images, which create subtle associations of ideas in a cultivated viewer.

Mulberry leaves, on which the silkworm feeds, evoke spring. This study is signed: "Made by Fu lo-tai," and the seal reads: Fu-t'ang (one of Li Shan's names).

The narcissus and bamboo shoots evoke winter, or, more accurately, New Year's Day. The poem, among other things, alludes to the bamboo shoots that are eaten at the New Year's banquet:

> Slender, elegant silhouette quivering, just able to stay above water. The make-up and the eyebrow blacking have just been applied. This is not a fairy but such refinement will never be found again. It is time, then, to prepare the bamboo shoots to celebrate the New Year.

There is one of the artist's seals: Li Shan.

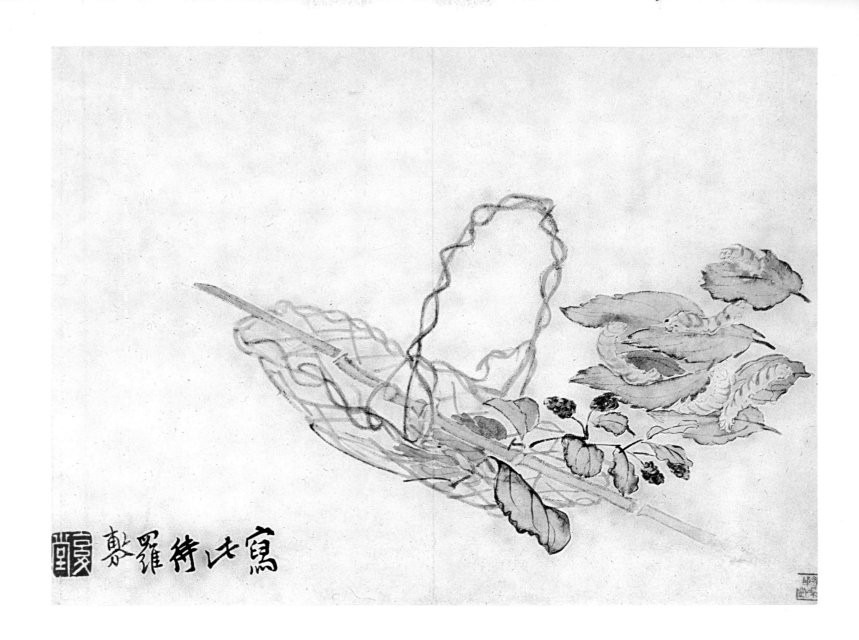

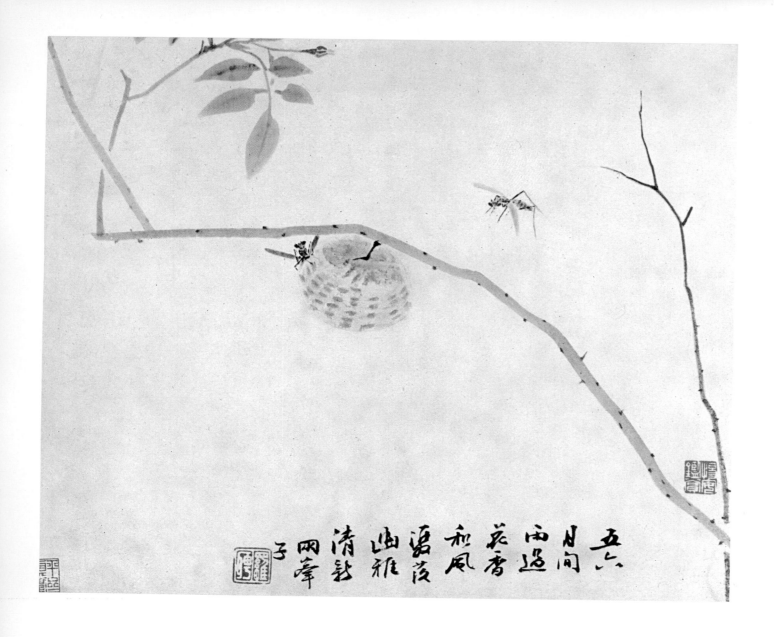

46. Wasps and Brambles

47. Dragonfly and Poppy

Lo P'ing (1733–1799)
Album leaf, ink and colors on paper. 9 1/2 × 11 3/8 inches

Lo P'ing, one of the Eight Eccentric Masters, was a subtle, delicate, sensitive, and often ironical artist. He painted and sold "ghosts painted from the life." That he belongs to the literati tradition is clearer in little studies like these, sensitive and witty—flowers, insects, birds, accompanied by highly literary poems, often hard to make out.

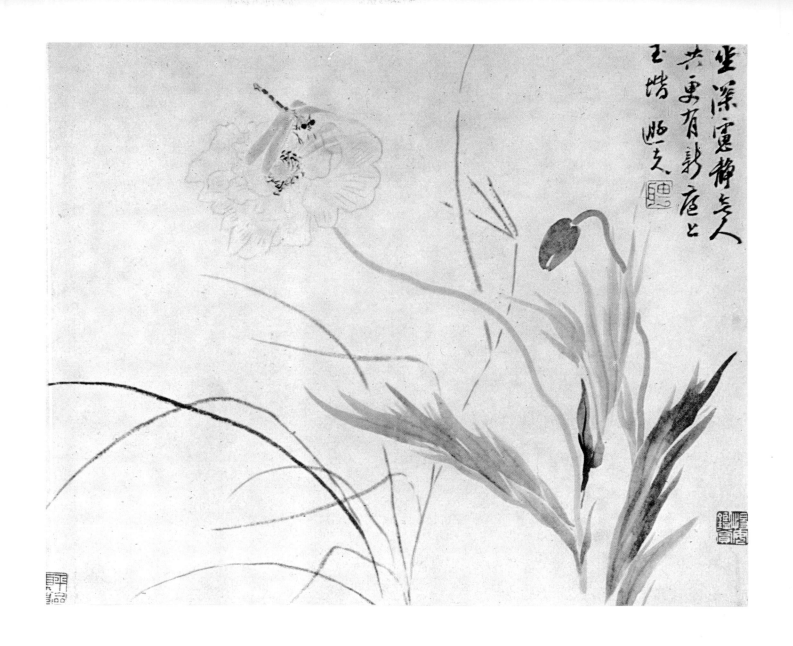

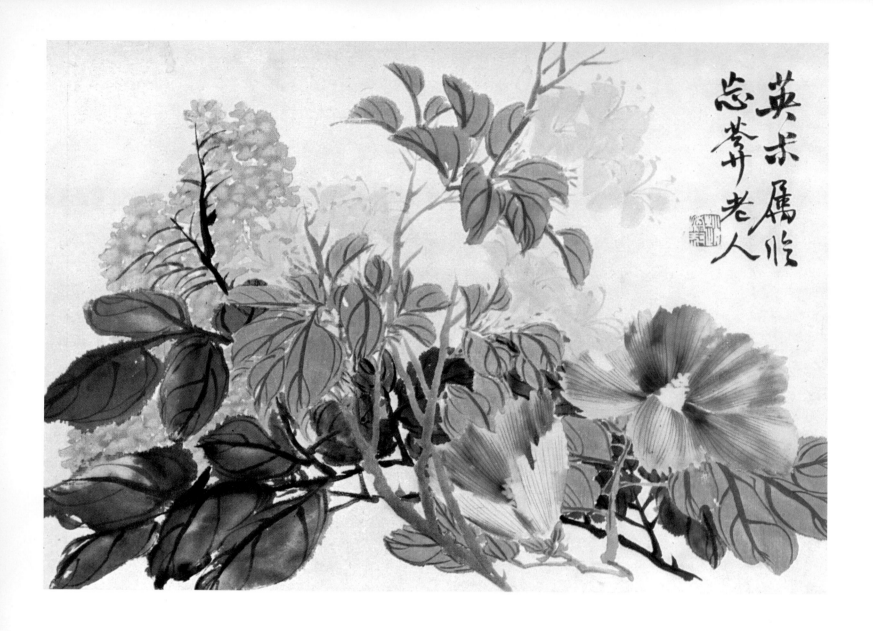

48. Flowers

49. Flowers

Chao Chih-ch'ien (1829–1884)
Ink and colors on paper. 9 × 12 ⅝ inches

Born in Chekiang, Chao Chih-ch'ien continued the literati tradition at the close of the Ch'ing Dynasty. He was a poet, writer, calligrapher, and a renowned engraver of seals. His "boneless" technique is often inspired by Li Shan. He mostly painted flowers and rocks. His works are florid but of sure taste, and strike a modern note.

His influence on Ch'i Pai-shih was considerable.

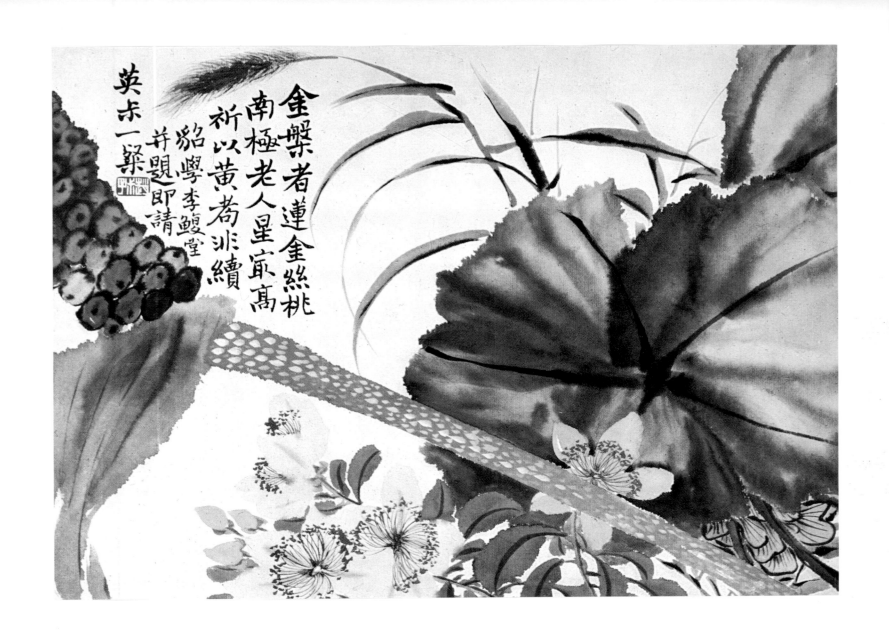

金盤者蓮金絲桃
南極老人星宿高
祈以黄菊非續
貂學李鯤堂
並題即請
英步一粲

50. The New Year's Flowers and Fruits

Wu Chün-ch'ing (1844–1927)
Ink and colors on paper. 60¹/₄ × 31⁷/₈ inches

Wu Chün-ch'ing, a literati artist, lived through the close of the Ch'ing Dynasty and the 1911 revolution·
He painted a great deal. He was a great calligrapher, and had a very personal style. His "boneless" paint¯
ings are very decorative. The work shown here evokes the New Year with its flowers and symbolic
fruits; among them we recognize plums, persimmons, and some narcissus. The inscription in the artist's
hand explains his intention:

> An offering on the occasion of the New Year. On New Year's morning, by painting flowers
> and fruits set on their tables, our ancestors expressed the passing of time, the impermanence
> of things. So have I done… in the same spirit.
>
> On the first day of the Yi-mao year [February 14, 1915]."

—Wu Chün-ch'ing

Two of the artist's seals appear.

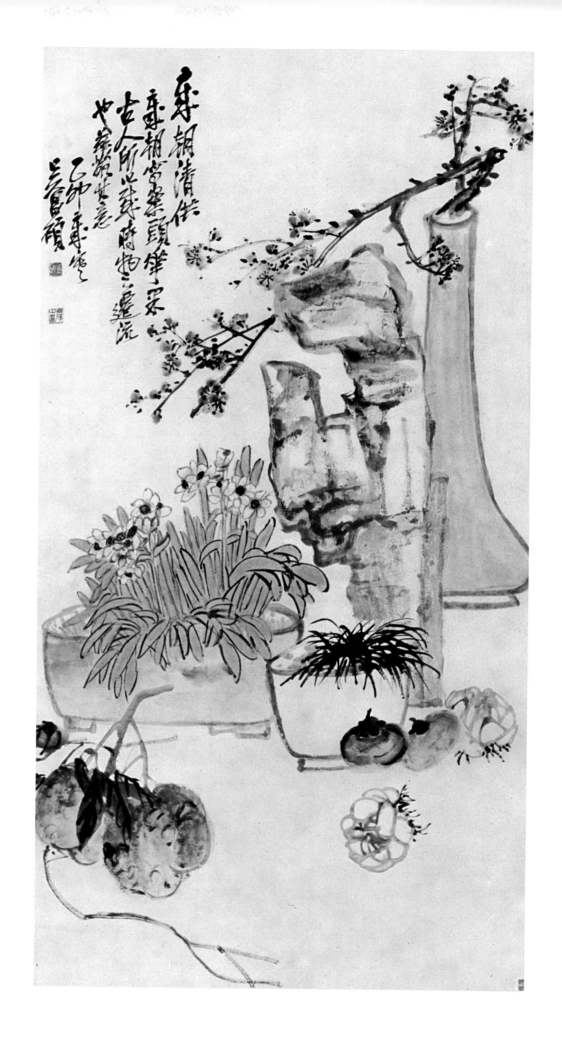

CHINESE CERAMICS

THE OLDEST legends, piously collected, commented on—and sometimes added to—by China's ancient historians and philosophers, bear witness to the importance of the ceramic arts at the most remote periods of Chinese civilization. Thus, in the mythical epoch of the Five Sovereigns before the founding of the first dynasty recorded in the traditional chronology—the Hsia (second millennium B.C.)—Shun, the last of the Five Sovereigns, was a potter as well as a farmer and fisherman.

Ceramics has been held in the highest esteem over the centuries as a basic, self-contained art and has never been relegated to the status of a minor or merely "decorative" art, as so often in the West. Collectors of beautiful ware appear at an early date, and educated men such as poets, painters, emperors, and highly placed functionaries comment from time to time on pieces in their collections from especially prized kilns.

The imperial court was not slow to preempt the production of certain kilns, and eventually imperial pottery works were created. The most famous of these, that of Chingtechen (now Fowliang) in Kiangsi province, was founded in 1368 at the beginning of the Ming Dynasty (1368–1644) and went on to heights of unexampled renown.

That this art was carried to so incomparable a pitch of perfection in China was due to the presence of collectors there whose refined demands went far beyond anything normally expected of porcelain or decorated earthenware manufactured in Europe. It was not enough that a piece be suitably and agreeably shaped, it had to arouse much subtler grounds for admiration as well. It was expected to touch the feelings of the connoisseur, to bring into play his mind and the full range of his cultivation.

A piece should *speak* to the fingers that touch or fondle it. Some objects, for example, are unctuous to the touch, recalling the flesh of pretty women who use make-up. Particularly prized are the ever-so-slightly uneven glazes, dotted with tiny holes produced by escaping air during the firing; also glazes with a faintly wavy surface, comparable to the skin of an orange. Or, the collector may treasure a piece for the mineral purity it evokes to the touch while presenting to the eye the brilliance of precious jade. A number of beautiful pieces, especially some produced under the Sung Dynasty, appear to be the result of deliberate researches along these lines.

Timbre plays a very important part in the appreciation of hard-paste stoneware and porcelain; the pieces should give off a ringing tone, frequently compared to that of the jade "sounding stones" (lithophones) in ancient Chinese orchestras. From the T'ang Dynasty onward, special "musical" bowls were produced in sets of five. When lightly struck, each of these gives off a note of the Chinese scale.

Lastly, and it is on this score that the difference between the Chinese and the Western connoisseur is most marked, a ceramic work is expected to speak a poetic language addressed to the whole of our sensibility, culture, and education. No less than a painting, a work in bronze, jade, pottery, stoneware, or porcelain may evoke images, allusions, symbols, or analogies. There are numerous masterpieces in which the body, colors, and decoration, besides being closely knit in a pattern of functional significance, at the same time harmonize with some given moment in the cycle of the seasons or with some particular event in human life.

For example, a vase designed to hold blossoms of one or another fruit tree—symbolic of winter and the New Year (which falls later in the lunar calendar than in our own)—will somewhere inconspicuously embody motifs bringing out the significance of the blossoms.

Or, a vase for holding peonies—which are emblematic of spring—will be designed, not just to set off the flowers, but also to evoke the season of renewal through the vigor of its shape and elegance of its decoration. Similarly, a vase for chrysanthemums will through the use of half tones in its glazes or painted enamel decorations be in tune with the nostalgic charm of summer's last warm days and the first falling leaves of autumn.

To evoke such impressions of the stirring of nature and the passing of time—a central preoccupation of Chinese art—it is sometimes enough to suggest certain insects or seasonal vegetation, on the basis of which the cultivated collector will be led to paint his own picture, write his own poem. In later stages, some ceramic pieces will with a brief verse or two spell out in characters the artist's poetic intentions.

Potbellied flasks for holding rice wine are designed as ceremonial pieces and are brought out for holiday celebrations or at banquets of friends. Here, the style of decoration will, without aggressiveness, strike a note of optimism. Everyone present, without necessarily being aware of doing so, will in terms of his own hopes, desires, and ambitions recognize the good will and encouragement the ceramic piece extends to him. The classic motif of goldfish, *li*, will for example recall the other *li* which signifies "profit" in both practical and spiritual senses: sumptuous display,

propitiousness, good augury. To a merchant it will embody hopes of better business conditions, to a government official, ambitions for promotion. Each, in terms of his own life, will find in it the expression of his aspirations.

POTTERY FROM THE NEOLITHIC ERA TO THE T'ANG DYNASTY

Archaeological finds over the past fifty years prove that the art of pottery was already quite advanced as early as the age of polished stone implements, toward the close of the third millennium B.C. At this time many parts of China were producing pottery in which we find the same concern for balance and technical perfection—allowance being made for the means at their disposal—the same force and sureness of taste, which were to characterize the great ages of Chinese ceramics.

The ornamental themes in this pottery—spirals, circles, checks, and latticework motifs—are associated with very ancient symbols evoking death (black or red jagged lines) and fecundity (cowrie-shell designs).

Vases, urns, and jars were arranged around the bodies of the dead, filled with grain both as food for life in the other world and to symbolize renewal and the power of germination.

From tombs in Shantung and Honan some fine work has been brought to light, often turned on the wheel and sometimes very hard and thin in body. The restrained, elegant shapes are not unlike those of Shang Dynasty bronzes. Decoration is always restrained, whether incised, impressed, or in shallow relief.

From the Shang Dynasty (1523–1028 B.C.), besides the finest bronzes any civilization has bequeathed to posterity, come a few remarkable pottery pieces discovered only about thirty years ago (and sold at the time to foreign collectors). The very fine, very white body has been almost entirely vitrified and resembles porcelain. In form and ornamentation the pieces are very like the ritual bronzes of the same epoch: fantastic animals, stylized dragons and grasshoppers, and *lei-wen*—the Chinese version of the Greek key pattern, which symbolizes thunder.

In the first millennium before our era, pottery manufacture was extended to parts of China that had not known it before. During the so-called Period of the Warring States (from the sixth to the third century), a time of harsh feudal struggles

which led to China's unification under the state of Ch'in, profound changes occurred in all artistic spheres. The bronzes, especially, take on new shapes and types of ornamentation—partly through the influence of the nomads of the steppes—and these leave their mark on ceramics. This was the epoch that seems first to have employed the technique of glazes, in view of giving pottery a bronzelike appearance.

The flourishing of the arts, crafts, and sciences under the Han Dynasty (206 B.C.–A.D. 220) was not without repercussions in the ceramic domain. Pottery, which we know almost solely from funerary pieces destined to accompany the departed in their graves, is still inspired by bronzes of the period in respect to shape and ornamentation. Use of glazes has become general. Most often copper oxide was added to a base of lead silicate, a combination from which lovely green patina effects could be obtained; after a long stay underground, these effects are further enhanced by delicate iridescences.

It does not seem that the art of ceramics made much progress, technically speaking, during the centuries between the close of the Han Dynasty and the beginning of the T'ang. The best-known pieces from the period are small funerary statues in painted earthenware which tend to become more refined under the Wei and the Sui; the gray earthenware of Honan; and the stoneware of the south, especially that of Chekiang known as Yüeh ware. With its lovely covering glazes colored by iron oxide, this last foreshadows the celadon of later epochs.

However, in shape and decorative motifs, many pieces from this epoch reflect external influences introduced from the West in the course of cultural contacts built up since the Han Dynasty between the valley of the Yellow River and Central Asia, Persia, India, and even Asia Minor. Mainly in North China, ceramic vessels now begin to appear which were inspired by bottles from the Syriac portion of the Roman Empire, by the oenochoae and rhyta of western Asia's Hellenistic art, and by the silver ewers of Persian craftsmanship.

It was also around this era that the introduction of Buddhism to China began to make itself felt. Certain ceramic shapes make their appearance and will turn up again under the T'ang and Sung dynasties: libation bowls, ceremonial pitchers, etc. New decorative themes appear, such as the lotus, emblem of purity, which plays an important role in all Buddhist art. On the sides of some vases we find inlaid

medallions, usually separately molded, representing super-natural beings: Apsarases and other figures from Buddhist iconography, dancing and playing musical instruments. Sometimes they irresistibly evoke the sculptures in the round of the cave sanctuaries in North China and Central Asia.

T'ANG CERAMICS (618–907)

China's international trade expanded under the T'ang Dynasty, with ceramics taking an important part among Chinese exports. This is attested by numbers of pieces of Chinese origin that have turned up in Persia, in Southeast Asia, in Indonesia, and in Japan. In the sphere of the arts, too, important advances were made in letters, painting, sculpture, etc., including what we in the West call the applied arts.

The collector and art lover was from now on to demand that the objects of everyday life should satisfy his most refined tastes. We note increasing numbers of ceramic pieces, intended for use, being conceived, executed, and respected as works of art.

Without abandoning his tradition of good taste and painstaking craftsmanship, the potter increasingly seeks to satisfy a clientele of knowledgeable collectors who are often in search of novelty, not to say of the "exotic." In certain classes a taste for the odd and the foreign develops, especially among the circles of aesthetes living in the highly cosmopolitan capital of Changan. Potters were thus frequently led to make copies or transcriptions of models imported from abroad, and to experiment with new colors and technical processes.

Besides pieces in vividly contrasting colors, we find monochrome porcelains—the first—of great delicacy and finesse, as well as stoneware notable for its strength and sobriety. There is increasing diversification of shapes as more and more objects for use are devised: cups, plates, bowls, boxes, pillows, vases, etc.

In form the works frequently reflect foreign inspiration: Persian silver plates, ewers, and pitchers, for example, and sometimes Hellenistic influences can be discerned, as in the long-necked flasks of rounded or ovoid shape which recall Syrian craftsmanship in the eastern Roman Empire.

Many T'ang pieces display lively polychromatic glazes, with greens, orange-reds, and purple-browns predominating. Often, by means of a technique possibly related to enameling on precious metals, the artist keeps each color separate by careful incisions on the paste prior to the firing. Sometimes, over a lighter body, a few spots of brilliant cobalt blue or iron brown stand out.

Besides the above, we find pieces with marbled decoration, obtained by letting the clay or slip mingle freely during the potting; the effect recalls certain objects with a body of colored glass. In general, however, all the highly fired ceramics, both porcelain and stoneware, keep a notable degree of restraint.

The appearance of porcelain during the T'ang Dynasty was of crucial importance for Chinese ceramics. It seems to have been first manufactured at Hsingtai in Hopeh province, in North China, and from the very beginning to have exhibited that perfect smoothness and translucence of body, delicacy of forms, and restraint in ornamentation which would characterize its later development.

SUNG CERAMICS (960–1279)

The Sung Dynasty was a very great era in the art of ceramics. There was a sizable increase in production sustained by the export market—mainly in the Middle East and Japan—and by a growing demand on the home market for pieces of the highest quality.

Sung ceramics reflect tendencies in the art of the period: what seems to be an extreme simplicity, a highly conscious sobriety backed up by impeccable technique. What the artists of the Sung epoch excelled at, above all, was achieving masterful harmony among the elements: balanced volumes, purity of line, and beauty of surface.

At the basis of Sung ceramics was a very subtle appreciation of volume, of the most suitable volume in relation to the shape of the piece and its ultimate function. In other words, the purity and harmony of the lines seem to derive primarily from a happy grasp of the element of volume. The beauty of a Sung cup can be felt at least as keenly by the hand holding and fondling it as by the eye dwelling appreciatively on its lines.

Porcelain and stoneware were the favorite mediums of the Sung potters, and the majority of such pieces received a monochrome covering glaze. Exceptions are the painted Tz'u-Chou ware which even in China has been held in lesser esteem, and the earliest enameled ware produced toward the close of the dynasty. By and large, the Sung potters felt

distaste for too striking a pattern of surface decoration as detracting from the piece's delicate inner harmony.

However, it did not follow that the eye had to be presented with surfaces perfectly regular in texture, perfectly uniform in color and brilliance. On the contrary, the covering glaze was supposed to be *alive*, the unctuous surface presenting to vision and touch alike multiple small irregularities such as are found in nature. Tiny holes produced by escaping air during the firing, crackle effects due to sudden cooling, and well-nigh imperceptible unevennesses of shape—all these were cultivated.

The carefully applied glazes—as many as eight successive applications to a single piece—were allowed to produce their own "natural" effects, so to speak, in the course of the firing. More or less abrupt variations in the oxidation and reduction processes, alteration of firing conditions and position of the piece in the kiln were found to produce unusual tones, to make spots and form crusts, to give rise to unusual effects.

Where a decoration has been supplied under the monochrome glaze, it may be etched, incised, or in shallow relief, but is invariably unobtrusive, inseparable from the shape, body, and color of the piece. To appreciate it properly, the piece has to be looked at under various lighting conditions, or even—in the case of the so-called secret or hidden decorations—held up to the light and looked through.

The pieces we illustrate represent the production of the most admired kilns of the Sung epoch:

Ju ware: a stoneware manufactured in Kaifeng when that city was the capital of Honan, at the beginning of the twelfth century.
Chün ware: rather heavy stoneware produced in Honan and Hopeh between the tenth and twelfth centuries, with a thick blue or lavender glaze, occasionally light blue with purplish suffusions.
Kuan and *Ko ware:* stoneware with crackle glazes produced at Hangchow in Chekiang province during the twelfth century.
Ting ware: fine porcelain, first manufactured in Hopeh in North China, where the T'ang porcelain had been made, and later in Kiangsi.
Celadon from Lung Ch'üan in Chekiang, the decoration etched, incised, or in relief.
Celadon "of the North," originating at various kilns in Honan province, an important export during the Sung Dynasty.

CERAMICS UNDER THE YÜAN (MONGOL) DYNASTY (1279–1368)

The conquest of South China by the Mongols disturbed, slowed down, or completely stopped production in a great many centers.

When the Yüan administration took hold, representatives of a number of the peoples of Central Asia and the Western Empire, including Mongols, were appointed to posts in China, while at the same time a number of Chinese officials were sent abroad, notably to Persia.

There had been a long tradition of ceramic manufacture in Iran, and its influence is marked upon Chinese production in this epoch. The Mongols adapted to their own purposes a number of Persian varieties of plates, cups, vases, etc., and had them manufactured in China—in porcelain. Further, they actively encouraged production for export.

As it happens, their sole innovation in the field of administration bore upon a reorganization of the arts and crafts. Of especial importance to ceramics, they created government studios and workshops manned by slave labor, the total production of which was reserved to the Mongol officials.

It was in this period that the hamlet of pottery makers at Chingtechen in Kiangsi province began to expand. Located near sizable deposits of high-quality raw materials, and staffed with skilled workers, Chingtechen was soon to become the biggest center of porcelain manufacture in China, eventually in the world.

Partly as a result of Persian influence, use of cobalt blue and the technique of blue underglaze decoration now came increasingly to the fore. It may well be that the analogous—but much more delicate—technique of underglaze red, using copper oxide, was similarly inspired by ceramic pieces already made for centuries in the Islamic world from Arab Spain to Persia.

CERAMICS UNDER THE MING DYNASTY (1368–1644)

Under the reign of the Ming, porcelain ware made considerable headway. The domestic demand for it was growing, and never had there been so many collectors and knowing enthusiasts. Outside China, admiration for Chinese porcelain was spreading, with Europe shortly to become a

major customer. The imperial government continued its development of state workshops, employing slave labor, but the private ones were staffed with journeyman workers. This dynasty's special interest in porcelain manufacture becomes apparent from its founding. In 1369 the emperor Hung-wu made Chingtechen an imperial pottery works, directly responsible to him. Not long after this, an edict was promulgated threatening with death anyone who manufactured polychrome porcelains outside the government workshops. In this way, all production became a government monopoly. Both Lung Ch'üan and Chingtechen were affected, the latter soon possessing 3000 government workshops and extending over an area of nearly four square miles.

Although the vogue for monochrome pieces remains, an ever larger part of production is given over to more elaborate decoration. Porcelain ware of underglaze blue continues the technique inaugurated in the preceding dynasty and attains exceptionally fine quality, which is maintained nearly to the close of the dynasty. There is some falling off in the second half of the sixteenth century, but by the close of the seventeenth and the beginning of the eighteenth a very high standard is once again reached.

Porcelains decorated in enamel colors enjoy a growing vogue, the painting in two colors being completed by blue underglaze effects. Especially prized is the *wu-ts'ai* so-called five-color ware (which merely means there are more than three colors), with or without underglaze blue. One especially remarkable technique known as *tou-ts'ai* or "contrasting colors," consists of placing the enamel colors within spaces defined by drawing in underglaze blue.

At the close of the dynasty, "biscuit china" makes its appearance. This is porcelain which has been baked before glazing, decorated in enamel colors.

Among the monochrome porcelains, the most famous are the China or Fukien Whites produced at Te-hua, exceptional for the whiteness of their body and glaze: small figurines, cups, bowls, and vases.

The kilns at Chingtechen also turned out whites of extremely fine body, and a very few much sought-after reds based on copper oxide, the difficult technique of which soon had to be abandoned. Though porcelain production was most important under the Ming, we should not pass over the pottery and stoneware without mention. Of the latter, the most highly valued pieces seem to be the *san-ts'ai*, "three-color ware." Manufactured in North and Central China, the surface of these is covered with medium-fired glazes.

CERAMICS UNDER THE CH'ING (1644–1912)

Production was slowed down by disturbances attending the fall of the Ming Dynasty and the conquest of China by the Manchus. Chingtechen, where only pottery workers lived, had risen against the imperial officials in 1602 and was all but destroyed in 1673. A few years later, however, when Manchu power was secure and its leaders had become fully Sinicized in their tastes, the emperor K'ang Hsi (1662–1722), who was a great art lover, decided to rebuild the town and its industry. By the close of his reign, early in the eighteenth century, about 3000 kilns were back in operation at Chingtechen and the former government monopoly over the production of polychrome porcelain had been lifted.

In the imperial pottery works the principle of the division of labor was carried quite far, certain pieces passing through as many as seven different operations from the first mixing of the paste to the final inspection of the finished piece. This last was still very strict, at least down to the middle of the eighteenth century, the proportion of pieces scrapped remarkably high.

Now the European countries, whose sea trade with China was steadily growing, became buyers in quantity. In the eighteenth century most of them, including France and Great Britain, bought directly in the Canton market, where Chinese porcelains enjoyed particular favor. European taste was sensitive to the quality of Chinese porcelain, and there were a number of attempts—at Meissen, for example—to imitate it. Nonetheless, Western appreciation, for all its warmth, rests on criteria remote from those of the Chinese collector.

Europe has always emphasized the exotic aspect of Chinese ceramics, summed up in the term *chinoiserie*, and has always thought of them as curios, as bric-a-brac for the boudoir. Vases and cups are adapted to current fashion by being given elaborate mountings in gilt bronze. Whereas the Chinese concept of decoration stresses spaciousness, balance, and harmony—even where the most provocative color combinations are involved—Western taste has a tendency to crowd, complicate, and overelaborate its designs, a tendency that Chinese production has often reflected in its attempts to satisfy the foreign market.

At the close of the eighteenth century a series of internal crises and the growing decadence of the Manchu court begin to be reflected in ceramic production. No longer capable of invention, caught up in the toils of his own technical

virtuosity, the ceramicist begins to imitate bronze, wood, ivory, stone, bamboo, precious metals, etc.

At the start of the dynasty, however, under the emperors K'ang Hsi and Ch'ien Lung, considerable advances were made in technique and works were produced that have never been surpassed or even equaled for the quality of their execution. Color comes into its own as never before or since: the monochrome hues, as well as the enamel colors in polychrome decoration, are extraordinarily rich. From the deepest black to the purest white, research into the subtlest nuances was vigorously pursued. Their virtuosity on the score of color made it possible for the Ch'ing ceramicists to re-create every earlier achievement in the art: the celadon, Chün, Ting, and Kuan ware of the Sung Dynasty; and the white, copper red, blue-and-white, and red-and-white underglaze ware of the Ming.

And yet dazzling though the best Ch'ing pieces are—often superior in execution to their models—their very conception betrays a lack of the truly creative genius. What had been achieved under conditions of controlled experiment, letting natural forces have their way at this-and-that stage of the modeling and firing, now became a matter of laborious calculation. Enormous effort was spent in reproducing certain oxidation effects, such as the dark spots of cobalt blue that embellish the underglaze blue in Ming pieces. By carefully modifying the composition of the glaze, in conjunction with elaborately calculated coolings, the crackle patterns of Kuan and Ko ware were repeated. The thick, bubbly glaze of Chün ware was reproduced. Porcelain versions of T'ang earthenware and stoneware were turned out in the same lively colors. It was even possible to imitate successfully the well-nigh imperceptible irregularities of certain Ming whiteware. On close inspection, however, the eye detects something mechanical in such technical virtuosity, a kind of standardization in the production of *accidental*

effects, which derives from the fact that these works were conceived of as copies, not as original works.

Nonetheless, pieces were produced at the very beginning of the Ch'ing Dynasty that are great because of the originality of their colors and decoration. Besides monochrome pieces in deep blacks, yellows, greens, and blues of the most striking intensity and originality of hue—achieved by superimposing one enamel on another—we also find monochrome pieces of true enameled ware. This last constitutes the most famous production of the reigns of K'ang Hsi, Yung Cheng, and—but now decline sets in—Ch'ien Lung.

In the West this type of ware has been classified according to "families." Under K'ang Hsi a *famille verte*, named for the particular hue of green employed, continues the tradition of Ming polychrome porcelains—the five-color ware, or the red-and-green—but the underglaze blue now gives way to a blue enamel.

In the *famille rose* produced under Yung Cheng, the characteristic, lovely purplish pink has been achieved through use of an enamel on a gold chloride base discovered in the seventeenth century by the Dutch chemist Cassius; the Chinese began to import it toward the close of the K'ang Hsi reign. Further, during the eighteenth century a number of highly painstaking small pieces were made in which the porcelain body has been left wholly or partially bare. These are the biscuit enamels, which often achieve extreme refinement, attesting to the ease with which the hardest technical problems were solved.

In decoration, the eighteenth-century porcelains are frequently inspired by painting. Some vases, but cups most especially, are often covered with what amount to real paintings; these are done with enamel colors, but they frequently recall the brush. Attempts were even made to reproduce the effects of watercolor. Frequently such pieces are signed, as paintings in China are, with a short poetic phrase in written characters, and the artist's seal in red.

Chinese Ceramics

PLATES

1. Funerary vase

Neolithic era, end of third or beginning of second millennium
Decorated earthenware
Height: $14^1/_8$ inches
Origin: Pan Shan, Kansu province

This vase was used to hold grain which the deceased would need for survival in the afterlife. Before firing, the body was given a thin coating of slip (clay in a nearly liquid state) so there would be an even background for the energetic decoration painted in vegetable colors. The ornamental motifs include a trellis pattern, spirals, triangles, and wavy bands which symbolically evoke the themes of death, fertility, and renewal.

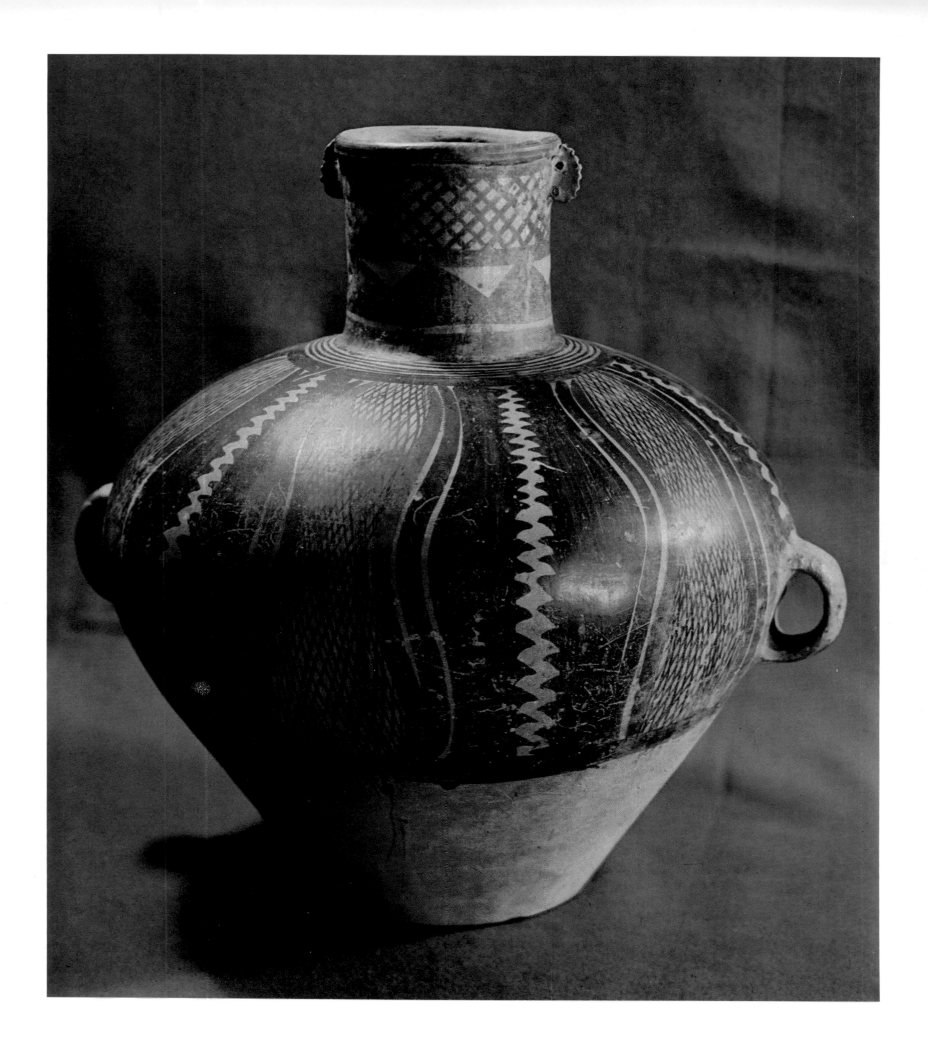

2. Funerary vase

Neolithic era, end of third or beginning of second millennium
Earthenware, incised and raised decoration
Height: 15 3/8 inches
Origin: Shantung province

This oddly shaped container for heating liquids is actually a *li*, a tripod, in form recalling two types of ceremonial bronze common from the Shang Dynasty onward. The base is a tripod, and the upper part recalls the *chüeh* type of libation bowl with its thinly tapered legs and a pouring spout.

The handle of the piece imitates basketwork. The simple decor consists of some incised lines and some raised bands.

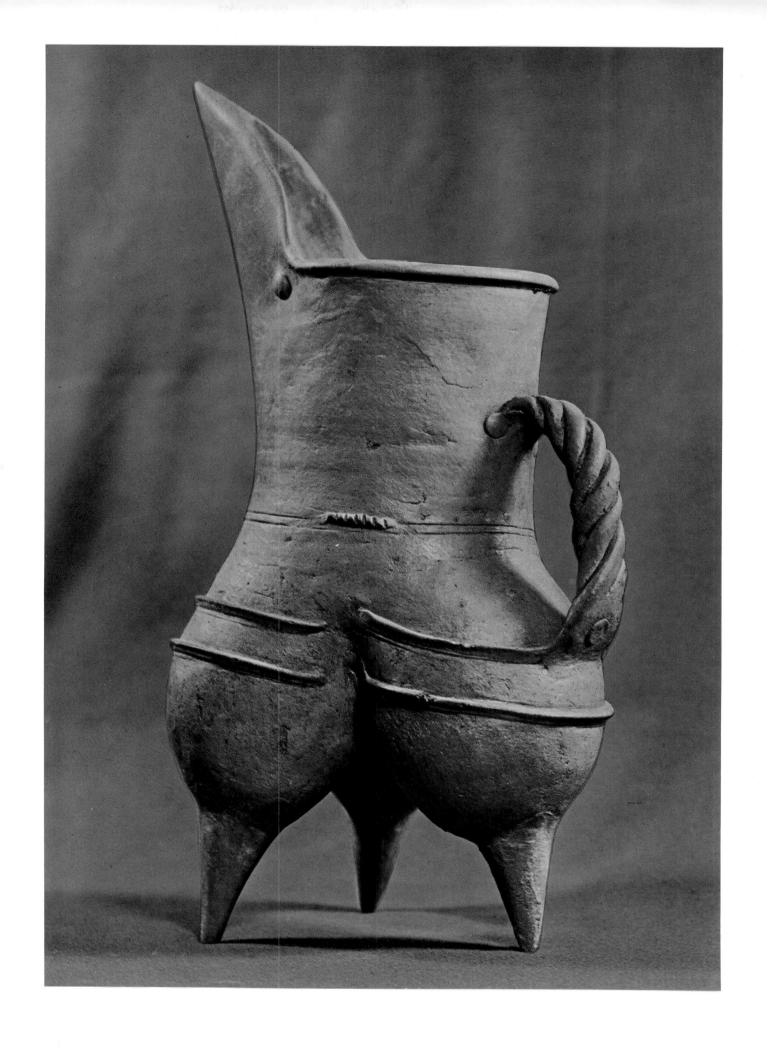

3. Ram, and genie riding a chimera

Western Chin Dynasty (256–316)
Glazed porcelaneous stoneware, with incised decoration
Height of ram: 5 ³/₈ inches ; height of genie: 11 inches
Origin : Chekiang province

These two pieces attest to the progress made by Chinese potters during the early centuries of our era. They are very early examples of what later came to be known as Yüeh ware.

The body has been almost entirely vitrified in the course of a relatively high firing. The feldspathic glaze colored with iron oxide has produced two somewhat unlike tonalities. The brownish coloring of the piece on the left indicates oxidation firing; that on the right, which has received a reduction firing, comes close in color to the celadons of later periods. Pieces of this type are sometimes called "proto-celadons."

The curious figure riding the chimera (a mythical, grotesque yet unferocious lion) was like the latter supposed to dispel evil spirits, especially when lighted sticks of incense were stuck in its hat.

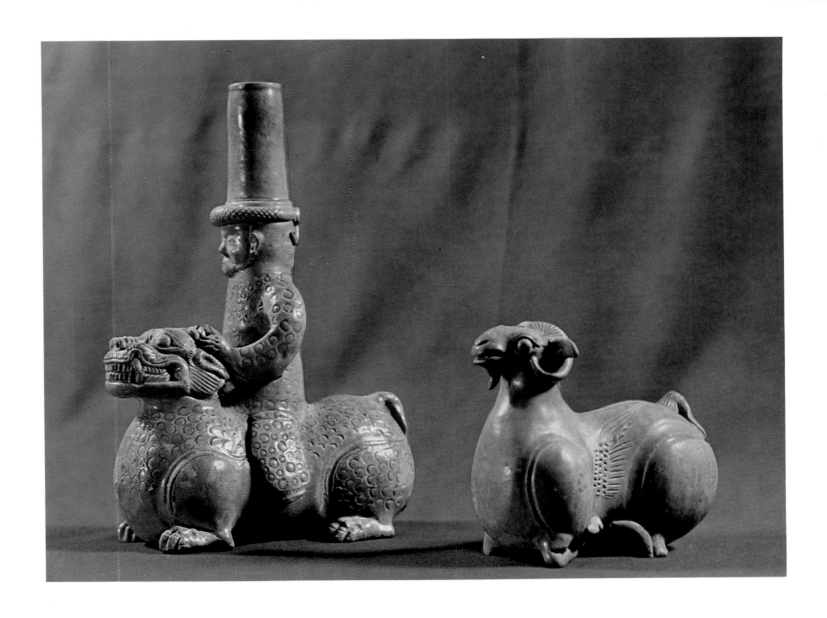

4. Wine decanter

Eastern Chin Dynasty (317–419)
Porcelaneous stoneware, with blackish glaze
Height: 6 inches
Origin: Chekiang province

This extremely rare piece is related to the two just preceding. Like them, it is stoneware with a feldspathic glaze colored with iron oxide, of the type called Yüeh ware. The blackness of this highly fired piece is caused by intense oxidation. In shape it seems based on a Persian model which, in turn, had drawn on Hellenistic influences.

In the opinion of some, the rooster's head that ornaments the spout may have been borrowed from Persian art. The rooster appears on many Western Asiatic art objects and was sacred to Zoroastranism. The rooster appears very early as an emblem in China, however, its name, *chi*, is homophonous with the character conveying "propitiousness." In ceramics of later periods the rooster frequently appears, for example on tiny, extremely delicate, very carefully made wine cups that may have been intended for use in marriage ceremonies (see Plate 19).

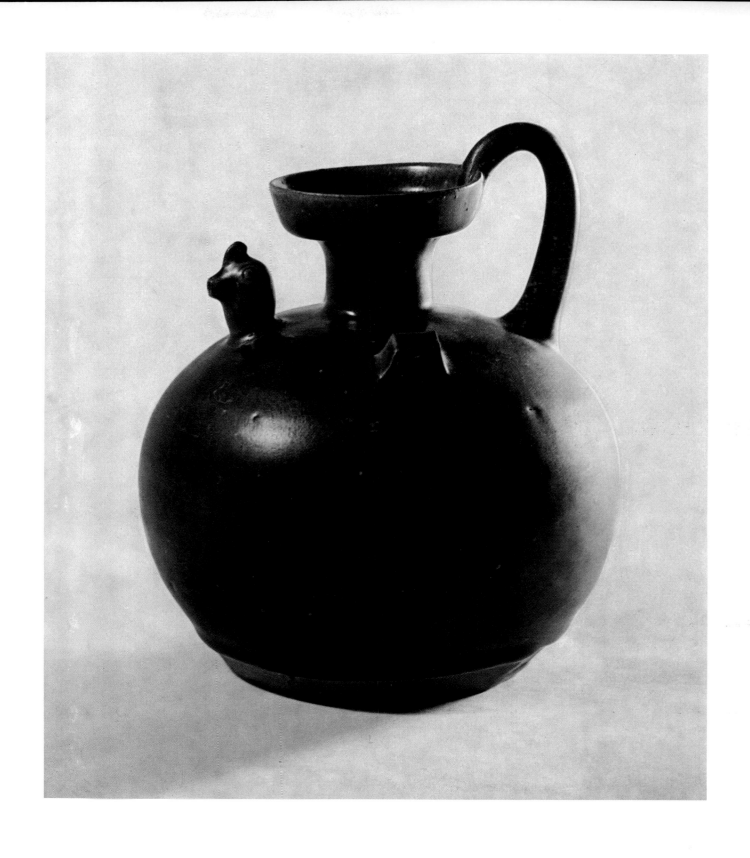

5. Tall funerary vase

Northern Ch'i Dynasty (550–577)
Glazed gray earthenware, decorated in high relief
Height: 22 inches
Origin: Funghsien, Hopeh province

In its fundamental lines, this tall funerary vase is related both to the bronzes of earlier periods (those of the Han Dynasty, especially) and to various types of later vases known in the West as "trumpet" or "baluster" vases, such as were made under the Ming and Ch'ing dynasties, most notably.

In the decoration we glimpse the impact of Buddhism, which reached the west and the north of China through Central Asia. The lotus, Buddhist emblem of purity, from this period on provides the decorative theme in many ceramic works. This vase is contemporary with the spread in China of the worship of Kuan Yin, goddess of mercy or compassion, the basic text for which was "The Lotus of the Good Law."

The eight medallions on the neck of the piece, depicting young dancers, recall certain sculptures in the round from the cave-sanctuaries of North China and Central Asia itself. The glaze is finely crackled all over.

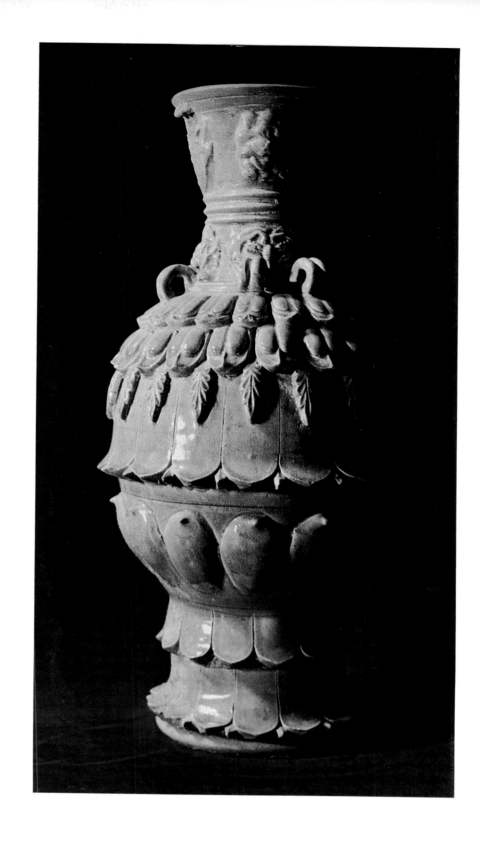

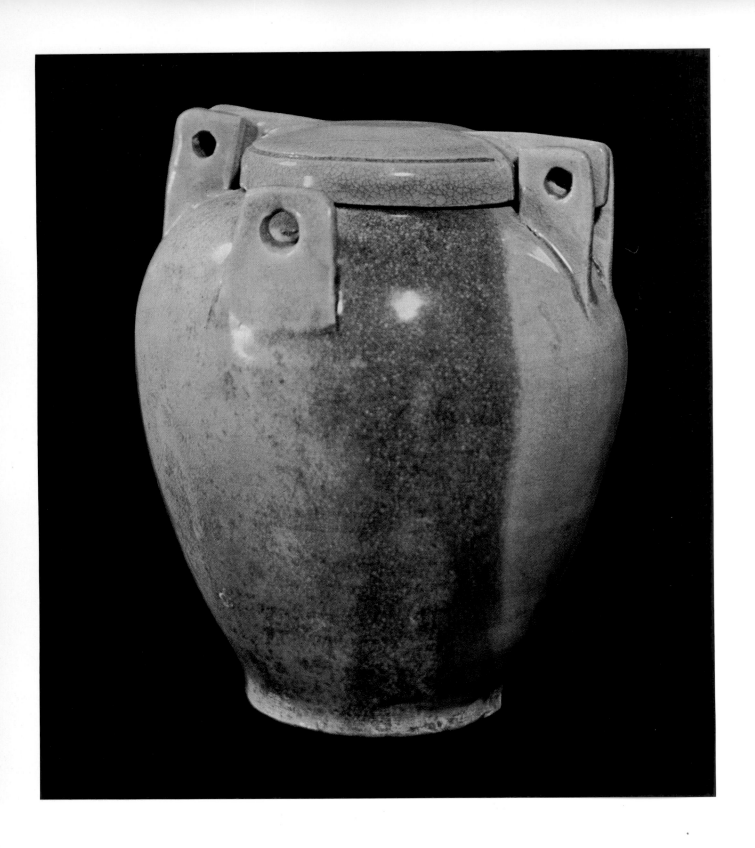

6. Small jar with lid

T'ang Dynasty (618–907)
Stoneware, with crackle glaze
Height: 7¹/₈ inches
Origin: Panyiu, Kwangtung province

The lid of this little jar is held fast in an unusual way: two studs fit into two slots on the shoulder of the piece, and there are holes for tying the lid on with cord. No doubt an object intended for use, this may have been a wine jar.

The body, which is of stoneware, has been colored with iron oxide. The big brownish spot may be due to time or weathering.

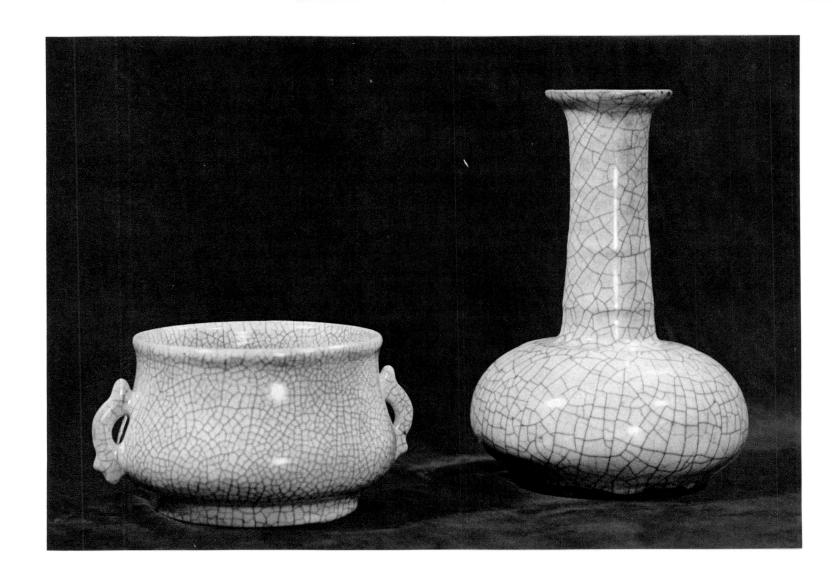

7. Kuan vase and incense burner

Sung Dynasty (960–1279)
Porcelaneous stoneware, with gray-blue crackle glaze
Height of vase: 8 inches; height of incense burner: 3 ³/₈ inches
Origin: Lung Ch'üan, Chekiang province

These two outstanding pieces illustrate the refined, elegant simplicity characteristic of the great potters of the Sung period. Glazing techniques had now reached their peak, and these pieces are incomparably delicate, unctuous, and jadelike to the touch.

It is supposed that these pieces originated at the imperial kilns in Lung Ch'üan, which worked for the court. Hence the name *kuan*, meaning "official," which is usually given them. The fine crackle of the glaze here is the result of lengthy experiment and is a source of keen aesthetic pleasure to the Chinese connoisseur for the images and analogies it suggests.

In shape, both vases go back to bronzes of the early periods, greatly admired by the literati of the Sung period. The little incense burner is a modified replica of the type of bronze called *kuei;* the vase-bottle recalls a bronze of the Han Dynasty. The flattened shape of the body is traditional, whereas the oval or rounded bottles have been copied from models originating in parts of Western Asia within the Roman Empire.

The term *ko*, meaning elder brother, is sometimes assigned pieces with this type of glaze, though the origin of the term is uncertain. Possibly it was associated with the production of the elder of two brothers who worked at Lung Ch'üan. Some Chinese specialists maintain that subtle variations in the crackle distinguish Ko ware from Kuan ware, the latter having a larger, less dense pattern.

8. Chün vase

Sung Dynasty (960–1279)
Porcelaneous stoneware, with copper oxide glaze
Height: 7¹|₄ inches
Origin: Honan province

Chün ware has a splendid bluish or blue-lavender glaze spattered with one or more areas of a lovely purple red. Copper oxide comes out blue in the course of a reduction firing, turns red with oxidation.

The unctuously thick glaze of the Sung Chün ware has many tiny holes and gives an impression of depth and life. It is this that one misses in the otherwise remarkable eighteenth-century copies of the ware.

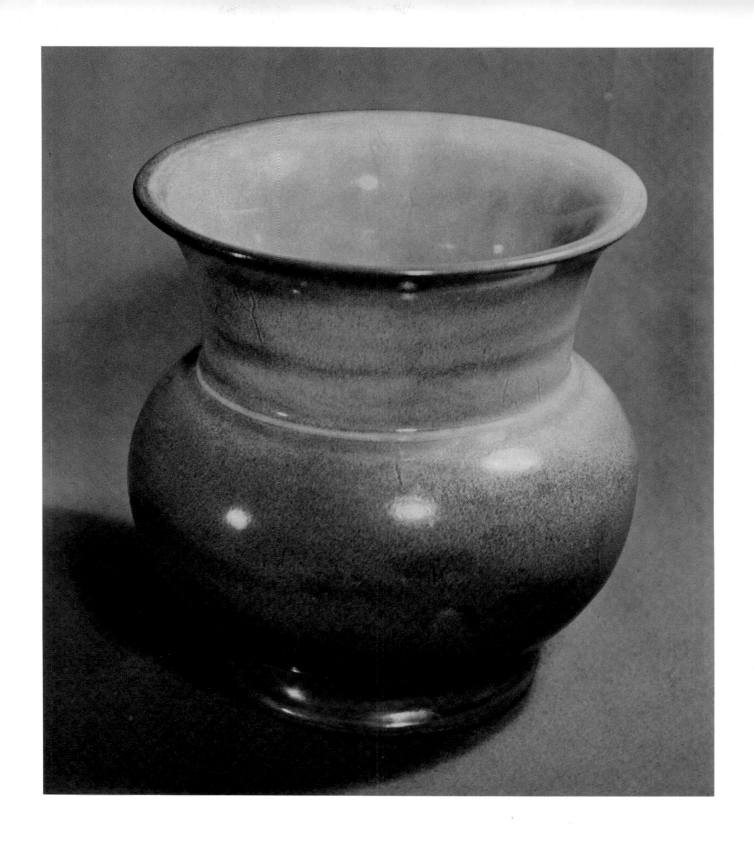

9. Vase for fruit blossoms (Ting ware)

Sung Dynasty (960–1279)
Fine porcelain, flower decoration incised under a cream glaze
Height: 17³/₄ inches
Origin: Tsingyuan, Hopeh province

This very lovely vase was made to hold one large branch of a fruit tree in blossom (and no more than one), and to create a harmonious whole with it.

The blossoming fruit tree symbolizes the end of winter and the promise of spring. A vase to hold such blossoms must in shape, material, and decoration contribute to a subtle evocation of buds bursting with the last snows still on them or melting in the first warm sunshine.

The body of Ting vases is of extremely fine-textured porcelain, over which a magnificent ivory or cream glaze is spread. Depending on the firing, in transparency it sometimes takes on a faint orange or bluish reflection. Under the glaze a decoration—finely incised, engraved, or in shallow relief (see the following plate)—can just barely be made out, sometimes only under certain lighting conditions. When it can only be made out by holding the piece against the light, it is spoken of as "hidden decoration," a technique at which Sung and Ming potters excelled.

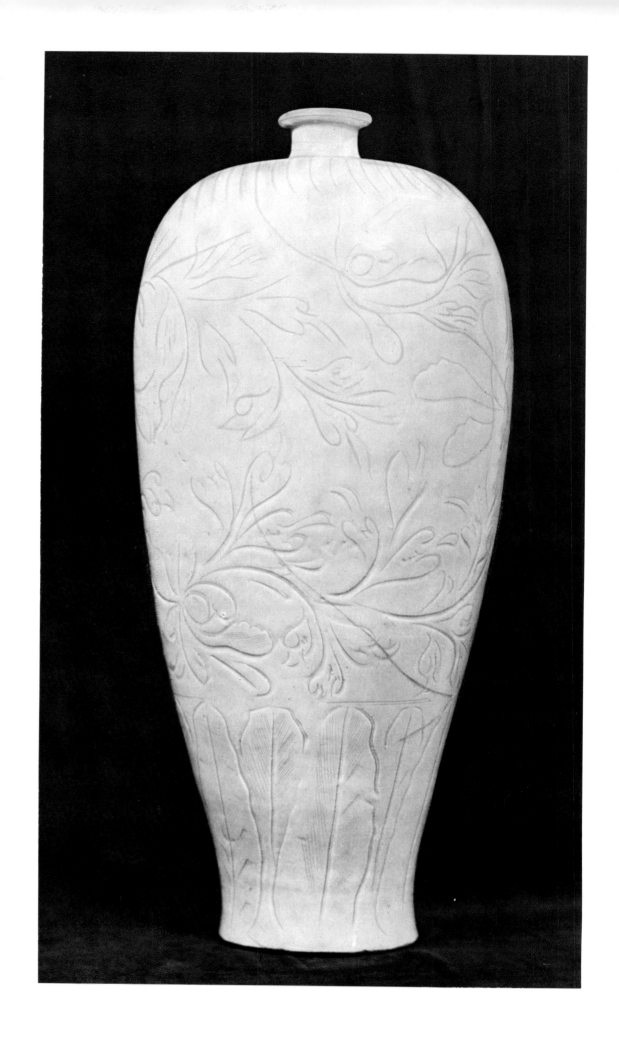

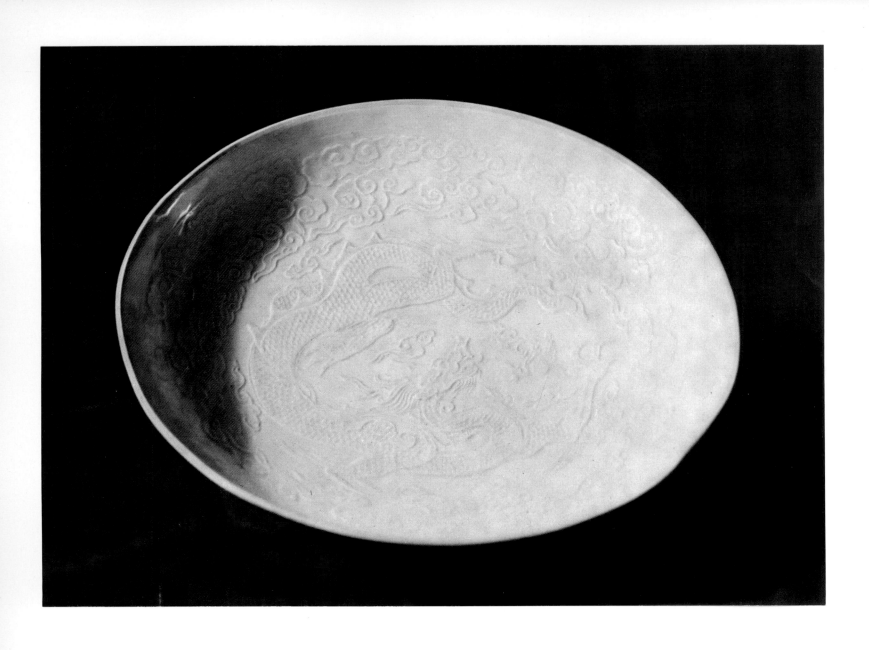

10. Ting bowl

Sung Dynasty (960–1279)
Fine white porcelain, shallow relief decoration under glaze
Diameter: 9 inches
Origin: Tsingyuan, Hopeh province

Similar in body and glaze to the preceding piece, this bowl differs in its decoration: it has not been incised but modeled in shallow relief. The theme of the dragon, emblem of power, playing in the water with a pearl goes back to ancient fertility beliefs, the cycle of the seasons, the coming of the first storms heralded by thunder and life-giving rain.

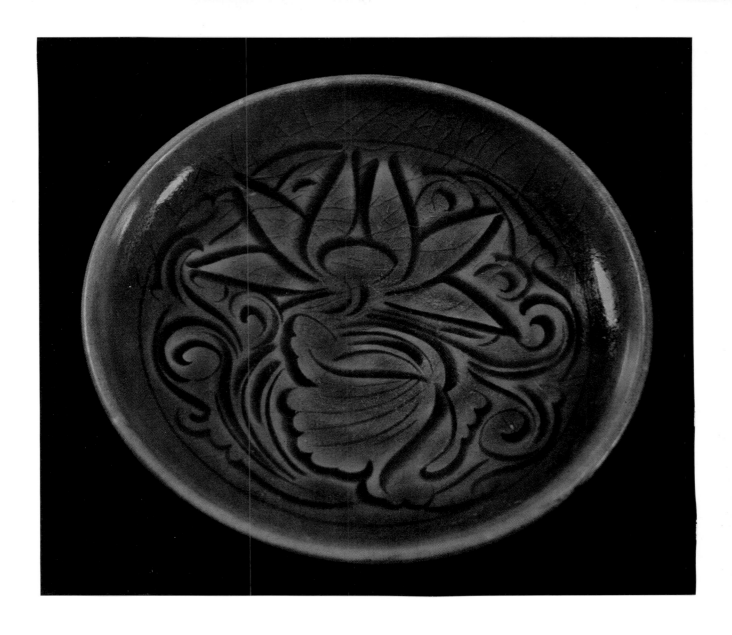

11. Dish (celadon "of the North")

Sung Dynasty (960–1279)
Porcelaneous stoneware, incised peony underglaze decoration
Diameter: 7 1/8 inches
Origin: Tungchou, Honan province

This bowl differs from the preceding piece in the technique of decoration—a single, vigorously incised peony of great elegance. Within the incising the thickness of the glaze produces an interplay of highlights and shadows.

12. Peony vase (celadon "of the North")

Sung Dynasty (960–1279)
Glazed porcelaneous stoneware, peony decoration in relief and slightly incised
Height: 7³/₄ inches
Origin: Tungchou, Honan province

Celadons from the Sung period are extremely rare. This piece is a fine example of the northern variety, which differs from the southern in color of glaze and, often, in the spirit with which they have been shaped. Potters of the North, no doubt for technical reasons, did not as a rule carry reduction of copper oxide so far in the course of the firing, so that the glazes came out one or another shade of olive green.

In the South, reduction firing was carried further and produced greens of more varied, often faintly bluish shades. The potters of the North seem to have sought to achieve an impression of vigor and plenitude in their choice of shapes, whereas those of the South were primarily concerned with purity and elegance of line.

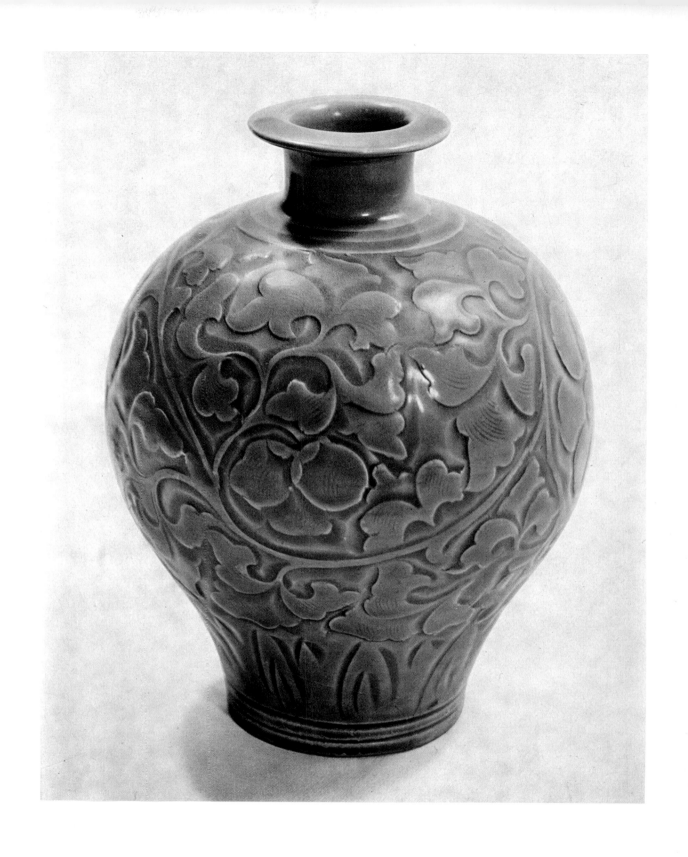

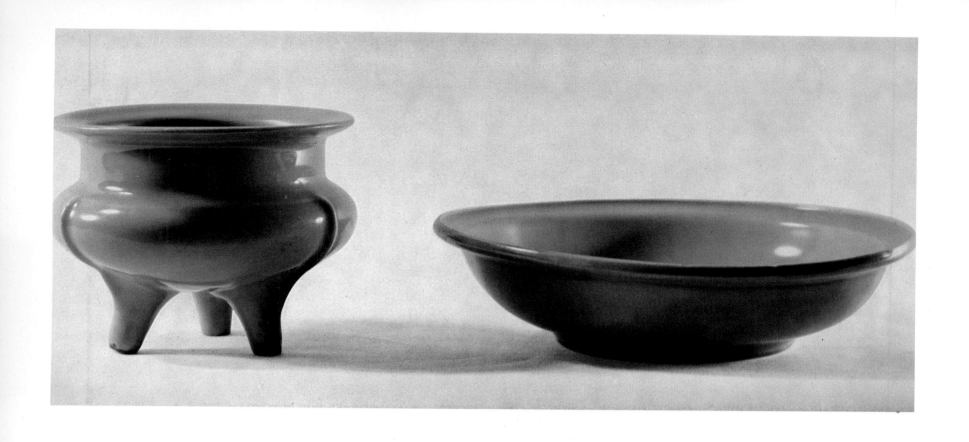

13. Bowl and *li*-shaped incense burner (celadons "of the South")

Sung Dynasty (960–1279)
Porcelaneous stoneware with celadon glaze
Diameter of bowl: 10 7/8 inches; height of incense burner: 5 inches
Origin: Lung Ch'üan, Chekiang province

These pieces show Sung ceramics at their peak. The simplicity of shape and sober restraint of decoration focus attention on the superb glaze, which here attains perfection.

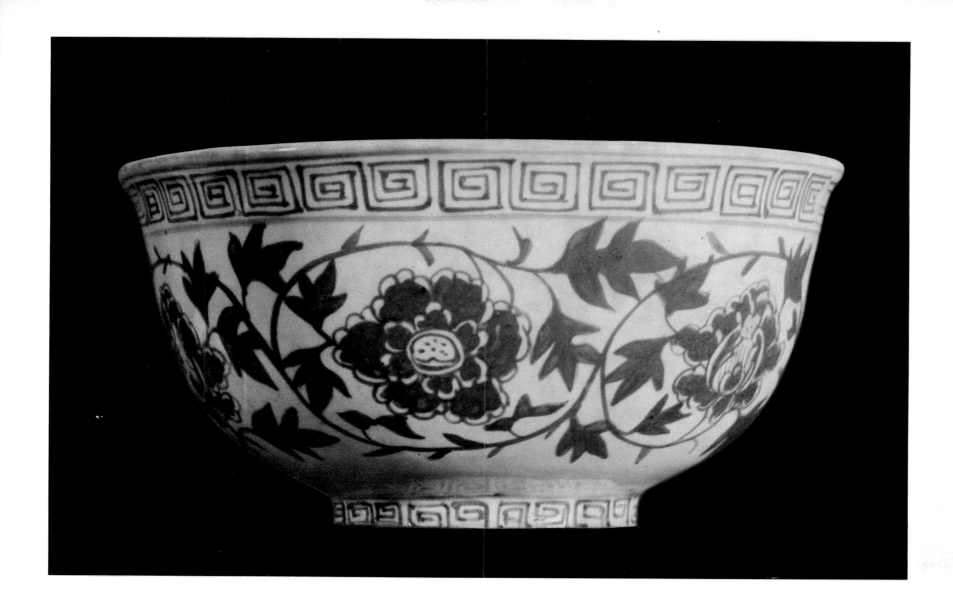

14. Bowl

Yüan Dynasty (1279–1368)
Glazed porcelain, with underglaze peony decoration
Height: 3 ⁷/₈ inches
Origin: Chingtechen, Kiangsi province

This piece is one of the rare surviving examples of the earliest porcelains painted in underglaze copper red. The technique involved is the same as for the blue-and-white. In this case the color appears to have set imperfectly and been given a bluish tinge by the glaze itself. Copper red began to be used under the Yüan, and we find it as late as middle Ming. It is technically difficult to control and eventually an iron red was substituted for it, which we find in use down to the eighteenth century. It may be that use of copper red, which we also find on the lusterware of the Arab world from Spain to Persia, reached China from the West. In Moslem art of the finest period a coppery red tone was achieved with a film of copper silicate.

The border decoration is the *lei-wen*, symbol of thunder, sometimes called the Chinese version of the Greek key pattern. It appears in the Chinese vocabulary of ornament at every period.

15. Large dish with scalloped and ornamented rim

Yüan Dynasty (1279–1368)
Porcelain, underglaze blue decoration
Diameter: 18 inches
Origin: Chingtechen, Kiangsi province

Porcelains painted in underglaze blue made their appearance under the Yüan (Mongol) Dynasty. The Mongol conquests had the effect of reopening and increasing China's relations with the countries of Western Asia.

Persian ceramics, especially from Nishapur and Rhages, the ancient Media, seem to have inspired the Chinese potters. From the ninth century on, we find pieces decorated in cobalt blue with a technique already close to that of the Chinese blue-and-white. Cobalt was imported from Western Asia under the Yüan Dynasty and at the beginning of the Ming, and cobalt blue was thereafter known in China as "Mohammedan blue."

The blue-and-white decoration was painted directly on the unfired body, often with a coating of slip over it. The faintly bluish glaze over this gives depth and brilliance to the painted decoration.

The shape of the dish has also been borrowed from Persia. The raised rim made its appearance in China as early as the T'ang Dynasty, another period of Near Eastern influence. It is rare except on pieces manufactured for the Mongols or for export.

The decoration represents two fantastic animals, the phoenix and the unicorn, in a setting of clouds and flowers. It should be noted that a fantastic bird, the simurgh, appears on many Persian plates (whether in silver or porcelain) of the same period presented—as here—in a medallion and surrounded with floral themes.

The clouds are stylized: the "cloud streamers" motif is traditional in Chinese ornament. The two flames coming out of the unicorn's shoulders may also go back to some remote Persian origin; they are found in Sassanid sculpture and later in the Buddhist art of Central Asia and North China.

It seems probable that this piece dates from the very start of production at Chingtechen, which was before long to become the biggest ceramics center in China and in the world.

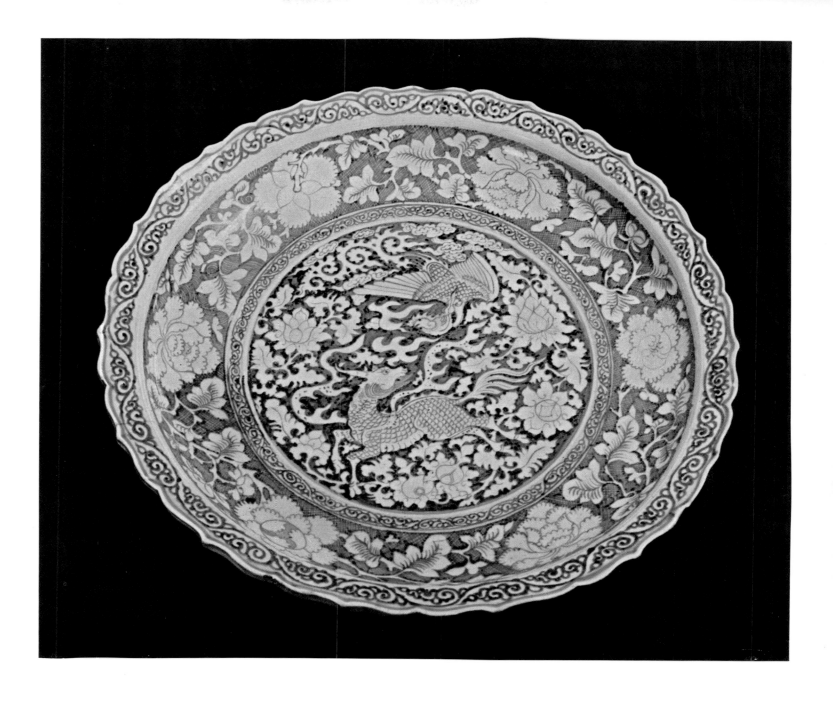

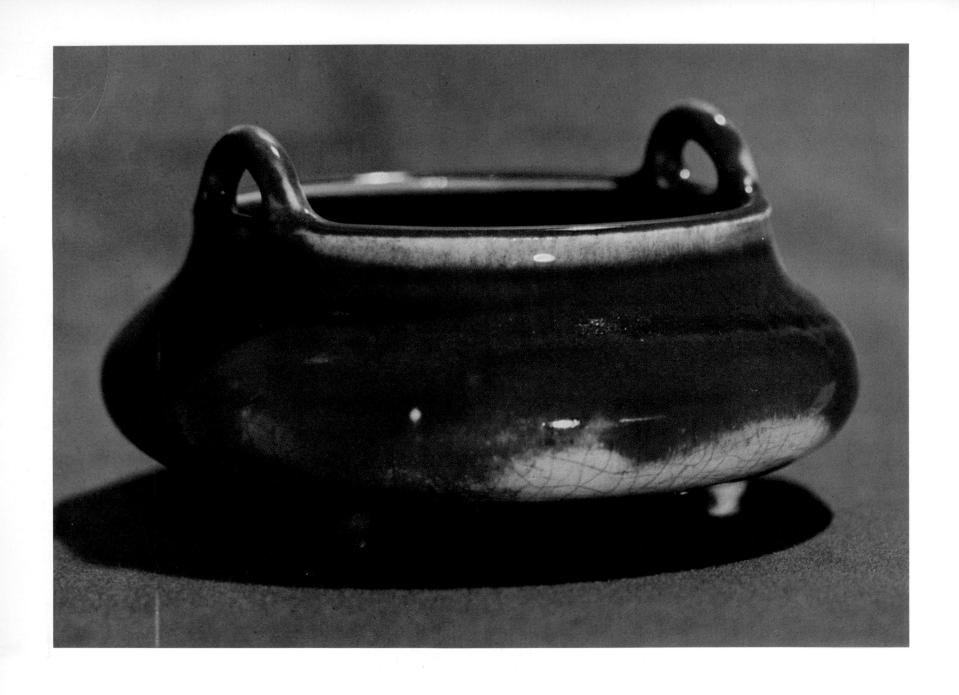

16. Incense burner

Ming Dynasty, Yung Lo reign (1404–1425)
Porcelain, underglaze red and white
Height: 3 inches
Origin: Chingtechen, Kiangsi province

This is an extremely valuable "copper red," scarcely known in Europe save by copies made in the eighteenth century under the Ch'ing Dynasty, sometimes designated by the term "oxblood."

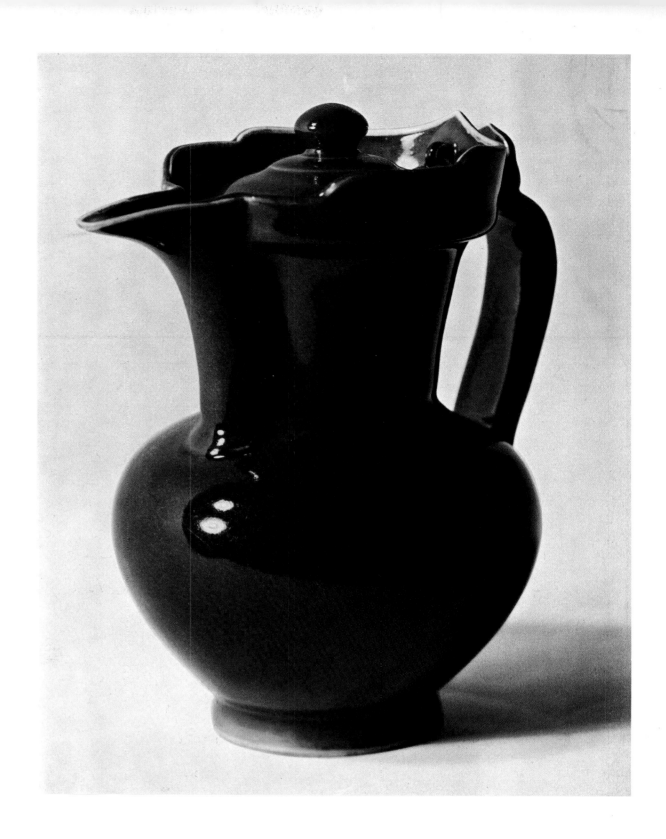

17. Ewer with lid

Ming Dynasty, Hsüan Te reign (1426–1435)
Porcelain, monochrome underglaze copper red
Height: 7¹/₂ inches
Origin: Chingtechen, Kiangsi province

This ewer had a place in Buddhist worship, as can be seen from the odd shape and lines of the upper part of the piece. These, together with the lid, suggest the ceremonial headgear of a high dignitary in the Buddhist church. This is one of the very few known examples of "copper reds" from the Hsüan Te period.

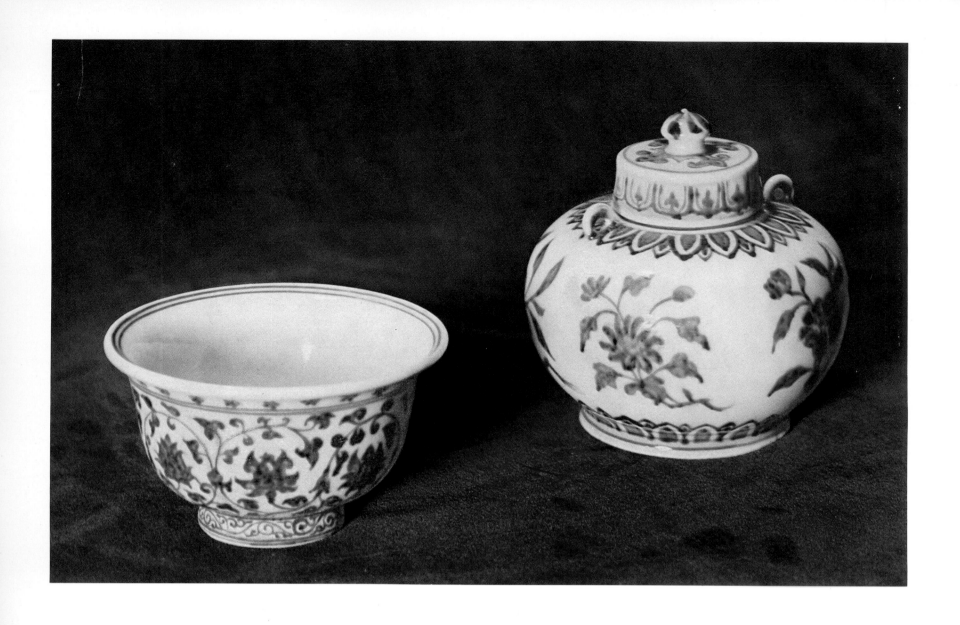

18. Cup and small covered jar

Ming Dynasty, Yung Lo reign (1404–1425)
Porcelain, with floral decoration painted in underglaze blue
Diameter of bowl: $3^1/_2$ inches; height of pot: $3^5/_8$ inches
Origin: Chingtechen, Kiangsi province

Only a few examples of blue-and-white ware with floral decoration from the Yung Lo period survive. Here we admire the elegance and vigor of the decoration, the brilliance of the white background, and the soft, faintly bluish glaze.

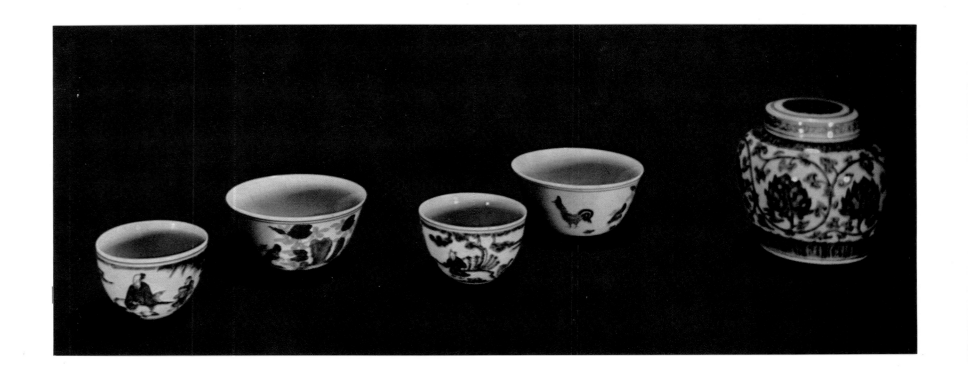

19. Four small cups and a small covered jar

Ming Dynasty, Ch'eng Hua reign (1465–1487)
Extremely thin porcelain, tou-ts'ai decoration of underglaze blue and enamel colors
Diameter of cups: 2³⁄₈ inches and 3¹⁄₄ inches; height of jar: 3¹⁄₄ inches
Origin: Chingtechen, Kiangsi province

Specialists and collectors agree that tiny pieces of this type, produced in the Ch'eng Hua period, represent the ultimate in porcelain refinement. Such pieces are rare in the West, and are best known through copies executed in the eighteenth century under the Ch'ing Dynasty.

20. Tall round-bellied vase and a covered jar

Ming Dynasty, Hsüan Te reign (1426–1435)
Porcelain, blue and white decoration of a dragon amid waves
Height: 17³/₄ inches
Origin: Chingtechen, Kiangsi province

Two more fine examples of Hsüan Te blue-and-white ware. The decoration, which is painted in slip, comes through very vigorously.

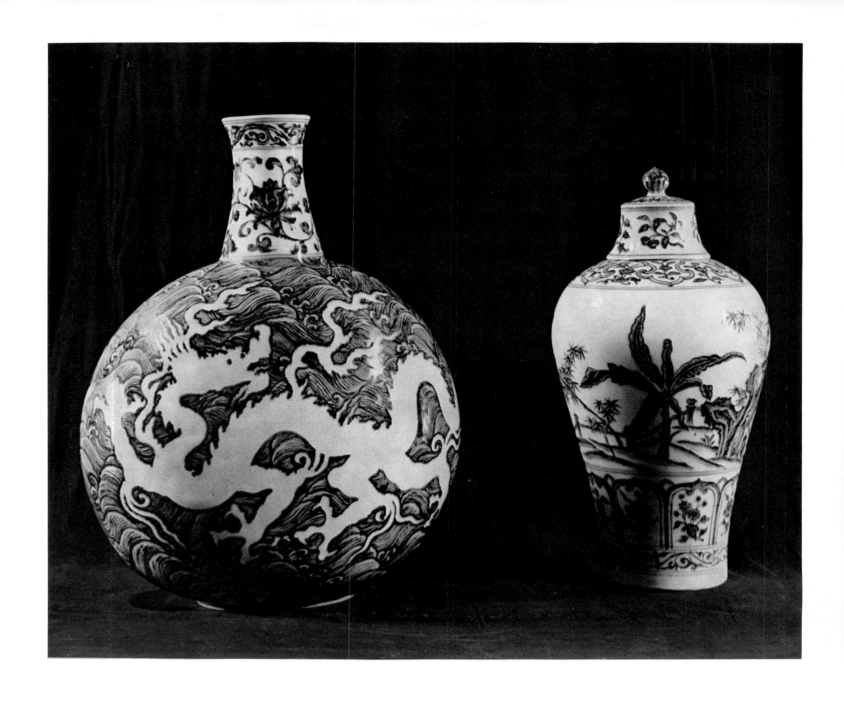

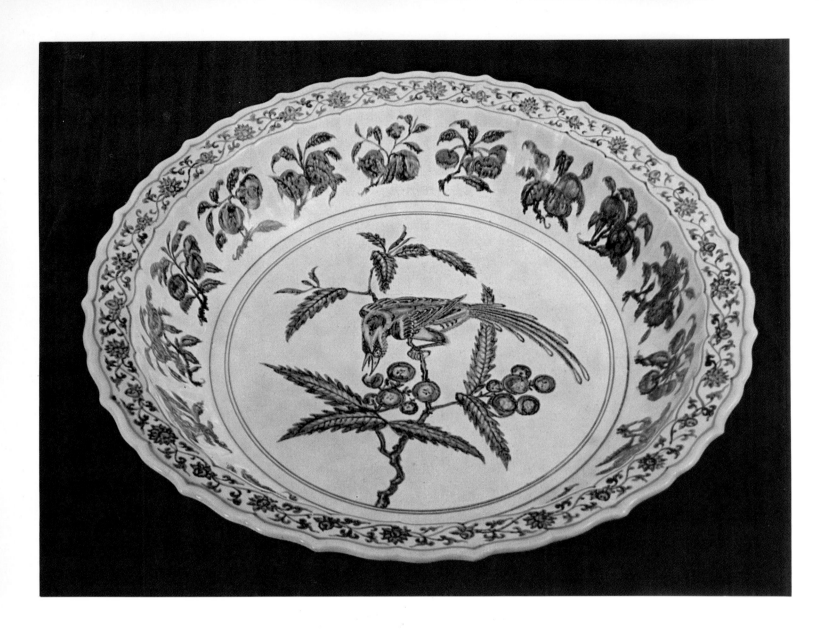

21. Large dish with scalloped and ornamented rim

Ming Dynasty, Hsüan Te reign (1426–1435)
Porcelain, with bird and flower decoration painted in underglaze blue
Diameter: 20 inches
Origin: Chingtechen, Kiangsi province

This piece, the shape of which recalls that with the phoenix and the unicorn pictured on Plate 15, is noteworthy for its balance, the elegance of its decoration, and the quality of the glaze.

A number of specialists believe that it was in the Hsüan Te period that blue-and-white ware attained its highest peak. Pieces from that period were frequently imitated later, even to the reproducing of certain oxidation effects, such as the blackish spots that occasionally appear within areas of blue.

The central theme in the decoration is a bird pecking at the fruit of a *p'i-p'a*, the Chinese loquat tree. What it expresses is a petition to some very high-ranking individual, which might be interpreted: "Do you suppose you could, like this little bird, pluck the fruit from the very highest branch?" The desire expressed is to be promoted to, or remain at, some high official post.

Pieces of this type were used as anniversary gifts and especially on a sixtieth birthday.

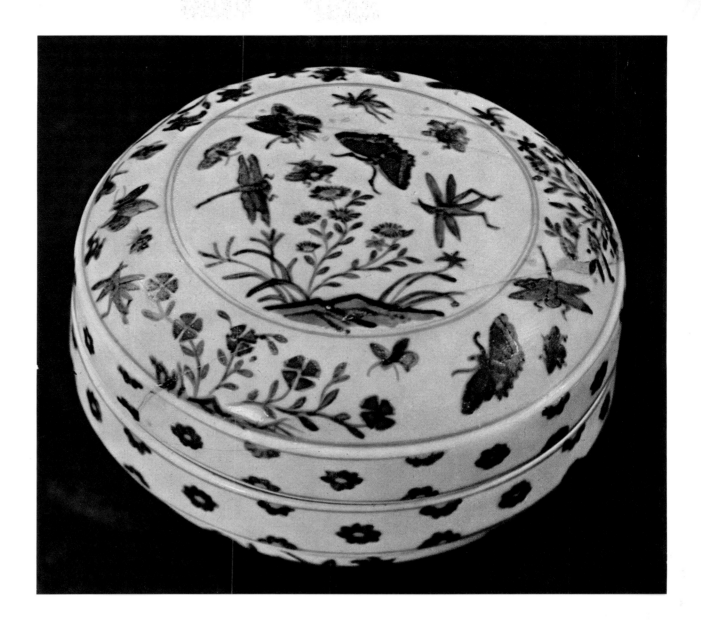

22. Cosmetic box

Ming Dynasty, Ch'eng Hua reign (1465–1487)
Porcelain, underglaze blue decoration with added enamel colors
Height: 3 1/8 inches
Origin: Chingtechen, Kiangsi province

Boxes of this shape were used to hold a red paste of semisolid ink for stamping and sealing purposes, and elegant women also used it to touch up their cheeks.

We are of the opinion that this particular piece was conceived for the latter purpose. The butterflies and dragonflies of the decoration, flying in pairs amid tiny blossoming carnations, give off an autumnal, feminine atmosphere. One may recall, for example, the lines from a famous poem by Li T'ai-po describing a young wife's longing for her husband who is far away:

> The eighth month of the year! Butterflies are skimming in pairs over the plants in the Western Garden!... The scene tears at my heart!

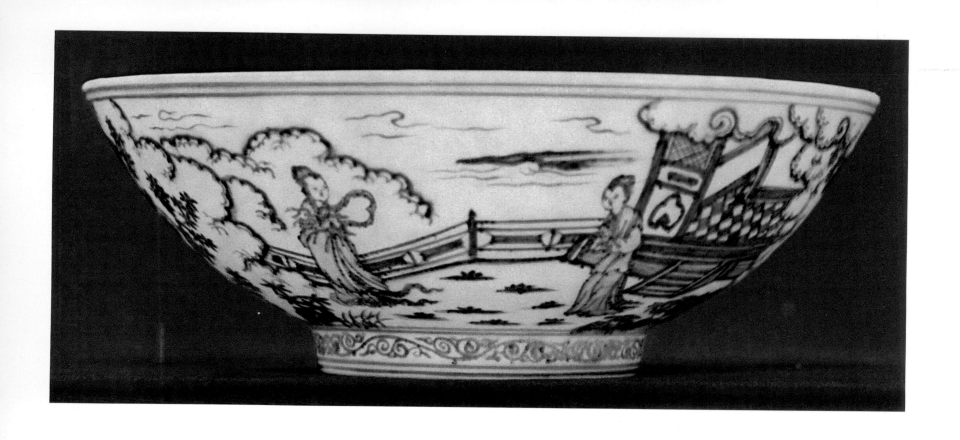

23. Large bowl

Ming Dynasty, Ch'eng Hua reign (1465–1487)
Porcelain, with underglaze blue decoration and red, yellow, and green enamel
Height: 7³⁄₈ inches
Origin: Chingtechen, Kiangsi province

This piece, which is of exceptionally fine quality, is an early example of *wu-ts'ai*, "five-color ware."

It was first fired with a portion of the decoration painted in underglaze blue, and then enamel colors were applied over the glaze. The yellow in the wing of the duck swimming among the lotuses is painted within an area drawn in underglaze blue: this is the technique known as *tou-ts'ai*, "contrasting colors." We should recall that a pair of ducks is a symbol of fidelity and that the lotus is a Buddhist emblem of purity.

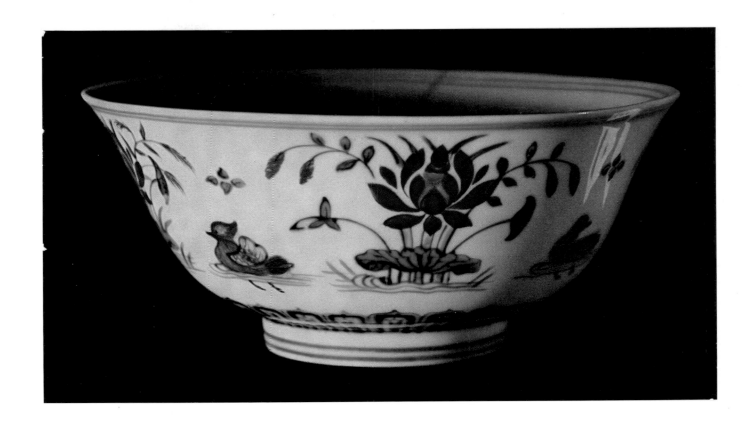

24. Large bowl

Ming Dynasty, Hsüan Te reign (1426–1435)
Porcelain wih underglaze blue painted decoration
Height: 7 5/8 inches
Origin: Chingtechen, Kiansi province

The decorative theme of "educated ladies" in a garden, rare in this period, was to be frequently treated
in the seventeenth and eighteenth centuries.

As with other blue-and-white ware of the Hsüan Te period, we admire the perfect execution, the
subtle tonalities of blue, and the delicacy of the glaze.

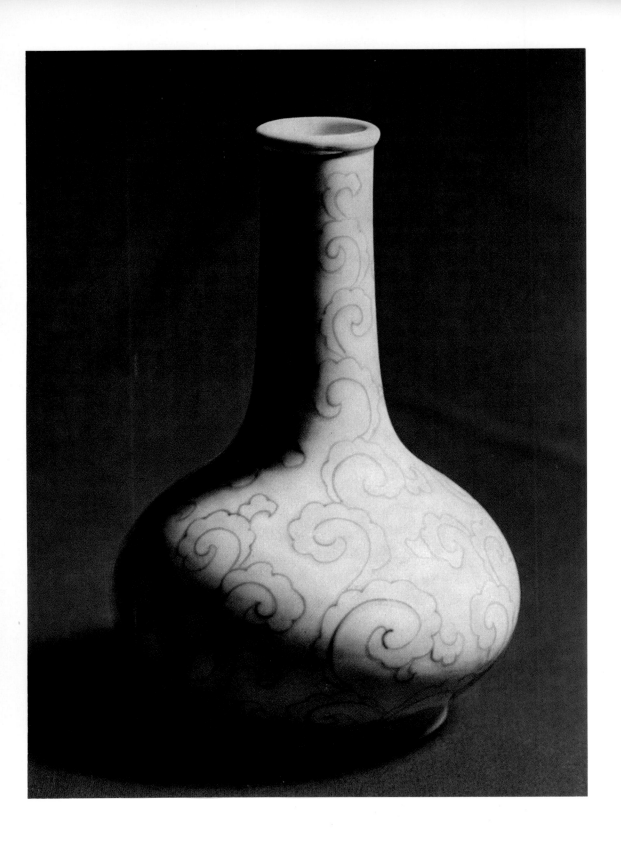

25. Vase

Ming Dynasty, Ch'eng Hua reign (1465–1487)
Porcelain, underglaze blue decoration and delicate enamel coloring
Height: 7¹⁄₂ inches
Origin: Chingtechen, Kiangsi province

This is a splendid example of the *tou-ts'ai* technique. The wavy streamers represent clouds, a form of ornament to be found with variations in all periods of Chinese art. Here they are treated with remarkable elegance. The outlines for the colors were drawn in underglaze blue, and the glaze itself is slightly bluish, over which the artist applied a delicate enamel.

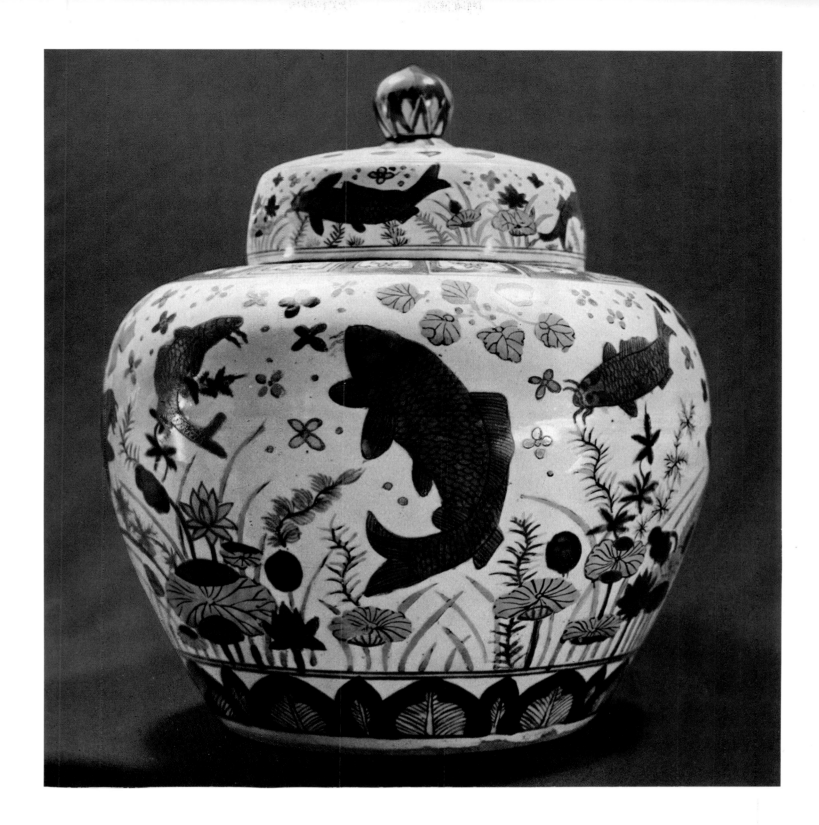

26. Wine jar

Ming Dynasty, Chia Ching reign (1522–1566)
Porcelain with wu-ts'ai *or five-color decoration*
Height: 17³/₄ inches
Origin: Chingtechen, Kiangsi province

This wine jar, executed with particular fastidiousness, is of a type to be used on festive occasions.

Some elements of the decoration were drawn in blue under the very pure glaze, and the artist added the enamel colors after the piece had undergone its first firing.

Traditionally, jars of this type are decorated with goldfish swimming among aquatic plants. The Chinese word for goldfish, carp, or any red fish evokes another word, also pronounced *li*, which stands for whatever is of good augury, auspicious in the sense of profit or success.

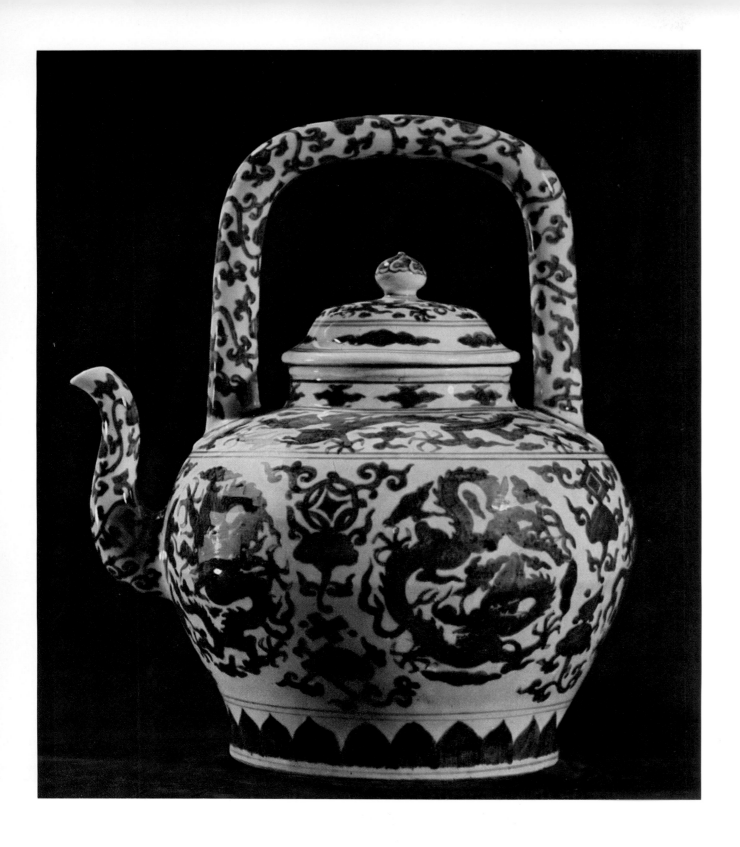

27. Hot-water pot

Ming Dynasty, Chia Ching reign (1522–1566)
Porcelain, with painted blue and white underglaze decor
Height: 11 ³/₄ inches
Origin: Chingtechen, Kiangsi province

This piece was designed to hold hot water for making tea. The decoration is very complex: imperial five-clawed dragons are set in medallions, and two other dragons extend in a frieze around the shoulder of the pitcher and the knob of the lid. Floral themes, consisting in part of lotuses and peonies, share the rest of the surface, along with various symbols. There are also some stylized bats, which (homophonically) evoke happiness.

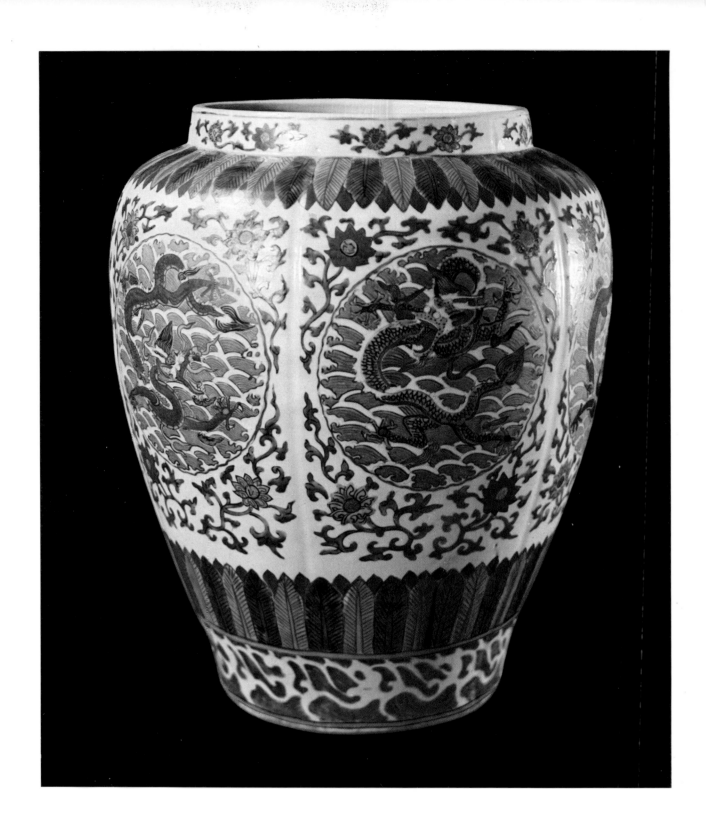

28. Vase

Ming Dynasty, Chia Ching reign (1522–1566)
Porcelain, with five-color enameled decoration
Height: 15 1/2 inches
Origin: Chingtechen, Kiangsi province

The vigorous decoration of this big vase incorporates such traditional themes as imperial five-clawed
dragons sporting amid waves, peony foliage, and stylized lotus blossoms.

29. Tall vase

Ming Dynasty, Wan Li reign (1573–1620)
Porcelain, with five-color enameled decoration
Height: 18¹/₂ inches
Origin: Chingtechen, Kiangsi province

In the Wan Li period, porcelains decorated in five-color technique reached the height of their development, though at the same time there was a falling off in quality of underglaze blue pieces. New shapes make their appearance which link up with developments in the following Ch'ing Dynasty. Such is the case with this vase, known as a "trumpet" vase in the West. The decoration combines a number of traditional themes: flowers on trellises, lotus borders, five-clawed dragons in medallions, cloud streamers, and peaches—symbol of long life.

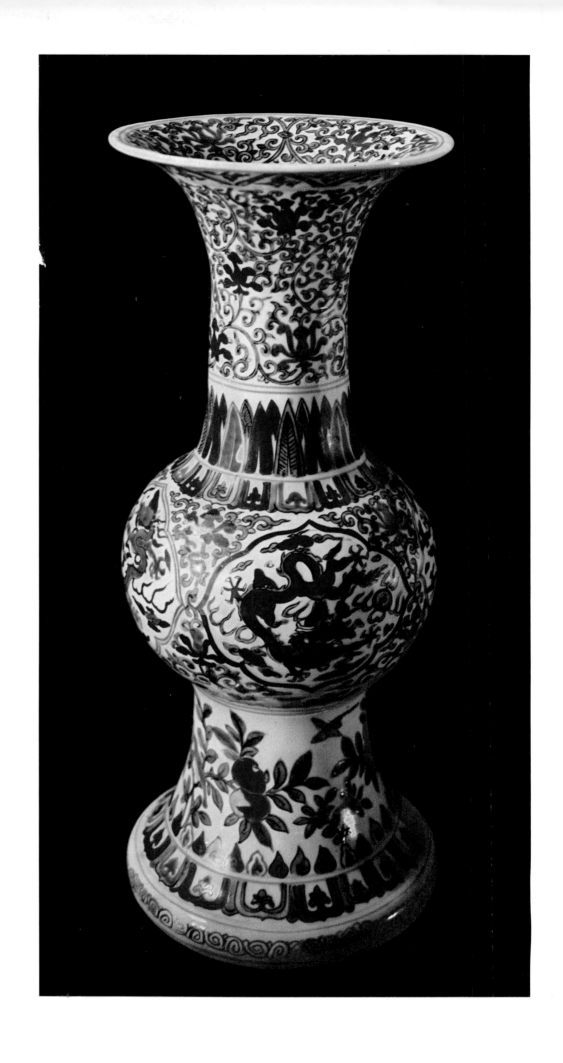

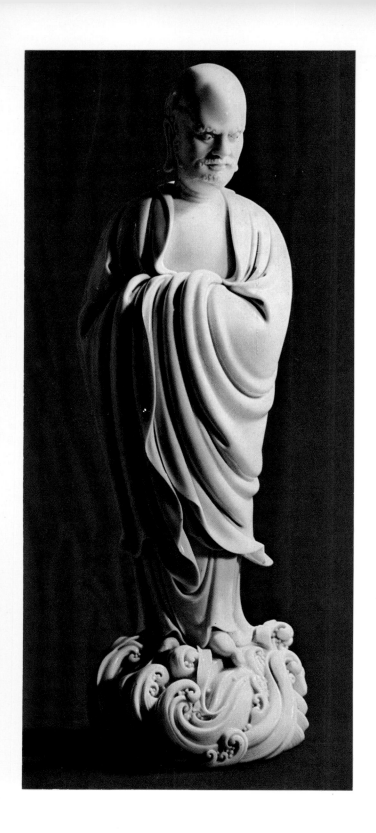

30. The patriarch Tamo Bodhidharma

Ming Dynasty (1368–1644)
Porcelain
Height: 16⁷/₈ inches
Origin: Te-hua, Fukien province

This little statue, probably made in the sixteenth century, is a fine example of what we in the West call "China white" or "Fukien white." The very thin porcelain is covered with a carefully prepared glaze—or successive glazes—so as to blend perfectly with the body of the piece. The eye cannot discover where, at any point, glaze and body meet.

Bodhidharma, whose full name means "Supreme in Knowledge and Doctrine," was the patriarch who first brought the teachings of Buddhism to China. According to tradition, he crossed the Yangtze River walking barefoot on the water with his sandals in his hand.

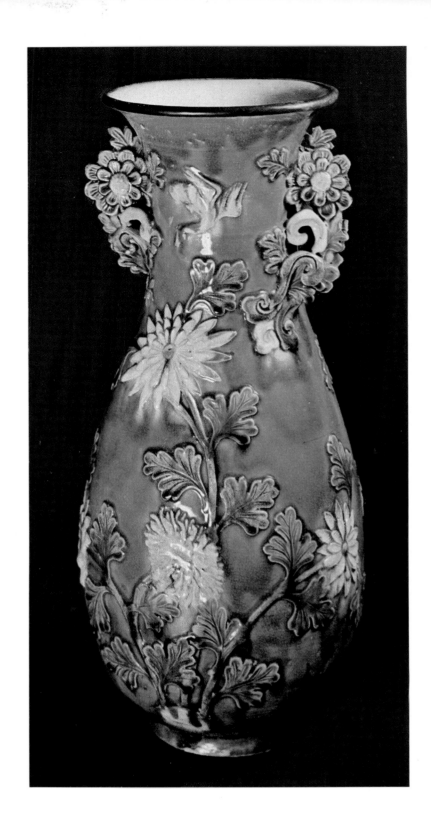

31. Vase for chrysanthemums

Ming Dynasty (1368–1644)
Stoneware, with underglaze three-color decoration in relief
Height: 16⁷/₈ inches
Origin: Shansi province

Probably dating from the second half of the Ming Dynasty, this vase illustrates the very special style of pieces decorated in *san-ts'ai*, the so-called three-color ware.

A lively decoration of chrysanthemums and other autumn flowers has been built up in relief on the stoneware body, and over this a variety of glazes has been applied: aubergine (manganese oxide), turquoise (copper oxide with a base), and cream. The piece did not require two firings. Glazes of this type are known as "medium fired." They fall midway between the higher-fired glazes of earlier periods and the enameled ware. They are subjected to a temperature just high enough to assure the firing of the piece as a whole.

32. Vase for blossoming fruit branches

Ch'ing Dynasty, K'ang Hsi reign (1662–1722)
Porcelain with five-color enameled decoration
Height: 14 1/4 inches
Origin: Chingtechen, Kiangsi province

It is interesting to compare this vase with the one shown in Plate 9. A very different spirit animated the creators of the two pieces, though there is a similarity of shape, both vases being designed to hold a single branch of fruit blossoms at the end of winter.

The stunning technical perfection of this vase, with enamel colors of the most subtle shades, stands in marked contrast to the refinement of the Sung piece and the restraint of its decoration. We find an orange-red trellis pattern and fruit blossoms among which butterflies are flitting superimposed on a background inspired by a silk brocade used for spring clothing. Would a lepidopterist recognize the species, or are these—as we suppose—imaginary butterflies?

Note the enamel blues on the underside of the butterfly wings. From now on these take the place of underglaze blue.

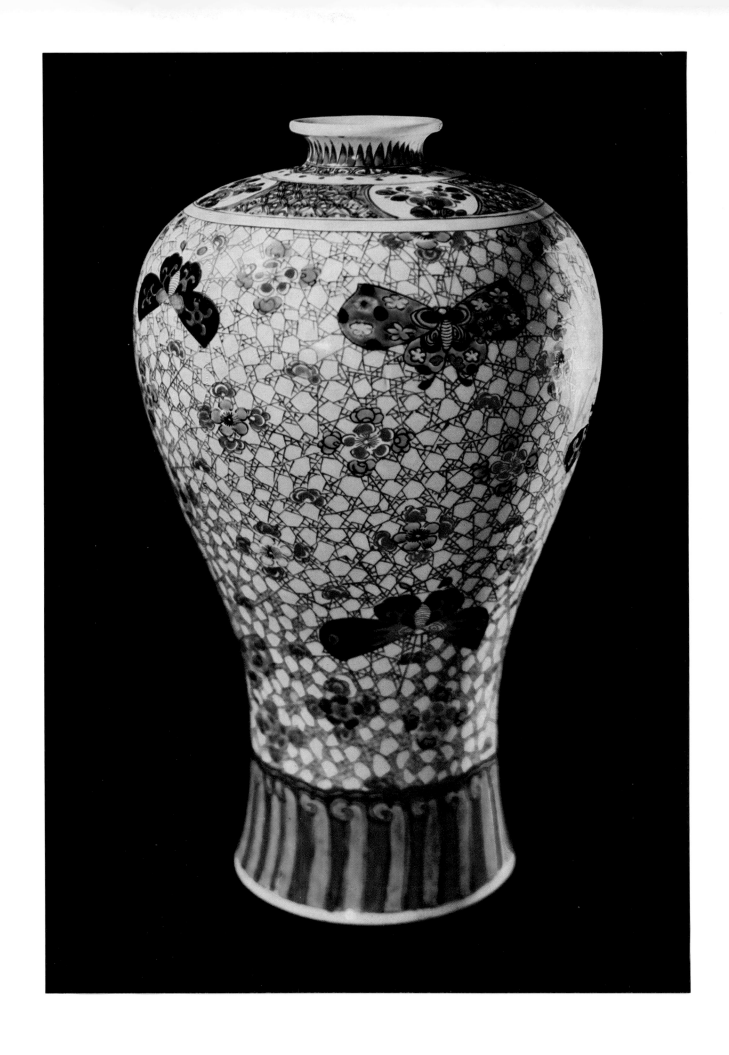

33. Chu K'uei the Immortal

Ch'ing Dynasty, K'ang Hsi reign (1662–1722)
Height: 6 1/2 inches
Origin: Chingtechen, Kiangsi province

This piece attests to the extreme virtuosity the potters of Chingtechen had attained at the beginning of the eighteenth century. It is a veritable anthology of the hard pastes.

Portions of biscuit porcelain are contrasted with portions of glaze and painted enamel. The jar sitting on the rock is an imitation of Ming pieces done in the Hsüan Te reign, its fish colored with copper red. At the same time, the other jar, which extends halfway over the foot of the rock, recalls Kuan crackleware of the Sung Dynasty. Such a piece could only have been produced by a series of firings under very different conditions of oxidation and reduction. The last operation was adding the lovely gold ornamentation to the gown at a relatively low temperature.

Chu K'uei is one of the Eight Immortals. He drives away evil spirits, and is generally drunk on rice brandy.

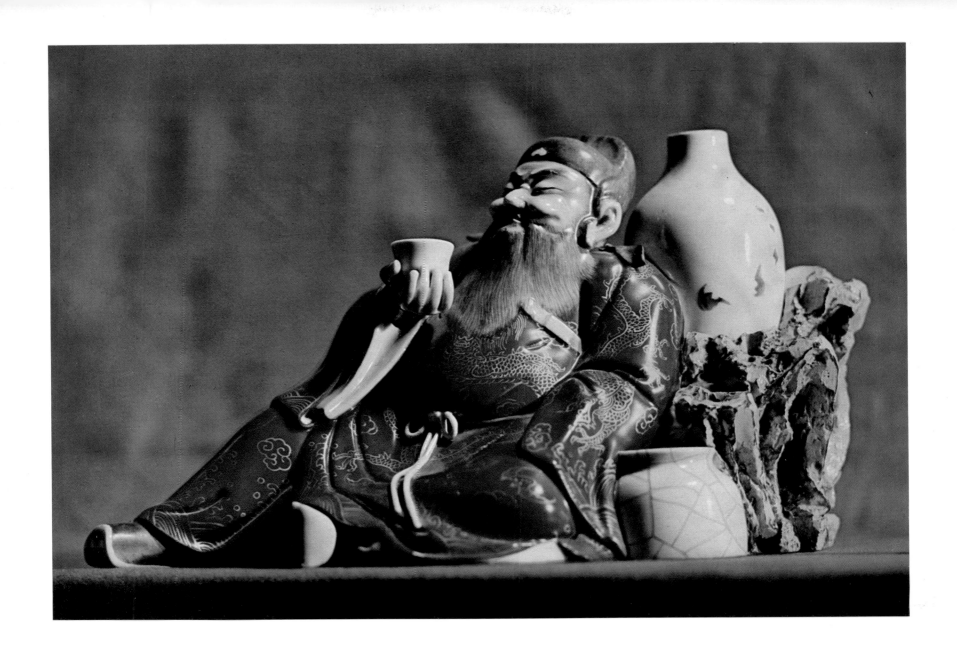

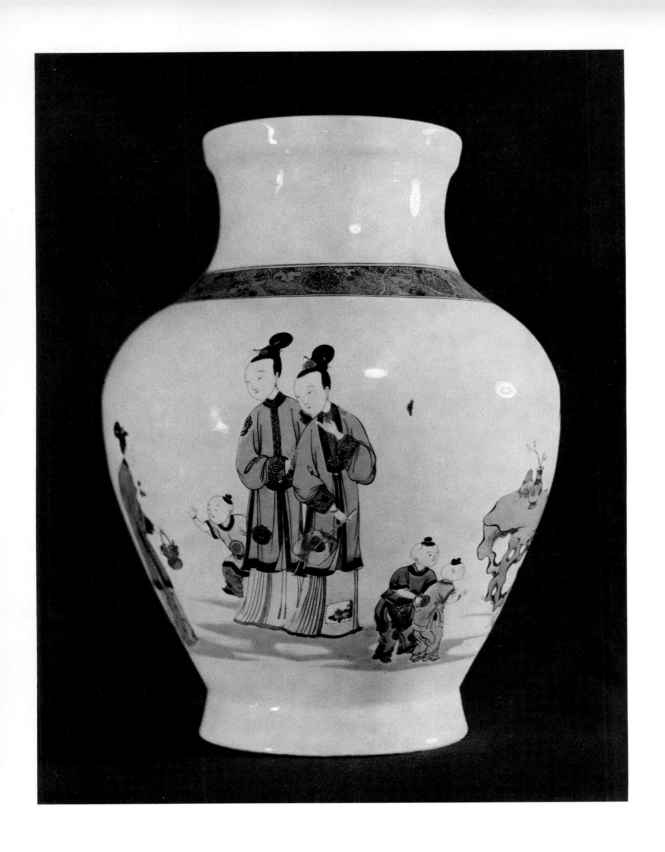

34. Vase

Ch'ing Dynasty, Yung Cheng reign (1723–1735)
Porcelain, with enameled decoration, famille verte
Height: 13⁵/₈ inches
Origin: Chingtechen, Kiangsi province

A traditional theme treated in pictorial style. Young women accompanied by children and servants are playing in a garden. The piece belongs to the so-called *famille verte*. Note the subtle combination of enamel colors, especially in the clothing of the women, which sets off so tellingly the blacks of their hair and ornaments. The quality of the white which serves as background to the scene is also admirable.

One gains some idea of how very different were the eighteenth-century pieces produced for Chinese collectors—strikingly more restrained—from those produced for the Western export market.

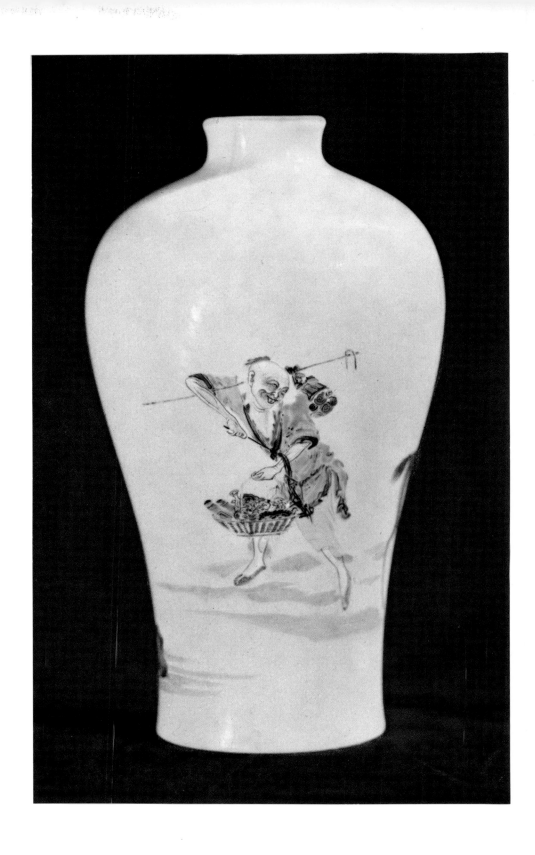

35. Small vase

Ch'ing Dynasty, Yung Cheng reign (1723–1735)
Porcelain, with enameled decoration of horses and people, famille rose
Height: 4 inches
Origin: Chingtechen, Kiangsi province

Again, a tiny picture impeccably executed on porcelain. The scene may make allusion to some written tale: a peasant coming home from market is carrying what looks like a horseshoe on the end of a stick, and pauses to look at a passing horse.

As with the preceding pieces, one has to admire the technical command, the sobriety and rightness of the decoration, the harmony of the colors.

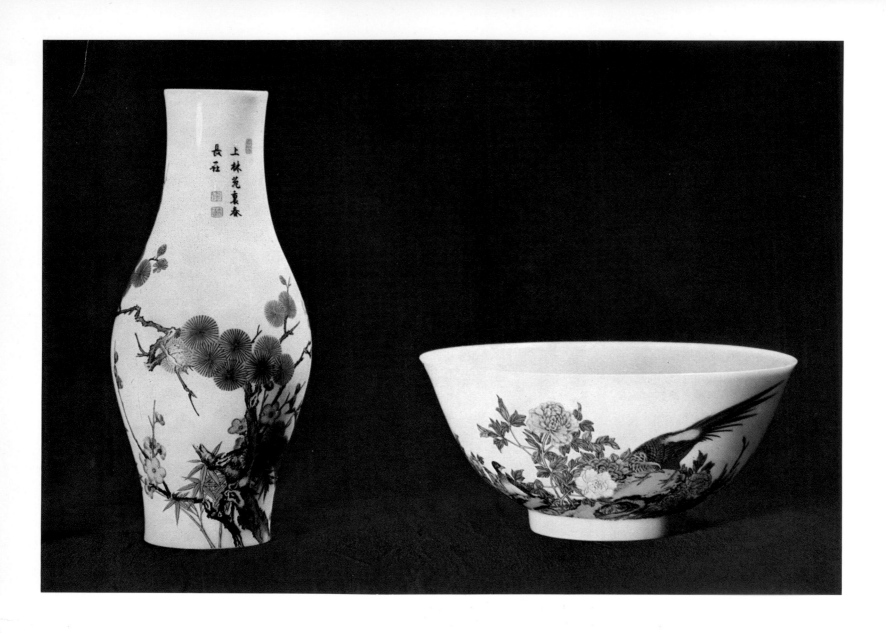

36. Vase and bowl

Ch'ing Dynasty, Yung Cheng reign (1723–1735)
Porcelain, with enameled decoration, famille rose
Height of vase: 6⁵/₈ inches; diameter of bowl: 5³/₄ inches
Origin: Chingtechen, Kiangsi province

These two pieces represent the most delicate and refined work achieved in the art of porcelain under the Ch'ing Dynasty. Extremely rare pieces, notable for their restraint, they have been assigned the name *ku yüeh hsüan*. No one quite knows the origin of the expression which could be translated "terrace of the old moon," but it may have been the name of the studio that produced these pieces.

The decoration of the vase is pictorial. On a superb white background (white with an arsenic base) we find the Three Friends: the pine, the bamboo, and the plum tree. There is also a short poetic phrase preceded and followed by seals, just as though this were a painting: "In Shang Lin's garden, where it is forever spring."

The cup is decorated with the classic theme of a bird amid flowers, which here are peonies.

174

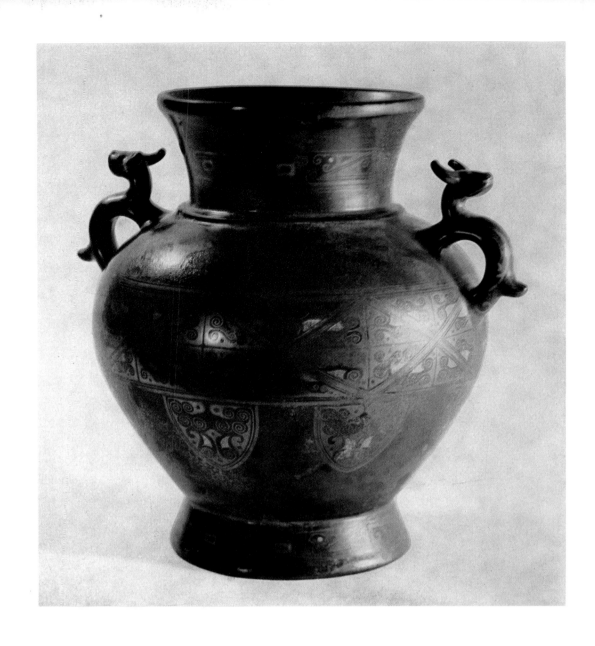

37. Vase in imitation of an ancient bronze

Ch'ing Dynasty, Ch'ien Lung reign (1736–1795)
Porcelain, with enameled decoration and gilding
Height: 8⁵/₈ inches
Origin: Chingtechen, Kiangsi province

As though winded from so long a run of originality, the creative spirit now turns to imitation. We must nonetheless admire the utter mastery of technique which here renders with strict fidelity the patina of an ancient ceremonial bronze in the Huai style, incrusted with gold and silver, such as were produced in the sixth and fifth centuries B.C. Enamels colored with iron oxide imitate the patina of bronze, and delicately handled gold renders the incrustations.

CHRONOLOGY OF PAINTERS

T'ANG DYNASTY (618–907)

 HAN HUANG (723–787)

 LI CHAO-TAO (670–730)

 LI SSU-HSÜN (651–716)

 WANG WEI (699–759)

 WU TAO-TZU (c. 700–760)

 YEN LI-PEN (died about 671)

SUNG DYNASTY (960–1279)

 HSIA KUEI (c. 1190–1225)

 HUI TSUNG (1082–1135)

 KUO HSI (c. 1020–1090)

 LIANG K'AI (active after c. 1200)

 LI T'ANG (c. 1050–1130)

 MA HO-CHIH (1130–1170)

 MA LIN (active c. 1246)

 MA YÜAN (c. 1190–1225)

 MI FEI (1051–1107)

 MU CH'I, KNOWN AS FA CH'ANG (1176–1239)

YÜAN DYNASTY (1279–1368)

 CHAO MENG-FU (1254–1322)

 HUANG KUNG-WANG (1269–1354)

 JEN JEN-FA (1254–1327)

 NI TSAN (1301–1374)

 TS'AO CHIH-PO (1272–1355)

 WANG MENG (1308–1385)

 WANG MIEN (1335–1415)

 WU CHEN (1280–1354)

 YAO T'ING-MEI (active c. 1360)

MING DYNASTY (1368–1644)

 CH'EN HSIEN-CHANG (1428–1500)

 CH'IU YING (1510–1551)

 HSIANG SHENG-MO (1597–1655)

 KUO PI (fourteenth century)

 SHEN CHOU (1427–1509)

 T'ANG YIN (1470–1523)

 WANG CHUNG-YU (fourteenth century)

CH'ING DYNASTY (1644–1912)

 CHU TA, KNOWN AS PA-TA-SHAN-JEN (1625–1705)

 FANG I-CHIH, KNOWN AS HUNG CHIH (middle seventeenth century)

 HSÜ T'AI (seventeenth century)

 KUNG HSIEN (active c. 1660–1700)

 K'UN TS'AN, KNOWN AS SHIH CH'I (1610–1695)

 LAN YING (1585–1660)

 TAO CHI, KNOWN AS SHIH T'AO (1630–1707)

 WANG HUI (1632–1717)

 YÜN SHOU'PING (1633–1690)

ECCENTRIC MASTERS OF YANGCHOW

 CHIN NUNG (1683–1764)

 HUA YEN, KNOWN AS HSIN-LO-SHAN-JEN (1683–1755)

 LI SHAN (1711–1754)

 LO P'ING (1733–1799)

NINETEENTH- AND TWENTIETH-CENTURY PAINTERS

 CHAO SHIH-CH'IEN (1829–1884)

 CHI PAI-SHIH (1863–1957)

 HSÜ KU (1824–1896)

 WU CHÜN-CH'ING (1844–1927)